WORD OF MOUTH

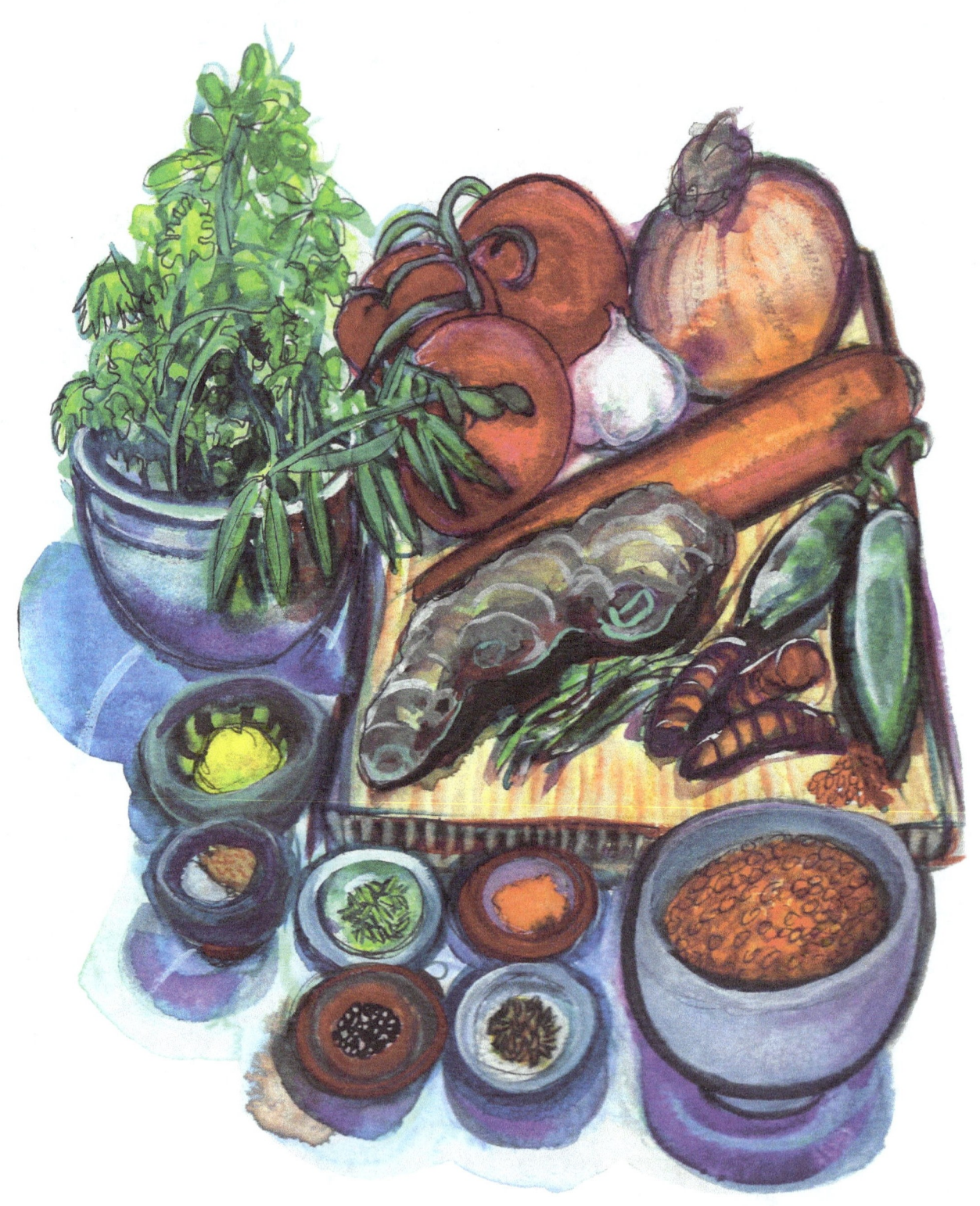

WORD OF MOUTH

ASIAN AMERICAN ARTISTS SHARING RECIPES

Edited and Illustrated by
LAURA KINA *and* **JAVE YOSHIMOTO**

The University of Arkansas Press

Fayetteville | 2025

Copyright © 2025 by the University of Arkansas Press. All rights reserved. No part of this book should be used or reproduced in any manner without prior permission in writing from the University of Arkansas Press or as expressly permitted by law.

ISBN: 978-1-68226-267-2
eISBN: 978-1-61075-832-1

28 27 26 25 24 5 4 3 2 1

Designed by William Clift

Frontispiece: Laura Kina, *Sunday Still Life of Ingredients to Make Baseera Khan's Red October Dal*, 2024. Watercolor and pen on paper, 9 × 12 in. *Image courtesy of Laura Kina.*

♾ The paper used in this publication meets the minimum requirements of the American National Standard for Permanence of Paper for Printed Library Materials Z39.48–1984.

Library of Congress Cataloging-in-Publication Data

Names: Kina, Laura, 1973– illustrator, editor. | Yoshimoto, Jave, illustrator, editor.
Title: Word of mouth : Asian American artists sharing recipes / edited and illustrated by Laura Kina and Jave Yoshimoto.
Description: Fayetteville : The University of Arkansas Press, 2025. | Includes bibliographical references.
Identifiers: LCCN 2024045113 (print) | LCCN 2024045114 (ebook) |
 ISBN 9781682262672 (paperback) | ISBN 9781610758321 (ebook)
Subjects: LCSH: Cooking, Asian. | Asian Americans—Food. | LCGFT: Cookbooks.
Classification: LCC TX724.5.A1 W67 2025 (print) | LCC TX724.5.A1 (ebook) |
 DDC 641.595—dc23/eng/20241029
LC record available at https://lccn.loc.gov/2024045113
LC ebook record available at https://lccn.loc.gov/2024045114

CONTENTS

Acknowledgments — 7

Preface — 9

INTRODUCTORY ESSAYS

Pandemic Comfort Cooking — 13
Laura Kina

Departures and Connections — 17
Jave Yoshimoto

An Artists' Cookbook: Forging Community in Isolation — 19
Michelle Yee

RECIPES

Double-Fried Garlic Chicken — 35
Anida Yoeu Ali

Kebab Karahi — 39
Ruby Chishti

Kimchi — 43
Hyegyeong Choi

Tripe Stew — 47
Hasan Elahi

Rabokki 라볶이 — 51
Aram Han Sifuentes

A Recipe for Survival Spinach Casserole — 55
Robert Farid Karimi

Red October Dal — 59
Baseera Khan

SPAM Musubi and Auntie Nora's Mac Salad — 63
Laura Kina

Chinese Milk Bread — 69
Phoebe Kuo

"I'm a Pepper, You're a Pepper, Wouldn't You Like to Be a Pepper, Too?" Chicago/LA Kalbi Marinade/Serenade and Trader Vic's Mai Tai — 73
Larry Lee

Milkfish Congee 虱目魚粥 — 77
Kathy Liao

Dumplings — 81
heather c. lou

Vegan Kare Kare — 85
Kiam Marcelo Junio

Pancit Guisado 2.0 — 91
Mia Matlock

Ground Pork Japchae — 95
Jarrett Min Davis

Pork My Buns XXXX — 99
Genevieve Erin O'Brien

Sourdough Starter Jian Bing — 103
Valerie Soe

Okonomiyaki Taro Takizawa	107
Beef Chow Fun (Fried Rice Noodles) Heinrich Toh	111
SPAM and Eggs Mathew Tom	115
Lien's Fried Banana Cake Lien Truong	119
Szechuan Spicy Alligator Francis Wong	123
Recipe for Political Action: The Auntie Sewing Squad Kristina Wong	127
Jave's Omega Mapo Tofu and Kimchi Fried Rice Flavor Explosion Jave Yoshimoto	131
Index	*137*

ACKNOWLEDGMENTS

Word of Mouth is also an online special exhibition first published through the Virtual Asian American Art Museum (https://vaaam.tome.press/) in 2023. Yvonne Fang was the web designer and programmer, Nathan Kawanishi was the graphic designer, and Alexandra Chang was the editor for the online exhibition. This expanded and revised print edition includes new contributions by Laura Kina, Jave Yoshimoto, and Hasan Elahi and an introductory essay by art historian Michelle Yee.

This project was funded by a 2020 Art Matters Foundation grant awarded to Laura Kina as well as by DePaul University's Society of Vincent de Paul Professors. Laura also thanks her studio assistant, Young Sun Choi, for image documentation and Mark Werle and Helen McElroy for accessibility consultation for the online exhibition. Special thanks to Jave Yoshimoto's studio assistant, Elisa Wolcott, for her moral support, timely jokes, wonderful dedication, and hard work throughout the process of this project. Thank you to all the participating artists for sticking with us as this project slowly simmered along and to our University of Arkansas Press acquisitions editor, David Scott Cunningham, for including our book in the U of A's Food and Foodways series.

Thank you to the University of Arkansas Press staff who shepherded our book through publication: managing editor Janet Foxman, design and production manager William Clift, marketing director Charlie Shields, and editorial assistant David Manuel Cajias Calvet. Finally, thank you to our copy editor Katie Herman and indexers Wei Ming Dariotis and Stephen Ingle.

PREFACE

Word of Mouth: Asian American Artists Sharing Recipes features original recipes and stories from twenty-four Asian American and Asian diaspora artists from across the United States, with contributions ranging from Los Angeles–based performance artist Kristina Wong's "Recipe for Political Action: The Auntie Sewing Squad" to New Orleans–based painter Francis Wong's family's Chinese restaurant recipe for stir-fry Szechuan alligator. Conceived in the spring of 2020 during the twin pressures of the COVID-19 lockdown and the rise in anti-Asian bigotry, this cookbook features original recipe illustrations by Laura Kina and Jave Yoshimoto as well as by contributing artists Hyegyeong Choi, heather c. lou, and Mia Matlock. Art historian Michelle Yee and the coeditors, Laura Kina and Jave Yoshimoto, contributed introductory essays.

Each recipe comes with a backstory from the artist reflecting how their Asian American cuisine has been impacted by histories of war, migration, relocation, labor, and mixing and how we have used food to care, connect, build, and sustain diverse communities in our personal lives and artistic practices. Each recipe also comes with a featured artwork and the artist's bio. The artists included in this book represent a diverse range of emerging, midcareer, and established artists: Anida Yoeu Ali, Ruby Chishti, Hyegyeong Choi, Hasan Elahi, Aram Han Sifuentes, Robert Farid Karimi, Baseera Khan, Laura Kina, Phoebe Kuo, Larry Lee, Kathy Liao, heather c. lou, Kiam Marcelo Junio, Mia Matlock, Jarrett Min Davis, Genevieve Erin O'Brien, Valerie Soe, Taro Takizawa, Heinrich Toh, Mathew Tom, Lien Truong, Francis Wong, Kristina Wong, and Jave Yoshimoto.

Taking inspiration from community cookbooks many of us grew up with, this artists' cookbook archives a specific moment of uncertainty during the pandemic when some of us with the luxury of working remotely found ourselves finding solace in food and spending inordinate amounts of time in the kitchen to keep our hands and minds busy. Others faced economic and food insecurity and yet still found the capacity to use their creativity to feed others in need and provide mutual aid. This pandemic cookbook project was a way to stay in touch, meet new artists, and build community during a time of isolation, grief, and loss.

INTRODUCTORY ESSAYS

PANDEMIC COMFORT COOKING

Laura Kina

I started this cookbook with Jave Yoshimoto before my world as I knew it fell apart. Before I was diagnosed with breast cancer during the pandemic in June 2020. Before I came out as queer at age forty-eight in May 2021 and got divorced after twenty-five years of marriage in January 2023.

Before October 7, 2023.

It was late April and early May 2020, at the beginning of the COVID-19 quarantine and before widespread social justice protests erupted across the US following the murder of George Floyd by a Minneapolis police officer.

I missed my friends and family. I missed community. I missed meeting new people. I was cleaning and cooking every day—working my way through my cookbooks and posting my creations on social media to stave off my panic. "Everything is going to be fine as long as I stay busy," I lied to myself. Elaborate menus and shopping lists for supplies to hoard filled the little time I had in between pivoting to teach my DePaul University undergraduate art classes online, running a graduate program in Critical Ethnic Studies, and taking care of my family. Masked and gloved trips to H Mart to stock up on Asian cooking ingredients were part of my emergency supply runs. I bought a second fridge to put in my basement for my growing piles of goodies, and it soon became a kimchi fridge that sat next to the stockpiles of toilet paper. It all seems like a petty, privileged, middle-class response now, especially considering that so many others were facing food insecurity at the time. But I know from the whole sourdough bread phenomenon and the many months I spent posting in the Facebook group "Eating in the Time of Coronavirus" that I wasn't the only one who to turned to cooking as a form of self-care.

I was inspired to make a zine after seeing the amazing *Asian American Feminist Antibodies: Care in the Time of Coronavirus* zine created by the Asian American Feminist Collective in March 2020.[1] I was curious what my other Asian American artist friends were cooking and how they were holding up, especially considering the rising tide of anti-Asian sentiment that was fueled by then President Trump's hate speech. I couldn't muster up the focus to start a new series of paintings. I wanted to do something small that would help me stay connected. Since the early 1990s when I first moved to Chicago from the Pacific Northwest, the Asian American art world has been my primary community through an interconnected network of artists' collectives, professional associations, festivals, alternative exhibition spaces, activist / social justice spaces, and cultural and social service organizations. Food has been the glue between the worlds of art and political activism. Somewhere in between thumbing through *Piihonua Kumiai Cookbook*—a 1987 spiral-bound cookbook from my dad's Big Island sugarcane plantation community in Hawai'i—and flipping through the illustrations in Ermine Herscher's 1996 cookbook *Picasso, Bon Vivant*, I got the idea to do this project with Jave, whose art I had admired for some time.[2]

Jave and I both draw from our Japanese cultural background (Okinawan American in my case and ethnically Chinese from Japan in Jave's case) in our art and have penchants for high-intensity color, contour line work, and busy patterns that complement each other. The intent of this book was to both archive our vibrant community and draw its future, including you, into existence.

But then I got sick. Very sick. Amid my surgery, chemo, and radiation treatments, I'd occasionally illustrate one of the recipes in this book, and holding on to this thin thread of my former life kept me going. There was going to be an after.

And so the project inched forward even when I was too weak and sick to cook anymore.

There were long pauses when things got really bad, but in the moments I could think clearly, this book was there puttering along. In this way, our book was birthed through disabled and queer time—time that is nonlinear, time that rests, time that is distracted or disrupted, and time that is deliciously wasted alone and together through food.

The project was first launched in 2023 through the Virtual Asian American Art Museum as a special exhibition. Art historian Michelle Yee invited Jave and me to talk about the show at the 2023 College Art

Above: Laura Kina, studio view of illustrations for SPAM Musubi and Trader Vic's Mai Tai recipes, 2020. Watercolor and pen, 7 × 10 in. each. *Image courtesy of Laura Kina.*

Association conference in New York on a panel titled "Beyond a Basic Need: Circuitous Paths of Food in Contemporary Global Asian Art." Michelle, Jave, and I are connected through the Diasporic Asian Arts Network, and Michelle has previously written about my art. David Scott Cunningham, the University of Arkansas Press editor in chief, was in the audience and could see the synergy between our work with Michelle's research on food studies in contemporary Asian American art. The four of us went out for dim sum after the panel, and the full vision for this book was sealed over Taiwanese soup dumplings.

This expanded print book includes a new introductory essay by Michelle Yee, which theorizes the diasporic intimacies and the radical potential of our project to "hold togetherness and difference at the same time." She frames her contextualizing history of artist cookbooks and the relational aesthetics of food in Asian American art with her own story of growing up in a Chinese grocery store / restaurant family in a predominantly white community in Utah. This book is also distinct from the online exhibition in that we were able to add artist Hasan Elahi and his Tripe Stew recipe, I added my late auntie Nora's Mac Salad recipe, and Jave added his Kimchi Fried Rice Flavor Explosion. We made other minor changes throughout the book, updating bios, headshots, some artwork, and a recipe illustration; expanding some of the artist backstories; fine-tuning recipes; and updating our own introductory essays.

I am now thankfully on the flip side of active breast cancer treatments, well into rebuilding my life in the wake of divorce, and well enough to fight other battles. I am in the after—the present that is dreaming yet another future. The myriad connections forged through this cookbook helped heal me and sustain me. The lessons I learned in the making of this book—to take time to rest, play, cook, and eat with friends—transformed me. Home can be far more expansive than I originally imagined. I hope that as you are introduced to the work of twenty-four diverse Asian diasporic artists from across the US, you will find comfort and enjoy their recipes and stories as much as I do.

NOTES

1. "Asian American Feminist Antibodies: Care in the Time of Coronavirus," *Asian American Feminist Collective Zine* 3, March 2020, https://static1.squarespace.com/static/59f87d66914e6b2a2c51b657/t/5e7bbeef7811c16d3a8768eb/1585168132614/AAFCZine3_CareintheTimeofCoronavirus.pdf.
2. *Piihonua Kumiai Cookbook* (Piihonua, HI: Piihonua Community Association; Collierville, TN: Fundcraft Publishing, 1987); Ermine Herscher, *Picasso, Bon Vivant* (New York: Rizolli, 1996).

DEPARTURES AND CONNECTIONS

Jave Yoshimoto

It was a sinking feeling as I watched my wife leave, descending the stairs. The sadness felt like a bottomless pit, and I had no idea how long this feeling was going to last. As if having been diagnosed as diabetic and contracting a case of COVID-19 that left me unable to breathe or move out of my bed for a while wasn't enough, my partner of fourteen years leaving felt like the final nail in the coffin during the pandemic lockdown of 2020.

My situation wasn't unique, of course, as the pandemic brought many challenges to everyone, leaving most of us lost in our own lives and searching for answers. We were all hoping to see the end sooner or later and for our lives to return to normal, whatever that meant for any of us during that time.

Normal had once looked like being in a lively public outdoor setting and eating out with friends. Such was my experience with Laura Kina when we used to explore the streets of New Orleans to search out new local cuisines and recipes to enjoy. Foods such as shrimp étouffée left our mouths salivating and wanting more. My friends and I enjoyed these times while sharing laughter and stories, and when the lockdown hit, we all thought it would be a very temporary setback. However, that setback felt like an eternity while it lasted.

Deterioration came in many forms, from my physical body shutting down from not moving as much, to breakdowns of communications in relationships, to my own mental health barely keeping me afloat on the daily. When Laura first approached me with the idea for this cookbook, it seemed like a no-brainer. It was a way back to our roots—to happy times, to sharing stories, to joys and memories. This would be our chance to recover to normalcy. Why not then invite other artists also to partake, those who had also used their comfort food as their coping mechanism through their personal challenging times? We got to work, and I reached out to a few of my Asian American artist friends to feel out interest as Laura looked around to cover a variety of regions for a more well-rounded and representative body of recipe iterations from around the country.

What was personally exciting for me was that I also wanted to share a recipe, but at the

Laura Kina and Jave Yoshimoto at the St. Roch Market in New Orleans during their Joan Mitchell Center residency, Summer 2019. *Image courtesy of Laura Kina.*

same time, I saw this as an opportunity to explore a number of new ones that I had never made before. My studio assistant, Elisa Wolcott, had been a consistent presence in my home studio, so I asked for her help in researching and experimenting with new recipes. What came about were moments of little discoveries that were fantastic: nuances of what made flavors successful, what ingredients might or might not work when considering combinations of sauces and textures, how some culinary techniques were more difficult to pull off than others (exploding omelet was rather a memorable mess to clean up). In the end, all the time that was spent in the kitchen, learning and trying new recipes and connecting with a dear friend over warm meals, was what made it all special.

I hope you can come away with your own positive stories and experiences through your exploration of these recipes. I hope you can take something away from each artist's stories, their experiences, their artworks, and begin to witness them for who they are—human beings who are trying their best to cope and live their lives like the rest of us, in search of joy through food and connection.

AN ARTISTS' COOKBOOK
Forging Community in Isolation

Michelle Yee

Throughout my life, my mother has had a worn cookbook that she will occasionally reference when cooking.

In my childhood mind, my mother's food recollected a specific past and heritage, and thus, I assumed, the recipes must have been passed down the generations of her family and then adjusted and tweaked once she arrived in the United States. The truth, however, is that I have no idea: What of her cooking emerged from the cookbook that I saw my mother referencing; what from her own earlier life in Taiwan; what from her marriage to my father who, although also from Taiwan, came from a family that hailed from Hunan Province, with its varying tastes and flavors; and what was mixed in from her time in the United States? What I took for granted as food that signified my ethnic and cultural heritage, as it turns out, had taken a complex and meandering path on its way to my stomach. This path, inextricably tangled, signals the particularly difficult, if not impossible, task of tracing the strands of familiarity and nostalgia that pepper the tastes and flavors of diasporic existence. In fact, despite the presence of my mother's cookbook in my childhood, I don't have a single actual written recipe with precise measurements and instructions for any of her food. Instead, I hold my phone camera, with my mother on FaceTime, over my pot as I try to make beef noodle soup. I pour in the soy sauce, waiting for her to say "That's enough" before then continuing on to the next verbalized step. Even without specific directions and regardless of my amateur cooking skills, the dishes produced always manage to contain the flavors, smells, and tastes that cast my mind and my body into nostalgic spaces of home, identity, and belonging.

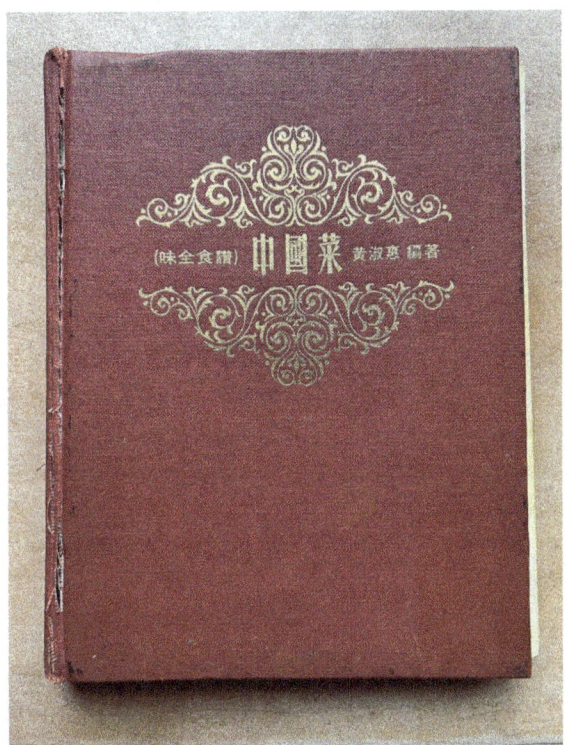

The front cover of my mother's cookbook. *Image courtesy of Angela Yee.*

My mother's cookbook, a physical object, presented itself more as a touchstone as she refined and tweaked her ingredients. It functioned less as an actual cookbook and more as a guide gesturing toward the flavors and tastes that connected her to a past, an identity, and a complicated present reminiscent of

what scholar Svetlana Boym has termed "diasporic intimacy." For Boym, diasporic intimacy is rooted in a complex idea of nostalgia, which she defines as "a longing for a home that no longer exists or has never existed. Nostalgia is a sentiment of loss and displacement, but it is also a romance with one's own fantasy."[1] Nostalgia is thus constituted by familiarity but also by an imagined and constructed relationship with what appears to be or *feels* familiar. Boym pushes further in her understanding of nostalgia through her contextualization of diasporic intimacy, asserting that "immigrants' stories are the best narratives of nostalgia—not only because they suffer through nostalgia, but also because they challenge it. These stories are often framed as projections for the nostalgia of others who speak from a much safer place. Immigrants understand the limitations of nostalgia and the tenderness of what I call 'diasporic intimacy,' which cherishes non-native, elective affinities."[2]

Boym raises the possibility that diasporic experiences can, within their ruptures, open up to connectivity precisely because "diasporic intimacy is not opposed to uprootedness and defamiliarization but is constituted by it."[3] I am struck by this definition of diasporic intimacy as it reaches into a particular form of nostalgia that is defined by a binary of both familiarity and disconnect. The tension embedded in this binary plays out in food, a particularly apt metaphor and conduit for the development and conveyance of diasporic intimacy. In my own quotidian experience, food has represented a connection to an unfamiliar homeland primarily through my mother, whose food is accompanied not only by hours and days spent in the kitchen but also by stories of her childhood in Taiwan, of Lunar New Year and Mid-Autumn Festival celebrations, of family histories and the lore of the best cooks among her nine siblings—many of whom she left behind when she immigrated to the United States. For me, food also constitutes the difference that accompanied my childhood experience growing up in a predominantly white community in Salt Lake City, Utah. It represents the working-class upbringing that I had as the child of immigrants who owned, first, a Chinese restaurant and, second, a Chinese grocery store. In these spaces, restaurants and grocery stores, the personal and familial associations of ingredients and dishes become public, and in these wider exchanges, work simultaneously to take on shifting intimacies and meanings that expand beyond and traverse in between the intimacies of family dinner tables. Over time, food has also been the site of shifts in societal perceptions as the flavors of what I always thought marked myself and my family as different became increasingly desired by American society. Xiao long bao, goji berries, boba tea—the delicacies of my childhood that I never dared to introduce to my friends—were suddenly not only trendy but also driving up the prices of formerly niche ingredients in grocery stores across the country.

The mutability of food and its constantly shifting meaning across time—in restaurants, on family dining tables, and shared among friends—show how food and its accompanying flavors and ingredients as well as its circuits of exchange and connection allow it to represent cultural heritage, familial traditions, and belonging in spaces and places where belonging is tenuous at best. Simultaneously, it functions as the manifestation of difference. Yet it is precisely in this dichotomy of difference and connection, in the processes of defamiliarization and uprootedness that define immigrant and diasporic lived experiences, that food emerges as a particularly potent form of connectivity and diasporic intimacy. While food is certainly

a common need among all people, among diasporic populations, it can also function as a point of connection. This connection is often formed not only by shared cultural tastes and flavors but also by the experience of exclusion from dominant culture that one's food can produce. Undeniably, Asian children bringing lunches to school have, across the United States, experienced feelings of difference and abjectness through the reactions of their classmates unfamiliar with kimchi or soy-braised bean curd.

More recently, when the COVID-19 pandemic became an inescapable reality for Americans in the middle of March 2020, food came to represent a basic need that was challenging to obtain. Fear of infection and lack of information about how the new virus spread meant that restaurants were closing or only doing takeout and delivery, and grocery stores became battlegrounds in which average shoppers entered only when armed with masks, gloves, and hand sanitizer. Further, the fear and terror sought and, unfortunately, found a scapegoat in people who looked Chinese and thus functioned as visual reminders of the Wuhan origins of the virus. In a throwback to the MSG hysteria of the 1970s and '80s, Chinese restaurants, ubiquitous in the United States, found themselves at the intersection of racism-fueled violence and pandemic-caused economic collapse.[4] Moreover, the initial reports that the virus may have originated in bats meant for human consumption in Chinese wet markets further signified the abject foreignness (and the dangers therein) of Chinese eating habits. In less than a month, between March 19, 2020, the day that the nonprofit group Stop AAPI Hate began taking reports of anti-Asian violence against Asians and Asian-owned businesses, and April 10, 2020, when NBC Asian America reported on the uptick, Stop AAPI Hate received more than eleven hundred reports of racialized violence against Asian Americans in the United States.[5] However, as other reports emerged in the news and on social media channels, restaurants, shuttered to the public in the face of potential infection, were cooking for and feeding frontline healthcare workers. Notable among them were, for example, 886, a New York City Taiwanese eatery that delivered bento boxes to hospitals around the city. Significantly, grassroots efforts prepared Chinese meals to be delivered to elderly Chinese residents locked in their apartments and senior living centers in Chinatowns across the country, offering them the comfort of familiar flavors. Caught in a dangerous double bind of pandemic and racism, Asian Americans rallied in the face of mounting violence. Even as food sat at the heart of the disgust toward the Asian community, it and the spaces in which it was made emerged as key symbols of community, resilience, and survival. And in isolation, food emerged as the conduit for possible connection, contact, and sociality.

It was at this pivotal moment that two artists, Laura Kina and Jave Yoshimoto, locked down in Chicago, Illinois, and Omaha, Nebraska, respectively, began this project in collaboration with their personal networks of Asian American artists. *Word of Mouth: Asian American Artists Sharing Recipes* is a compilation of (mostly) food recipes offered by contemporary Asian American and Asian diasporic artists who likely found themselves amid a lockdown with no end in sight, facing an uncertain world, simultaneously frustrated and terrified, staring into an even more uncertain future.

As a collaborative project, *Word of Mouth* came to be through a series of interconnected networks that underscore the sense of community and connectivity in the project. Kina and Yoshimoto invited a handful of artists who were personal friends to contribute recipes. Some

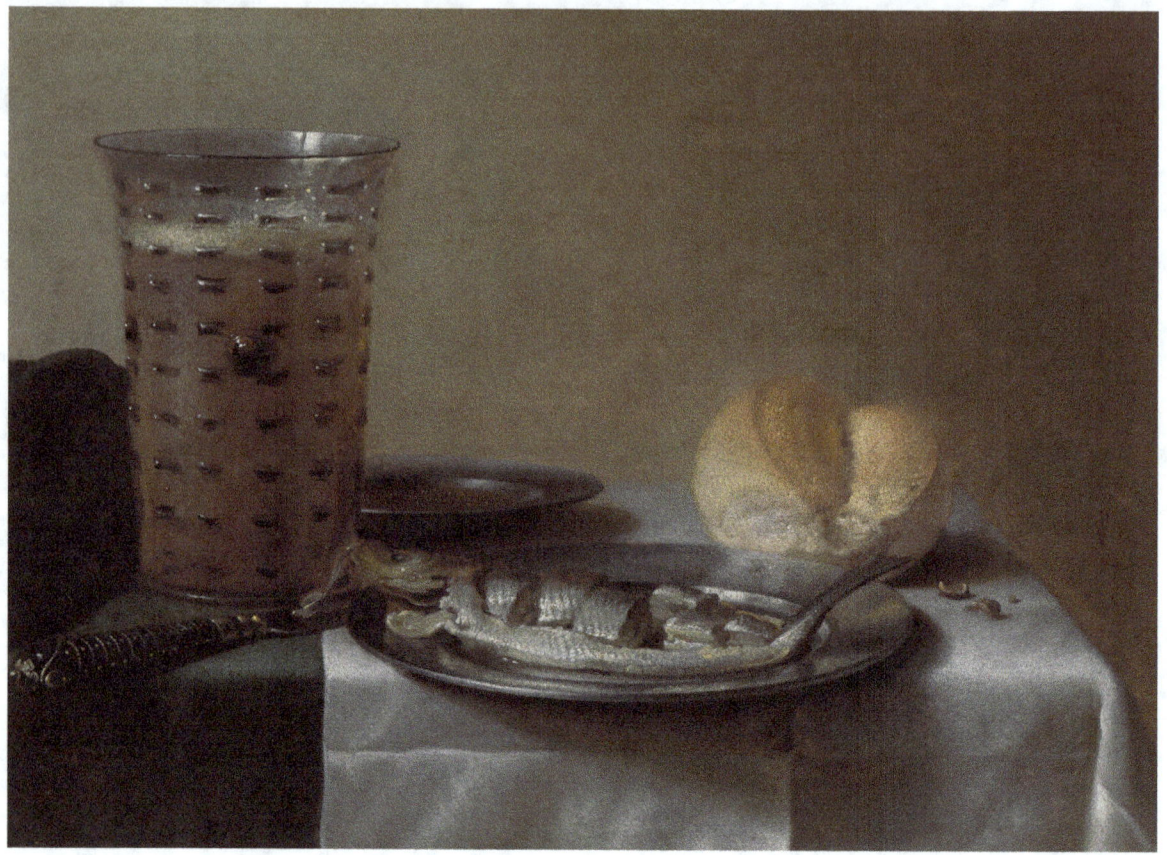

artists, in turn, suggested other artists who might be interested—gestures that inspired the title, *Word of Mouth*. Artists were thus introduced to one another, creating an even larger network. Indeed, similar to the act of eating together, the act of exchanging recipes transcended the physical isolation rendered by the pandemic and offered an opportunity for further connections and artistic networking. Most of the recipes were illustrated by Kina or Yoshimoto, who, in an organic process, each often illustrated the recipes of the artists whom the other knew better, thereby offering an opportunity for deepening relationships. Three artists, heather c. lou, Hyegyeong Choi, and Mia Matlock, elected to illustrate their own recipes. For the others, Kina and Yoshimoto were given photographs of the dishes or, in many cases, cooked the recipes themselves to see a final product from which to illustrate. In a private act of communal sharing, the act of cooking and then illustrating a dish created a long-distance bond between the artists. With each recipe, the artist from whom the recipe came is also featured. Each artist wrote their own biography and the backstory to their recipe and selected an artwork of their own to be printed alongside the recipe and its illustration. In this way, the authorship of the recipe giver is emphasized, and their identity

Above: Pieter Claesz, *Breakfast Piece*, 1636. Oil on panel, 14.1 × 19.2 in. *Collection Museum Boijmans Van Beuningen, Rotterdam / Photography: Studio Tromp.*

as an artist is underscored. Indelibly carved throughout the artists' identities and these recipes' backstories is a wider and deeper history of migration, departure, and separation tracing impossibly inextricable paths through family histories, political events, wars, displacement, and immigration. Yet, through the medium of food, the narratives of severing find themselves rooting and settling into end results that are, at their very core, nourishing and needed.

This project is a cookbook, an ostensibly utilitarian tool. More so, however, it is a collaborative work of art, proffering the creative production of not only Kina and Yoshimoto but also the twenty-two other artists who have now contributed to this volume. Food and art have always intuitively seemed to go together. In the history of art, food has long been a topic of interest to artists. Depictions of food abound in the canon of art history, as exemplified in, to name only a few: Leonardo da Vinci's *The Last Supper* from the Renaissance, Judy Chicago's 1979 *Dinner Party*, the still lifes of Dutch painters contemplating the capriciousness of life, and the drool-worthy desserts of Wayne Thiebaud. Food and the accompanying circulations of gatherings, exchanges, and economies have a long, storied, and deep history in the annals of art history wherein food has functioned as metaphor for and gateway into larger cultural, political, and social explorations.

Similarly, the concept of an art-based cookbook is nothing new. *Word of Mouth* also follows in a long line of both artist-produced and artist-inspired cookbooks. From cookbooks such as *The Modern Art Cookbook*, which features recipes inspired by or actually written by modern artists, such as Vincent van Gogh's instructions to his brother about caramelizing onions, to the George Eastman Museum's *The Photographer's Cookbook*, which features

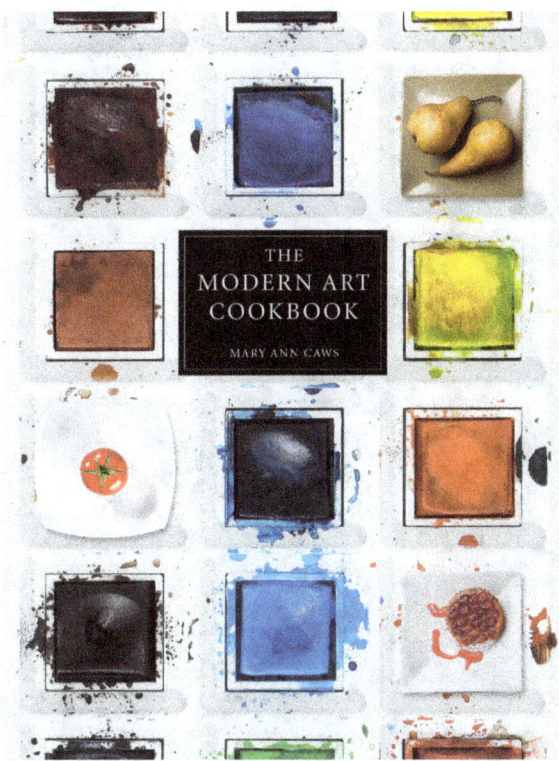

The Modern Art Cookbook by Mary Ann Caws. *Image courtesy of Reaktion Books.*

everything from Ed Ruscha's cactus omelet to Ansel Adams's beer-poached eggs, the seemingly inevitable relationship between artists and, not simply food itself, but the cooking of food, suggests an equivalence between the production of art and the production of food.[6]

Art lovers' curiosity to understand what their favorite artists not only ate but also cooked suggests a desire for intimacy and access to a human being—and the most vulnerable core of that human being—behind the work. Food is, although also so much more, a basic need. All humans must eat to survive, and despite the public nature of dining establishments, the act of witnessing another eat is an act of private intimacy. Akin to watching an artist at work in an open studio, watching someone cook or

knowing *how* someone cooked offers a privileged witnessing of the core of a person's humanity.

Recently, and arguably most notably in the post–relational aesthetics era, several scholars and curators have engaged with the intersection of food and art beyond the bounds of cookbooks—for instance, the Smart Museum's 2012 exhibition *Feast: Radical Hospitality in Contemporary Art*, which, in addition to the static exhibition, invited visitors to participate in a number of works that directly engaged food while pressing on larger cultural and societal issues. One such work, Michael Rakowitz's *Enemy Kitchen*, took the form of a performative food truck that not only engaged with the exhibition and the museum but also traveled around Chicago, serving regional Iraqi dishes on paper reproductions of china found in Saddam Hussein's palaces. Military veterans of the Iraq War worked as servers and sous-chef for the various stops on the food truck tour. While in many ways much like any other food truck, this work not only negotiates political issues but also engages with a wider audience beyond the immediate one of the museum. Other works, such as Alison Knowles's Fluxus project *Identical Lunch*, manifested as an exclusive and limited menu item in the museum's café.[7]

Above: Rirkrit Tiravanija, *untitled 1992 (free)*, 1992. Installation view. 303 Gallery, New York, NY. *Image courtesy of 303 Gallery and Rirkrit Tiravanija Studio.*

Included in the exhibition were trailblazing contemporary Asian artists Rirkrit Tiravanija and Lee Mingwei. Relevant to the discussion here, artists such as Tiravanija and Lee engage in larger questions of diasporic identity, offering viewers of their work access and insight into their performances, which inextricably link the production of food and art. It was in 1990 that Tiravanija emerged onto the contemporary art scene when he staged *untitled 1990 (pad thai)* at the Paula Allen Gallery. In 1992, the artist followed up with another iteration at 303 Gallery called *untitled 1992 (free)*, wherein he served Thai curry dishes to visitors.

As art historian Claire Bishop states, in this work, "the food is but a means to allow a convivial relationship between audience and artist to develop."[8] Arguably, beyond the convivial relationship, the food also pressed on questions of audience engagement, implicating the feasting public in issues of American military pursuits or societal negotiations of diasporic difference and belonging. What is critical to the project is that Tiravanija primarily cooked Thai food for his audience, a type of food that, while ubiquitous now, was fairly difficult to find in the 1990s even in New York City.[9] A few years later, Lee Mingwei, as an MFA student at Yale University, countered his feelings of loneliness by placing posters around campus inviting anyone interested in "sharing foods and introspective conversation" to contact him. Approximately forty-five people responded, and *The Dining Project* was born. Four nights a week, using the Whitney Museum's kitchen, Lee carefully cooked a meal for two, tailoring the meal to the dietary preferences of that evening's guest.

Although the food changed night to night, it remained the conduit through which a shared trust and intimacy could be developed between two strangers. More recently, whether artfully or not, the famed performance artist Tehching Hsieh opened a small restaurant called the Market in the Clinton Hill neighborhood of Brooklyn, New York, preparing Asian-inspired menu items in a casual coffeehouse for customers, many of whom likely are not aware that a famous performance artist is at the helm.

As French philosopher Nicolas Bourriaud has assessed, works such as these present "the possibility of a relational art (an art taking as its theoretical horizon the realm of human interactions and its social context, rather than the assertion of an independent and private symbolic space)."[10] Bourriaud's coining and defining of the term "relational aesthetics" recognizes that the potential to provoke and mediate relational acts between human beings underscores the importance of spaces of public interaction.

While such works and projects bring into consideration matters of hospitality as well as the power dynamics between hosts and guests as they unfold within public spaces, they also find meaning and power in the revolving door *between* the public and the private. It is within this particularly fraught space that the collision of food and art reveals the potential paths of inquiry into how food, in particular, has been used by diasporic Asians to make their way into diasporic spaces, both public and private. I turn here to what literary scholar Anita Mannur has termed "an intimate eating public." For Mannur, "an intimate eating public is a vexed and contested space that is hybrid and evolving. Every act of eating with others, or alone, is a form of intimacy. And yet each gesture of eating is laced with multiple meanings that acquire differential public meanings." Throughout Mannur's book, *Intimate Eating: Racialized Spaces and Radical Futures*, eating

LEE Mingwei, *The Dining Project*, 1997-98. **Right:** LEE preparing dinner for his guest at the exhibition *Way Stations* at the Whitney Museum of American Art, New York, NY. **Above:** LEE Mingwei having dinner with his guest at the exhibition *Way Stations* at the Whitney Museum of American Art, New York, NY. *Photos by Charly Wittock. Images courtesy of LEE Studio.*

encompasses not only the consumption of food but also the production of food and the fraught ways in which it is both consumed and produced. In her consideration of "intimate eating publics," Mannur roots her publics in a third space, a theoretical space that she locates simultaneously in food studies and in postcolonial/diaspora studies. In food studies, the third space represents something other than the domestic dwelling or the workplace. Instead, it references spaces such as restaurants that are "essential for community building and public sociality." At the same time, Mannur turns to Homi Bhabha's conceptualization of the third space as a space that "displaces the histories that constitute it and sets up new structures of authority and new cultural logics."[11]

Mannur's nuanced consideration of a third space, a space in between the public and the private, allows a consideration of *Word of Mouth* as a cookbook and an object to exist within this place where community building and public sociality is juxtaposed alongside and against the privacy of the kitchen, the dining table, and intimate exchanges of eating together. Furthermore, *Word of Mouth* offers another sort of third space, one in which—not dissimilar to the act of the art lover reading an art-inspired cookbook and finding out how their favorite artist liked to caramelize onions—a different affinity is created through the act of cooking someone else's recipe even if that someone else is physically absent.

Indeed, developed during the context of the COVID-19 pandemic, *Word of Mouth* is a project made collaboratively in isolation. The artists' isolation in their own homes did not preclude the collaborative nature of this particular project. While the pandemic was certainly a health crisis for the entire world, it was also, for Asians in many parts of the world and in the United States particularly, a moment of racial crisis. Cast into another moment of yellow peril, Asians in the United States found themselves in danger of racial violence that cared little about whether they were actually Chinese or not.[12] This moment of crisis proved yet again that the wide net cast by the identity of "Asian American" indiscriminately lumps together an immensely diverse group of people. Americans with East Asian–appearing features were at risk, with Vietnamese Americans, Hmong Americans, and other Asian American groups as likely to experience COVID-fueled violence as Chinese Americans. To return to Boym's understanding of diasporic intimacy as cherishing "non-native, elective affinities," it was perhaps a bit ironic that this diasporic "affinity" was not necessarily elective but rather quite forced.[13] Diasporic intimacy appears to be forged in a precarious shared identity that can be implemented from outside the diasporic community as much as from within.

Although a quick glance at the list of artists and their recipes in this cookbook immediately reveals the immense diversity of the participants, the shared identity is gestured to in the cookbook's subtitle, *Asian American Artists Sharing Recipes*. To a casual American reader, this book offers access to recipes that are presumably Asian. The title certainly suggests an offering of ethnic recipes for a primarily American audience even as it insinuates a shared identity among its contributors. Considering the historical context in which the cookbook was conceived, this problematic racial slippage points specifically to the racial affinity of its contributors while also opening up the potential for resistance. As the book title gestures toward ethnic authenticity, it utilizes the perception of the homogenization within Asian Americanness, particularly

emphasized by the rise of anti-Asian hate crimes during COVID-19. In categorizing the project as Asian American in light of the anti-Asian sentiment that permeated the United States during the project's formation, the slippage of racial unity and identity shifts to a space of radical resistance. Indeed, although the idea of diaspora stems from the scattering of the seed, it also begs an understanding of roots. Members of a singular diaspora might find their only commonality located in an imaginary homeland defined by an impossible past. If diasporic identity is predicated instead on a shared present rather than an imagined past, this identity relies more on the bringing together of people who don't actually share the same roots but arguably have had a shared root forced on them. A so-called diaspora that is formed through racialized identity is resistant to the nostalgia for a singular past that does not exist. This cookbook, then, creates an opportunity to hold togetherness and difference at the same time. And in that tension, as Mannur points out, "food, forms of eating, and commensality become sites from which to resist imperialist policies, homophobia, practices of racial profiling, and articulations of white supremacy."[14]

As a cookbook, *Word of Mouth: Asian American Artists Sharing Recipes* follows, to a certain extent, the conventions of fastidious recipe testing, careful measurements, and precise instructions. Yet, unlike traditional cookbooks, it fails to offer a standard or style consistent through all of the recipes. Instead, each recipe, prefaced as it is with a backstory written by the contributing artist, insists on a nonstandardized and nontraditional model. As Kina explained to me, "The way we each describe how to cook is unique and it shouldn't be all the same."[15] In protecting the individuality of each artist and their respective recipe,

Kina and Yoshimoto expand this cookbook into a project that does not simply give suggestions of intimacy but also intentionally centers the voice of the artist and fully invites the reader into the story behind (and beyond) the recipe. The backstories of the individual recipes, each unique to the artist's personal history, come together as witness to the sheer diversity of the Asian American experience. In this way, shared identity is given the space to fragment while still holding on to unification. Mirroring the conditions of the global pandemic, the cookbook represents a coming together at a time when togetherness was physically impossible. In racializing the notion of community, the cookbook also brokered a space for shared affinities defined simultaneously by difference. In this sense, the connections represented by the cookbook also offer a form of futurity that looked to an unimaginable world beyond the pandemic. As an intimate eating public, the cookbook cherishes "non-native, elected affinities," suggesting that togetherness exists not in finding sameness but instead in finding commonality and connection among differences.[16]

Indeed, much like how my mother's cookbook functioned in her actual cooking, recipes here are more than instructions on how to cook or even how to achieve the flavors of a particular culture. Here, for example, Anida Yoeu Ali's recipe for Double-Fried Garlic Chicken offers a list of ingredients with mere suggestions for measurements. Making this chicken recipe demands an active participation by readers, who must learn to trust and rely on their own taste to create a final product. Ali's recipe presents the potential for further collaboration and connectivity. The artist won't be there as the reader prepares for and cooks the recipe, but connection is nevertheless forged as the reader is invited into the flavors and the processes of

her recipe. If one can obtain alligator, Francis Wong's recipe for Szechuan Spicy Alligator might give the reader insight into life as an immigrant family near New Orleans along the Gulf Coast even as it stays true to the spicy nature of Szechuan food. Coincidentally, it was in New Orleans that Kina and Yoshimoto, as artists in residence, became close friends and formed a connection that endured through the isolation of the pandemic years. Ironically, it was also in New Orleans that I lived through the pandemic and its lockdown, finding myself physically isolated in one of the most social cities, known for its food culture and its convivial gatherings around food. There I witnessed neighbors yelling conversations from stoop to sidewalk responsibly maintaining their social distance and chefs offering free meals out of the backs of restaurant kitchens to their community, particularly when Hurricane Zeta hit that fall and most residents were left without power in the storm's aftermath. Moments of crisis are familiar to New Orleanians, and in the face of crisis, they always found innumerable ways to gather, to connect, and to help one another. It is a city of diasporas, of identities, of difference, and ultimately, of togetherness. It is no simple coincidence that it was there that Kina and Yoshimoto shared stories over shrimp étouffée or that yakamein, a New Orleans staple featuring a fusion of Creole, Chinese, and African American flavors that bears some similarities to my mother's beef noodle soup, became one of my favorite Jazz Fest foods. In food, identities collapse into one another, and a shared diasporic identity reaches not into the past toward an imaginary homeland but into a present in which affinities allow for a space of common experience. As Boym points out, diasporic intimacy "precludes the restoration of the past. Diasporic intimacy does not promise an unmediated emotional fusion, but only a precarious affection—no less deep, yet aware of its transience."[17] Recipes—and food by extension—become the conduit through which a more complex and complicated understanding of diasporic lives begins to emerge.

NOTES

1. Svetlana Boym, "Nostalgia and Its Discontents," *Hedgehog Review* 9, no. 2 (Summer 2007): 7. I am also reminded here of Salman Rushdie's conceptualization of the "imaginary homeland" in which he is confronted by the reality that his "physical alienation from India almost inevitably means that [he] will not be capable of reclaiming precisely the thing that was lost; that [he] will, in short, create fictions, not actual cities or village, but invisible ones, imaginary homelands, Indias of the mind." Salman Rushdie, *Imaginary Homelands: Essays and Criticism 1981–1991* (New York: Penguin Books, 1992), 10. For Rushdie, as for Boym, while what is conjured up as belonging to or reminiscent of the homeland is imprecise, it is nostalgia that is nevertheless experienced.
2. Boym, "Nostalgia and Its Discontents," 16.
3. Boym, "Nostalgia and Its Discontents," 16.
4. In 1968, a somewhat hysterical public health crisis known as "Chinese restaurant syndrome" emerged that sought to locate the source of a string of anecdotal health concerns linked symptoms such as headaches to the use of monosodium glutamate in Chinese restaurant cooking. Although public health officials and members of the medical community would widely debunk the link, Chinese restaurant syndrome nevertheless led to a health scare that targeted Chinese restaurants as propagators of an insidious attack on American health. See Ian Mosby, "'That Won-Ton Soup Headache': The Chinese Restaurant Syndrome, MSG, and the Making of American Food, 1968–1980," *Social History of Medicine* 22, no. 1 (April 2009): 133–51.
5. Sheng Peng, "Smashed Windows and Racist Graffiti: Vandals Target Asian Americans amid Coronavirus," *NBC News*, April 10, 2020, https://www.nbcnews.com/news/asian-america/smashed-windows-racist-graffiti-vandals-target-asian-americans-amid-coronavirus-n1180556. More information on the spike in hate crimes against Asian Americans in 2020 can be

found in this study: Sungil Han, Jordan R. Riddell, and Alex R. Piquero, "Anti-Asian American Hate Crimes Spike During the Early Stages of the COVID-19 Pandemic," *Journal of Interpersonal Violence* 38, no. 3/4 (February 2023): 3513–33, https://doi.org/10.1177/08862605221107056.

6. Mary Ann Caws, *The Modern Art Cookbook* (London: Reaktion Books, 2018); Lisa Hostetler, *The Photographer's Cookbook* (New York: Aperture, 2016).

7. Stephanie Smith, ed., *Feast: Radical Hospitality in Contemporary Art* (Chicago: Smart Museum of Art, University of Chicago, 2013), exhibition catalog.

8. Claire Bishop, "Antagonism and Relational Aesthetics," *October* 110 (Fall 2004): 56.

9. For an in-depth examination of the history of Thai food and the flourishing of Thai restaurants in the US that occurred in the early 2000s, see Mark Padoongpatt, *Flavors of Empire: Food and the Making of Thai America* (Berkeley: University of California Press, 2017).

10. Nicolas Bourriaud, *Relational Aesthetics*, trans. Simon Pleasance and Fronza Woods with the participation of Mathieu Copeland (Dijon: Les Presses Du Réel, 2002), 14.

11. Anita Mannur, *Intimate Eating: Racialized Spaces and Radical Futures* (Durham, NC: Duke University Press, 2022), 6.

12. "Yellow peril" refers to a casting of (primarily) East Asian bodies as a danger to Western ideologies that flares up at particular moments of history such as the fear that Chinese laborers would steal white jobs in the wake of the completion of the transcontinental railroad. I find David L. Eng and Shinhee Han's chapter "A Dialogue on Racial Melancholia" to be a particularly informative piece on the psychoanalytic and clinical effects of yellow-peril attitudes on Asian American communities. See David Eng and David Kazanjian, eds., *Loss: The Politics of Mourning* (Berkeley: University of California Press, 2002), 343–71.

13. Boym, "Nostalgia and Its Discontents," 16.

14. Mannur, *Intimate Eating*, 6.

15. Laura Kina, email message to author, July 7, 2023.

16. Boym, "Nostalgia and Its Discontents," 16.

17. Boym, "Nostalgia and Its Discontents," 16.

ABOUT THE AUTHOR

Michelle Yee (she/her) is an assistant professor of art history at Virginia Commonwealth University. She studies critical race visual culture and focuses on Asian diasporic and Asian American visual cultures. She holds a PhD in visual studies from the University of California, Santa Cruz. Her writing can be found in *Asian Diasporic Visual Cultures and the Americas*, *Third Text*, *Panorama*, and *Art Etc.*

RECIPES

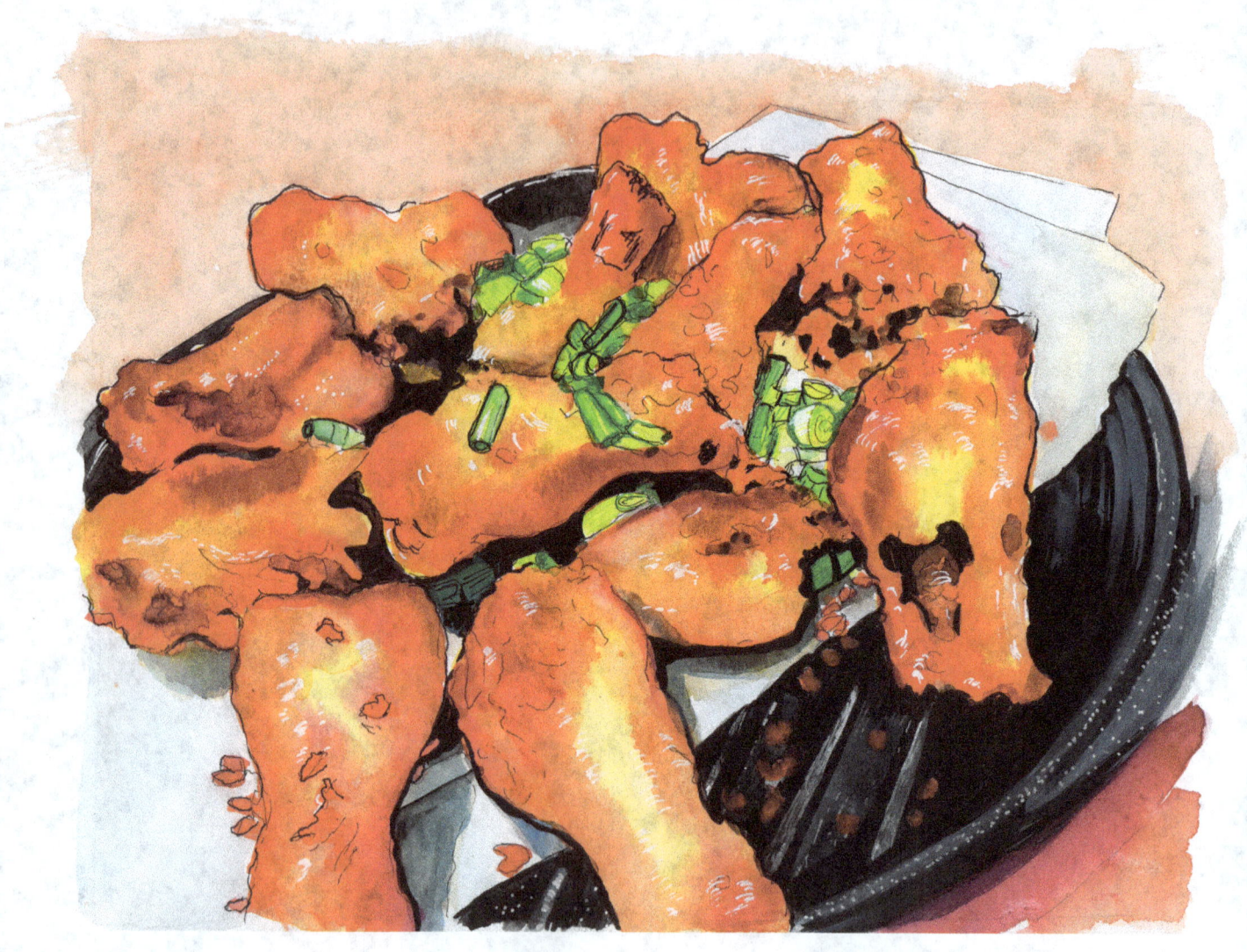

Laura Kina, *Anida Yoeu Ali's Double-Fried Garlic Chicken*, 2021. Watercolor and pen on paper, 9 × 12 in. *Image courtesy of Laura Kina.*

DOUBLE-FRIED GARLIC CHICKEN

Anida Yoeu Ali

When I got married at twenty-four years old and finally moved out of the house into my own home, my mother gifted me a stone mortar and pestle. I have had this same one since 1998 when she first gifted it to me. Khmer food can be very complicated to make because it comes down to having so many ingredients that get pounded together to make a paste that becomes the base for soups, marinades, curries, and medicine. The base paste is typically made with fresh garlic, salt, and pepper—everything else is added to the paste depending on the recipe. This technique is usually taught from generation to generation in the kitchen under the watchful eye of a matriarch. In my case, I learned to use a mortar and pestle at about twelve years old when my mom taught me the recipes for a range of Khmer cuisine. I remember how angry I was taking notes and scribbling her directions down into a pink spiral notebook. I hated that I had to learn to cook from her because I felt it made me domestic and un-American and unfeminist. I was wrong. I was terribly wrong and didn't treasure any of it until three decades later.

Unlike in Western or Eurocentric cooking, we don't stand and blend ingredients. We sit and pound. We sit on the floor, on a straw mat or directly on our linoleum floors. We pound with the pestle against the stone mortar. We pound while seated on the ground. I was taught to use a kitchen towel under my mortar and pestle and pound until things become a rough paste. It's low-tech, and I'd even say it's ancient. Kind of cool that it literally takes us back to the Stone Age.

The Double-Fried Garlic Chicken recipe came out of my desire to make something super crispy and tasty that used the basic Khmer ingredients of garlic, salt, and pepper.

I came up with my recipe while I was living in Phnom Penh and wanted something I felt was both American and Asian. Essentially, I wanted American comfort food while living in Asia. The result is that I feel that my recipe is very Asian American. This recipe borrows the double-fried method of deep-frying chicken from a Korean chicken wings recipe I stumbled onto but preserves the garlicky taste I love in Khmer food. And what American doesn't love good crispy fried chicken!

I realized the trick is to make sure the garlic does not burn in the deep fryer. I usually save the marinaded chunks and fry them at the very end after all the chicken has been fried. The secret is to sprinkle the fried garlic onto the chicken and garnish with some finely cut green onions. My family, especially my three kids, loves this. It's delicious, and they always request it for their birthday meals. Thank you, Mom. Thank you for teaching me the tradition of using a mortar and pestle. Thank you for teaching me despite my resistance.

Double-Fried Garlic Chicken Recipe

My measurements are by sight since I throw everything into a stone mortar, so these are all approximations.

Garlic (use a half or whole clove—it depends on your taste; I say the more the better)

About 1½ teaspoons of salt per package of chicken

About ¼ teaspoon of ground pepper (can also use a pinch of smashed-up peppercorns; just don't use too much, since the garlic already gives it a kick)

1 to 2 packages of wingettes and drumettes (each package is about 2 pounds)

A pinch of sugar (add as needed to balance the taste after you marinate the chicken with the paste)

Canola oil for frying

Green onions, sliced up finely (set aside as a final garnish for after the deep fry)

1. Using a traditional stone mortar and pestle, pound the garlic, salt, and pepper until it becomes a mushy paste. Then use this paste to marinate the chicken. Use your hands to blend the paste well into the meat. Cover and set aside for as little as 20 minutes or as long as overnight in the fridge.

2. When you're ready to do some deep-frying, prep your work area.

3. Heat enough oil to cover the chicken wings in a small stovetop saucepan.

4. Deep-fry the meat until well cooked or brown.

5. Pull it out, and let it sit on paper towels so they absorb some of the oil; give it an extra pat dry with more paper towels.

6. Pull out as much of the garlic still in the oil as you can before it burns; set the cooked garlic aside.

7. Then fry the chicken a second time for extra crispiness; the second frying should be no longer than 1–2 minutes.

8. Add the cooked garlic you saved to the top, and add green onions on top of that.

9. It's very yummy—serve while hot and crispy!

ABOUT THE ARTIST

Anida Yoeu Ali (she/her) is an artist, educator, and global agitator born in Cambodia, raised in Chicago, and transplanted to Tacoma. Ali's multidisciplinary practices include performance, installation, new media, public encounters, and political agitation. Utilizing an interdisciplinary approach to art making, her installation and performance works investigate the artistic, spiritual, and political collisions of a hybrid transnational identity. Ali has performed and exhibited around the world from the Palais de Tokyo to the Shangri La Museum of Islamic Art, Culture & Design.

Currently, Ali serves as a senior artist in residence at the University of Washington Bothell where she teaches art, performance, and media studies classes. Ali, a founding partner of the independent artist-run Studio Revolt, spends much of her time traveling and working between the Asia-Pacific region and the US. https://www.anidaali.com/

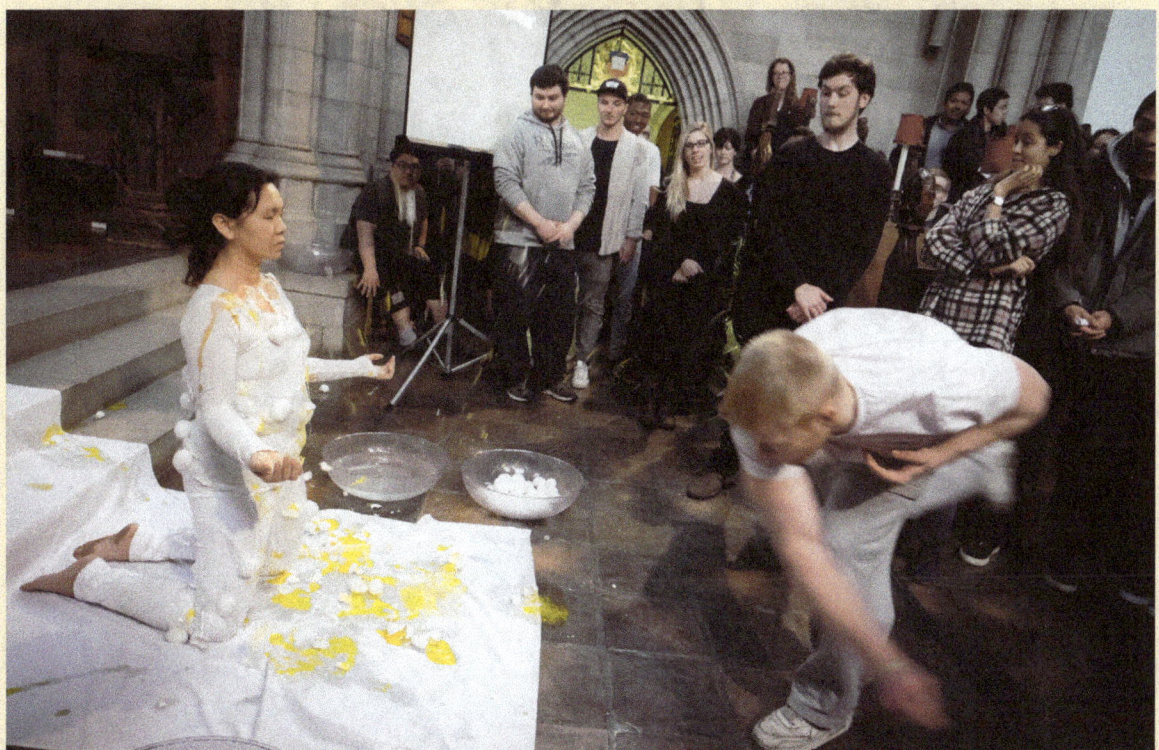

Performance still of Anida Yoeu Ali, *Push / 99 Eggs*, April 6, 2016. Trinity College Chapel, Hartford, CT. *Photo by Pablo Delano. Image courtesy of Anida Yoeu Ali.*

This performance was a response to the issues students of color were attempting to address on our campus in 2016. Inside the chapel, I allowed myself to become the sacrificial lamb as ninety-nine eggs were set out for people to take and "egg" me with. My hope was for students, staff, and faculty to take their anger and frustration out on me. It should be noted that I did give permission to everyone to participate and that in no way were my students penalized for egging their professor.

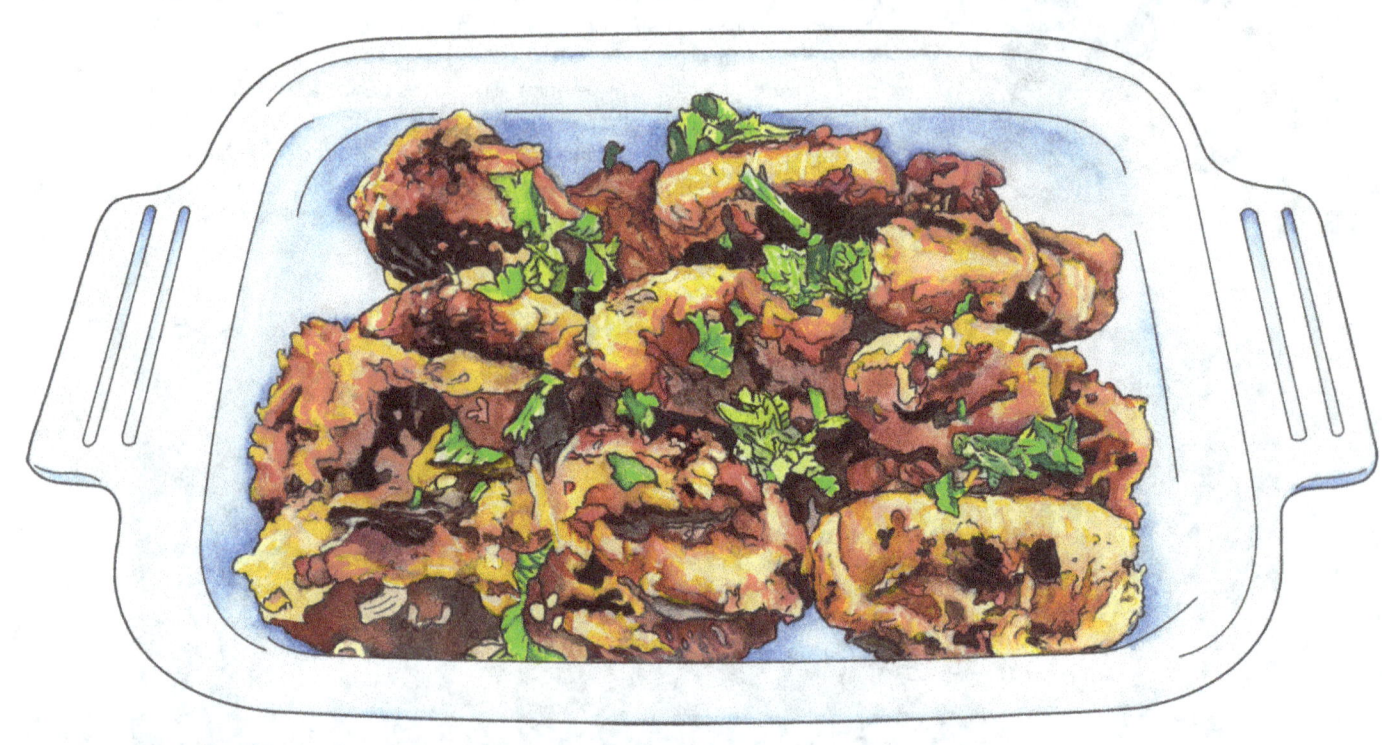

Jave Yoshimoto, *Ruby Chishti's Kebab Karahi*, 2021.
Ink, watercolor, and gouache on paper, 9 × 12 in.
Image courtesy of Jave Yoshimoto.

KEBAB KARAHI

Ruby Chishti

While I was growing up, feeding me any dish of meat was an impossible task for my mother. I had tons of logic ready for why I wouldn't eat it: "I am not going to eat this meat, because the goat smells like it didn't take a shower in its whole life." And another one was "If I were an emperor, I wouldn't let anyone take these live and roaming animals into our stomachs."

Not only this, but I had to struggle mentally to accept the goat-slaughtering ritual (*qurbani*) on Eid-ul-Azha and the distribution of meat and cooking afterward. My reluctance to eat meat was from seeing the animals slaughtered in front of us.

But many years later I discovered that I can only eat meat that does not look as if it was a part of an animal ever, does not smell like meat, and does not taste like meat. :)

Then I tried making these kebabs a few times and started to love them. So I eat about two square inches of beef or chicken once in a while. But it has to be perfect with lots of flavor of spices and green chilies.

You can fry them and keep some frozen and wrapped to use another time. These are the favorites of my dear friend Jaishri Abhichandani. She calls them "Ruby's Killer Kebabs." :) These kebabs are now a reason to meet and see each other.

Kebab Karahi Recipe

2 small onions, chopped

6-9 green chilies, chopped (save 2-3 chilies for garnish)

2 slices of bread, chopped

½ cup cilantro, chopped

1 tablespoon corn flour

1 tablespoon graham flour

1 tablespoon ginger paste

1 teaspoon salt

1 teaspoon cumin seeds, roasted and crushed

1 teaspoon garlic paste

1 teaspoon garam masala (optional)

½ teaspoon chili powder

½ teaspoon crushed red chili flakes

1 pound minced beef or chicken or boneless beef or chicken cut into small pieces and finely chopped in a chopper (or a food processor)

3 tablespoons oil to shallow fry kebabs

Lemon slices for garnish

2-inch small piece of ginger, thinly sliced, for garnish

Chopped cilantro for garnish

FOR THE GRAVY

3 tablespoons oil

1 teaspoon whole cumin seeds

1 medium onion, chopped

1 (small) can of tomato sauce or 2 cups diced tomatoes

Salt, to taste

Crushed red chilies, to taste

2-3 green chilies, finely chopped

1. Mix all the kebab ingredients, except the oil, into the minced beef or chicken. Refrigerate for 30 minutes.

2. Apply some oil on the palms of your hands, and roll about 2½-inch-long kebabs (makes 20–24).

3. Heat oil in a pan over medium-high heat.

4. Shallow fry kebabs on all sides until golden brown. Turn the heat low, cover, and let the kebabs cook for another 5 minutes. Cooking them on high first makes them crispy on the outside, and lowering the heat cooks the inside so it will be soft.

5. For gravy, heat 3 tablespoons oil. Fry 1 teaspoon whole cumin seeds. Add one chopped onion, fry it until soft, and then add diced tomatoes or canned tomato sauce. Add salt and crushed red chilies and chopped green chilies. Stir and let it cook for a few minutes, then add fried kebabs. Let it simmer.

6. Transfer to a wide platter, garnish with chopped green chilies, sliced lemon, ginger, and cilantro.

7. Serve warm with salad, naan, chapati, or rice. And eat at least once before you go plan to conquer the world. :)

ABOUT THE ARTIST

Ruby Chishti (she/her) is a Pakistani American sculptor and installation artist based in New York City. She was formally educated in the National College of Arts, Lahore. Her haunting and enigmatic forms represent the passage of fabric from discarded mass-produced and ceremonial clothing to the reconstruction filaments of artistic imagination. Her practice involves audiovisual installations and experimentation in melding the fabric of found garments and social memory and the artist's complex history of trauma, from unexpected family losses and the wanton destruction of her Pakistani home to the survival of migration and her persistence through transitional impediments.

Ruby has held residencies at home and abroad including as the 2018 critic in residence in fiber science and apparel design at the College of Human Ecology at Cornell University in Ithaca, New York. Her installations, sculptures, and site-specific works have been exhibited at Asia Society Museum, New York; Queens Museum; Rossi & Rossi Hong Kong; Aicon Contemporary New York; Vadehra Art Gallery, New Delhi, India; Canvas Gallery, Karachi, Pakistan; Arco Madrid; Art HK08, Hong Kong; India Art Fair; the Middlebury Museum, Vermont; and the Armory Show, New York, to name a few. Her work is in the collection of the Whitworth, Manchester, UK; the Kiran Nadar Museum of Art, Delhi; Art Mill Museum, Qatar Museums, Doha; and private collections. https://www.rubychishti.com/

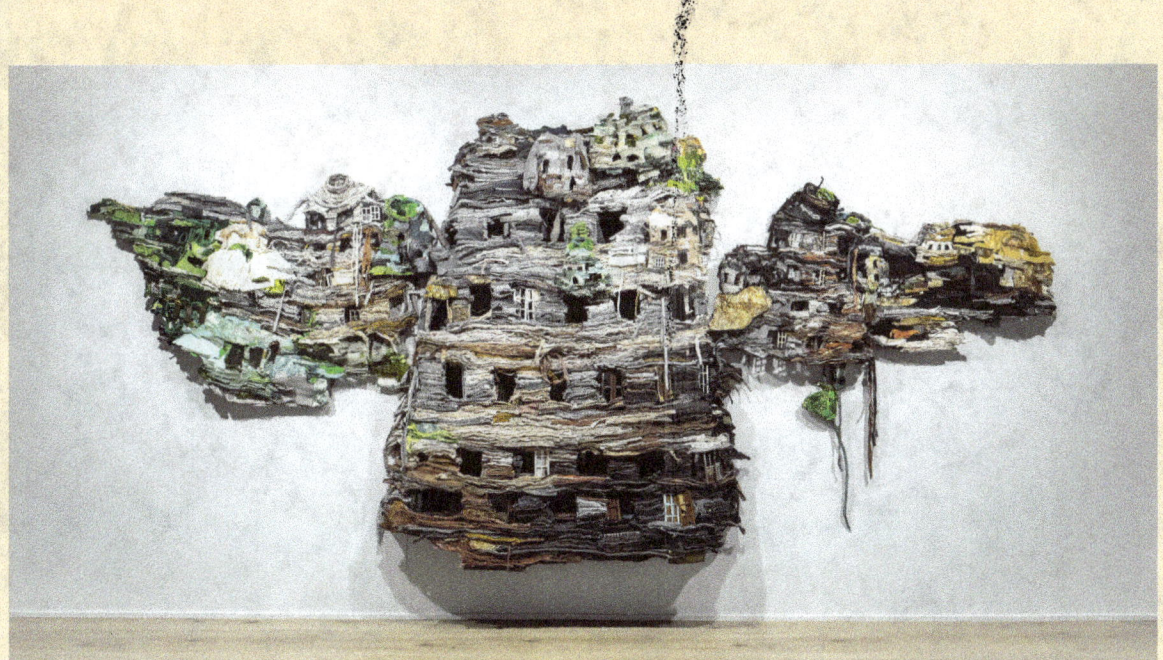

Ruby Chishti, *The Present Is a Ruin Without the People*, 2016. Recycled textiles, wire mesh, thread, wood, embellishment, metal scraps, and archival glue; with sound; 81.7 × 127.9 × 11.7 in. *Image courtesy of Ruby Chishti.*

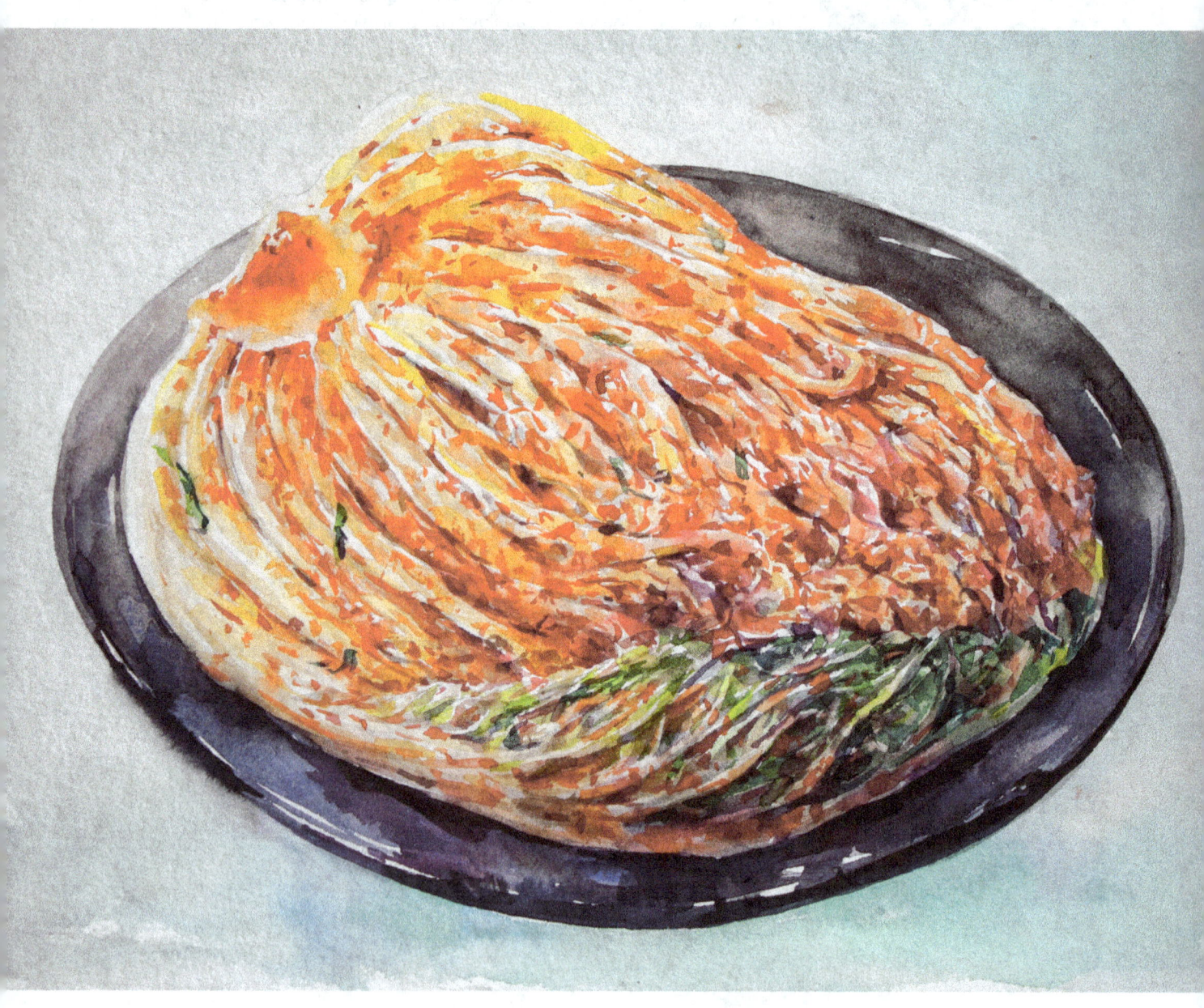

Hyegyeong Choi, *Kimchi Baby*, 2020. Watercolor on paper, 9 × 11 in. *Image courtesy of Hyegyeong Choi.*

KIMCHI

Hyegyeong Choi

My mom made this simpler version of kimchi when she visited Chicago for my graduation from the School of the Art Institute of Chicago in 2016. I had a hard time getting used to the kimchi from Korean markets in America because they are a bit too salty for me and not spicy enough. My mom's Kimchi has a more refreshing taste, so I've been making my own kimchi ever since then. This Kimchi is something between summer kimchi, which is chopped up before the salting process for a quicker pickling process, and winter kimchi. I also add fresh red peppers. Koreans often use fresh red peppers for summer kimchi to bring a more refreshing taste when the kimchi from winter is done.

Kimchi Recipe

1 napa cabbage (normally 4-8 pounds)

4 cups coarse sea salt

1⅓ gallons water

1 tablespoon sesame seeds

FOR THE BROTH

6¾ ounces water

Dried pollock head or 1 cup of dried pollock (you can find it in a Korean store)

1 cup dried shiitake mushroom

A piece of dried seaweed

FOR THE RICE PORRIDGE

6¾ ounces water

3 tablespoons sweet rice flour

FOR THE SAUCE

1½ cups Korean red pepper powder

8-10 fresh Korean red peppers (use serrano if you can't find Korean red peppers)

1 small onion

15-20 garlic cloves, minced (approximately 4 teaspoons)

1 small radish (optional)

3 tablespoon anchovy fish sauce

1 tablespoon fermented shrimp sauce

A bunch of chives

Salt the Cabbage

1. Cut cabbage into 3 (4-inch-long) pieces.

2. Mix 3 cups of coarse sea salt and 1⅓ gallons of water so that the salt dissolves into the water.

3. Scatter the rest of the salt over the cabbage.

4. Put the cabbage in a container and fill it with the salt water about ⅔ of the way to the top. Leave it for 1½–2 hours.

 Tip: If you want to wrap this with clean plastic wrap, it boosts the speed of salting so that it should take only about 1–1½ hours.

5. Turn the container of cabbage upside down, and leave it for another 2–3 hours (the cut side should face down). If you put a heavy pot on top of this, it can also speed up the process.

6. To check whether it's done, bend a leaf. You should be able to fold it without breaking it.

7. Rinse the cabbage under running water.

 Tip: If the cabbage is too salty, you can put it in a bowl and fill it with water, then soak it for 30–40 minutes.

Make the Broth

1. Pour the dried pollock, dried shiitake mushroom, and dried seaweed into a pot filled with water (6¾ ounces).

2. Boil it for 15–20 minutes.

3. Cool it before using it.

Make the Rice Porridge

1. Boil 6¾ ounces of water (you can also use the broth you made).

2. Put 3 tablespoons of sweet rice flour (mix it into a very small amount of water first; then it's easier to mix in) into boiling water and mix well. You can replace the sweet rice flour with wheat flour if needed.

3. Keep stirring until it gets thickened.

4. Cool it before using it.

Make the Sauce

1. Soak the red pepper powder in the broth or the broth and porridge mix. Let it sit for 20 minutes.

2. In a food processor, puree the onion, red peppers, radish, and garlic (you can skip the radish if it isn't that good; the quality varies by season).

3. Mix fish sauce, shrimp sauce, porridge, chives, and ground ingredients (onion, red peppers, radish, and garlic) into the red-pepper-powder mixture.

4. You can add more pepper powder if it's too watery.

The Final Step to Make Kimchi

1. Open the first piece of cabbage, starting with the bottommost layer, and rub the sauce onto each layer.

2. Add more sauce to the last layer of the cabbage piece.

3. Do the same thing for the other 2 pieces of cabbage.

4. Pour in the rest of the sauce.

5. Leave the kimchi at room temperature for 1–2 days to help ferment it.

6. Sprinkle with sesame seeds. Put it in the refrigerator. It will be perfectly fermented about 2 weeks after the day you make it.

PATRICK JONGMIN KIM

ABOUT THE ARTIST

Hyegyeong Choi (she/her) is a painter who works to address social and cultural issues she faces as a woman. As a South Korean woman, she has been subject to commentary and criticism based on the high standards of ideal beauty in her country that define womanhood in a limited way. Similarly, taboos revolving around sexuality are deeply embedded in Korean society, inevitably shaping how women are treated and objectified. Her work confronts these points of social friction head-on, dealing with body image, identity, gender, and sexuality.

Choi has lived in the US since 2010 and is currently based in New York City. She holds a BFA from Chung-Ang University in Korea and an MFA from the School of the Art Institute of Chicago. Her exhibitions have appeared at venues including Anton Kern Gallery, the National Arts Club, CHART Gallery, and Harper's Gallery in New York City; Jeffrey Deitch Gallery in Los Angeles; the Hyde Park Art Center in Chicago; Pond Society in Shanghai; and Carl Kostyál Gallery in London. Her publications have been featured in the *New York Times*, the *Washington Post*, Artnet News, Artsy, Hyperallergic, *Cultured*, *Purple*, *ArtReview*, the *Chicago Tribune*, and Sixty Inches From Center. https://hyegyeongchoi.com

Hyegyeong Choi, *Amazon Olympia*, 2020. Acrylic on canvas, 42 × 50.5 in. *Image courtesy of Hyegyeong Choi.*

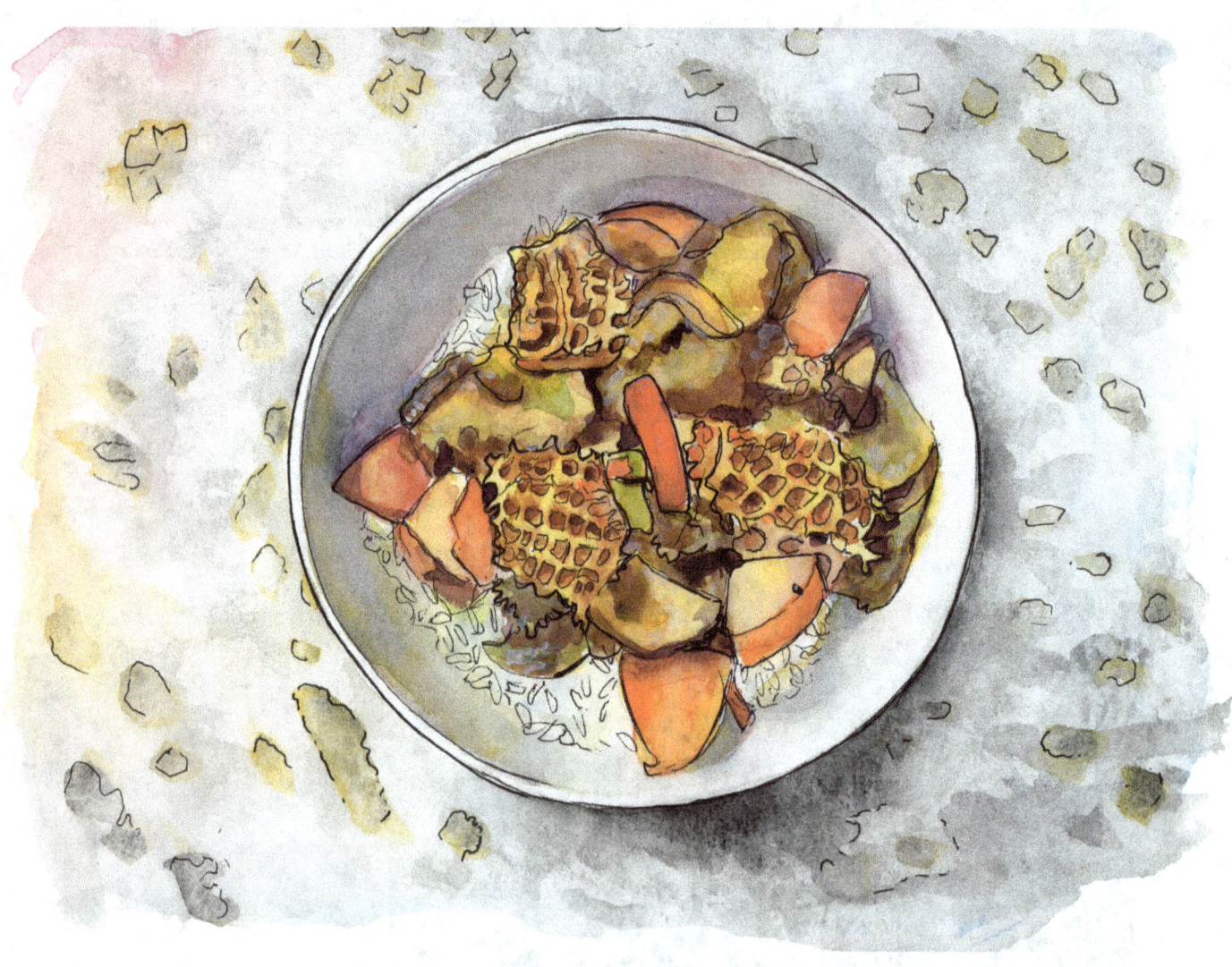

Laura Kina, *Hasan Elahi's Tripe Stew*, 2022. Watercolor and pen on paper, 9 × 12 in. *Image courtesy of Laura Kina.*

TRIPE STEW

Hasan Elahi

I've been thinking a lot about what constitutes comfort food. And why we seek out certain foods. For many immigrants, the act of assimilation is quite prevalent in nearly every aspect of life. While many things change about us, the one thing that refuses to assimilate is the taste buds. It doesn't matter how many generations a family has been in America; an immigrant family will revert to the comfort dishes and flavors that reflect its culinary home. In my case, the food I've always returned to has been tripe stew—the taste that I associate with home.

It took me a while to come to appreciate tripe. It's messy, stinky, chewy, innardy, and frankly an acquired taste for many. I hated it as a kid, but after I moved out of the house, I developed a deep love for this dish. It's what I remember of home. Every time I came to visit, my mom would have tripe stew cooking on the stove for me. It's a laborious process to cook this dish, and when I tried to make it, I could never get the texture the same as how my mom cooked it. Maybe because I'm an impatient cook or maybe because I just don't have the attention span to stand in front of the stove stirring a dish for hours. This is a dish that really requires lots of patience, or if you're like me, it requires a pressure cooker. Several years ago, I decided to no longer even try to replicate the texture of my mom's tripe stew, and I now resort to only using a pressure cooker.

In keeping with my mom's way of working in the kitchen, one note about this recipe is that there are no exact measurements for anything. It's not like the typical recipe that explicitly says half a teaspoon of this and 2 ounces of that. It's a bit of a rough estimate of everything, and it's all based on what tastes you prefer. If you like the taste of cumin, put more in, and similarly, if you don't like cinnamon, don't put it in.

I've cooked up this dish so many times that I've completely lost count. If I had to guess, I probably make it at least once a month. Yet even after that many times, I've never used anything other than honeycomb tripe for this. I imagine you could probably use book tripe, but my mom would have never done that, so using honeycomb tripe is one of the things I do automatically without thinking about it.

Given how chewy tripe is, you don't have to worry about overcooking it. You really can't go wrong as long as there's enough water in the pressure cooker and it doesn't burn the tripe up. There is also quite a bit of variance in what you can put into this. For purists, it would be nothing else after tripe. My personal preference is a little bit of potatoes. One time, I even mixed in some goat meat and threw some oxtail into the same pressure cooker.

For the longest time, I couldn't imagine eating this any way other than over some steaming white jasmine rice, but one day a few years ago, I decided to take some leftover Tripe Stew the next morning and put a couple of large spoonfuls on top of a bowl of Shin Ramyun. My mom would have never done this, but for me the unusual mix of flavors was quite a pleasant surprise.

Tripe Stew Recipe

Onion

Vegetable oil

Salt

Chili peppers

Turmeric

Cumin

Coriander

Garlic

Cardamom

1-2 bay leaves

Cinnamon

Honeycomb tripe, cut into small squares

Potatoes, cut up

Red lentils (optional)

My mom passed away in 2018, but if I had called her up, this is how she would have told me to make it:

1. Chop some onions, and cook them in some oil (vegetable oil works best). Let the onions sweat until they're translucent.
2. Add in some salt. Lots of chili peppers. A little bit of turmeric. Keep stirring.
3. Add some water so it doesn't get too dry.
4. Add in some cumin, some coriander powder, and a small amount of water. Keep stirring.
5. Add in garlic. Keep stirring.
6. Add in some cardamom, a bay leaf or two, and a piece of cinnamon. Keep stirring.
7. Add in more water so it doesn't thicken up too much.
8. Now add in the tripe. Keep stirring.
9. Get all the sauce in the pot all over the tripe. Add in more water. Keep stirring.
10. Add more water.
11. At this point, my mom would repeat this process over and over, but in my variation here, I put the lid on the pressure cooker and let it do its magic. About 45 minutes to 1 hour later, I release the pressure of the pressure cooker and add in some cut-up potatoes. How waxy the potatoes are will determine on how much longer to cook. I've used all kinds of potatoes and don't really have a preference. Sometimes I'll even add some red lentils into the dish just a few minutes before it's done.

ABOUT THE ARTIST

Hasan Elahi (he/him) is an artist whose work examines issues of surveillance, citizenship, migration, and transport and the challenges of borders and frontiers. His work has been presented in numerous exhibitions at venues such as SITE SANTA FE, Centre Pompidou, the Sundance Film Festival, the Gwangju Biennale, and the Venice Biennale. His work is frequently in the media and has been covered by the *New York Times*, *Forbes*, and *WIRED* and has appeared on Al Jazeera, Fox News, and *The Colbert Report*. Elahi has spoken about his work to a broad range of audiences at venues such as Tate Modern, the Einstein Forum, National Geographic Society, the American Association of Artificial Intelligence, the International Association of Privacy Professionals, TED, and the World Economic Forum. His awards include a Guggenheim Fellowship, a Herb Alpert/MacDowell Fellowship, and grants from Creative Capital, Art Matters Foundation, and the Doris Duke Foundation for Islamic Art, and he is a recipient of a Hugh M. Hefner First Amendment Award. He is currently dean of the College of Fine, Performing and Communication Arts at Wayne State University in Detroit, Michigan. https://elahi.wayne.edu/

E. BRADY ROBINSON

Hasan Elahi, *Home v1*, 2023. Pigment print, 22.5 × 35 in.
Image courtesy of Hasan Elahi.

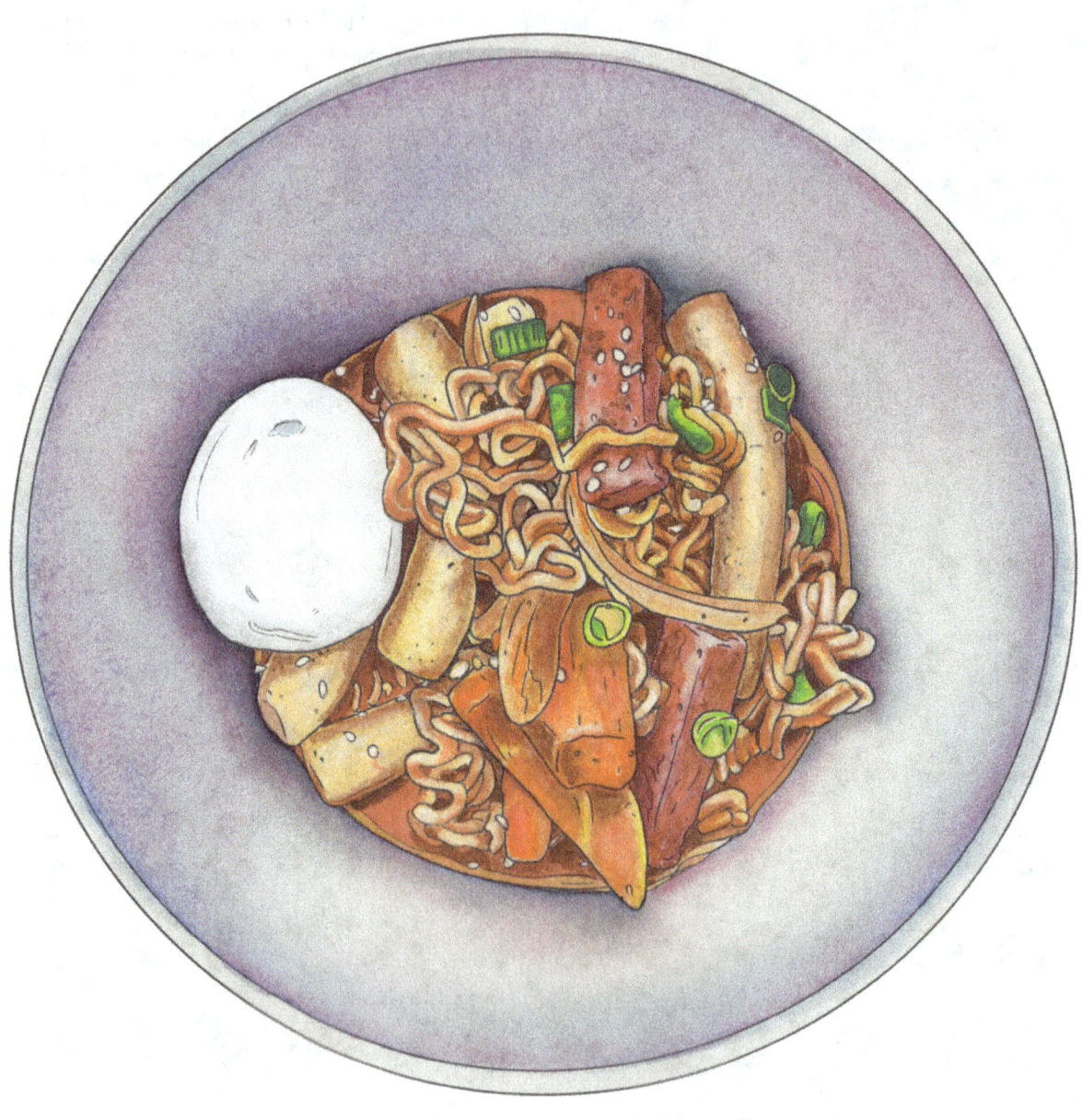

Jave Yoshimoto, *Aram Han Sifuentes's Rabokki*, 2021. Ink, watercolor, and gouache on paper, 9 × 12 in. *Image courtesy of Jave Yoshimoto.*

RABOKKI 라볶이

Aram Han Sifuentes

Rabokki 라볶이 is a well-known street food in Korea. It was always my favorite when I was a child. I would often ask for it as we walked by the stands in Seoul, where we used to live before we immigrated to the United States.

We moved in 1992 from South Korea to Modesto, California, where there was only a very small Korean community at the time. The closest Korean market was nearly a two-hour drive from Modesto, so my mom learned how to cook traditional Korean dishes with simple ingredients that were easily available in most supermarkets.

As a Korean American growing up in the Central Valley in California, I often got teased and bullied for the Korean food I ate. It feels strange now to see how popular Korean food has become in the United States. I can't approach this popularity without the resentment I have over how dominant culture made me feel ashamed of it for many years.

My parents worked six days a week at their dry-cleaning store, and Sundays were their only day off. Knowing that rabokki was my favorite food, my mom would make me this dish every Sunday morning before they cleaned the house and ran errands. I wonder if I'm so fond of this dish because it is such a perfect balance of sweet, salty, spicy, and crunchy and chewy texture or if it's because it's the dish that I ate when I spent the most time with my parents. When I was growing up, SPAM was a revered food product as a result of US military's presence in Korea because of the Korean War. My mom didn't always include SPAM or ramen, but every once in a while, as a treat, she would throw some in. Even now as an adult living away from my parents, I make this dish on Sunday mornings so that I can continue this tradition with my own child.

Rabokki 라볶이 Recipe

- Dduk (fresh or frozen)
- 3 cloves garlic
- 1 medium onion
- 1 carrot
- 1 can of SPAM
- 1 teaspoon sesame oil (or premium perilla oil)
- 1-2 tablespoons gochujang
- 1 tablespoon honey
- ½ teaspoon black pepper
- 1 package of ramen
- 2 green onions
- 1 teaspoon toasted sesame seeds
- Soft-boiled eggs (optional)
- Shredded cheese (optional)

1. I usually use ½ a package of fresh dduk or about ⅓ of a frozen package. If it is frozen, defrost in cold water, and leave it for 10 minutes. Fresh or frozen, you'll need to separate each of the dduk pieces from each other.

2. Mince 3 garlic cloves, slice the onion and carrot, and cut up half the can of SPAM. I like to cut the SPAM into small rectangles.

3. Throw garlic, onion, carrot, and SPAM into a deep sauté pan with 1 teaspoon of sesame or perilla oil. Cook over medium heat until the onions are translucent.

4. Then add the dduk, and put in enough water to submerge it. I use the water used to defrost the frozen dduk because it has starch in it to thicken. This isn't necessary.

5. Add 1 tablespoon honey, ½ teaspoon black pepper, and depending on how spicy you want it, 1–2 tablespoons gochujang. Make sure you dissolve and mix the honey and gochujang well. Cook until the liquid boils and bubbles.

6. Once the liquid is boiling, add your dry ramen noodles. Make sure you can submerge them in the liquid. If there isn't enough, feel free to add more. Let it cook for another couple of minutes until the ramen is cooked, then turn off the heat.

7. Add green onions and toasted sesame seeds.

8. Spoon onto your plate, and you can add your soft-boiled eggs at this point. You can also add some shredded cheese on top.

VIRGINIA HAROLD / PULITZER ARTS FOUNDATION

ABOUT THE ARTIST

Aram Han Sifuentes (she/they) is a social practice and fiber artist, writer, and educator. Her work is political and informed by her own experience as an immigrant living in the United States. It centers immigrant and disenfranchised communities and explores themes of race and identity, immigration and immigrant labor, possession and dispossession, citizenship and belonging, voting, dissent, and protest.

Her projects confront social and racial injustices against the disenfranchised and riff on official institutions and processes to reimagine new, inclusive, and humanized systems of civic engagement and belonging. She does this by creating participatory and active environments where safety, play, and skill sharing are emphasized. And even though many of her projects are collaborative and communal in nature, they incite and highlight individuals' experiences, politics, and voices.

Aram Han Sifuentes lives and works in Chicago. Solo exhibitions of her work have been presented at the Jane Addams Hull-House Museum, Chicago; Chicago Cultural Center, Chicago; Hyde Park Art Center, Chicago; Pulitzer Arts Foundation, Saint Louis; Museum of Contemporary Art Cleveland, Cleveland; and Skirball Cultural Center, Los Angeles. She has received numerous awards including a Smithsonian Artist Research Fellowship, 3Arts Award, 3Arts Next Level Award, Map Fund Grant, and Joyce Award. https://www.aramhansifuentes.com/

City of Philadelphia Mural Arts Program / Aram Han Sifuentes and art education students, *Messages to Our Neighbors: Tired of Waiting For Permission to Call America Home*, 2021. Castor and Tyson Avenues, Philadelphia, PA. *Photo by Steve Weinik. Image courtesy of Aram Han Sifuentes.*

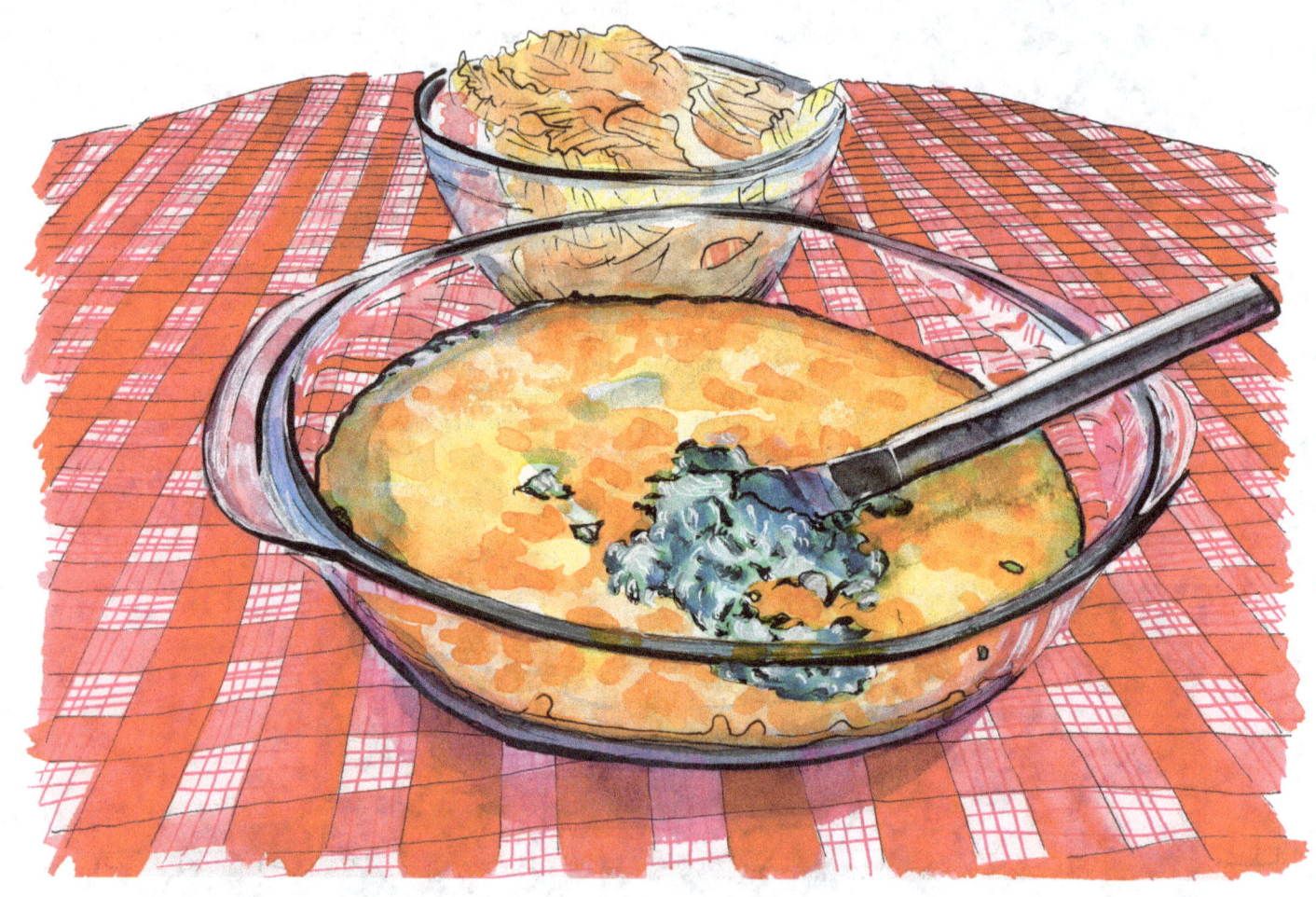

Laura Kina, *Robert Farid Karimi's Spinach Casserole*, 2021. Watercolor and pen on paper, 9 × 12 in. *Image courtesy of Laura Kina.*

A RECIPE FOR SURVIVAL SPINACH CASSEROLE

Robert Farid Karimi

My mother, Laura Colouch, gave me this recipe when I was a youthful undergrad at the University of California, Los Angeles. I had a potluck Xmas office party. The rules: cook your own dish.

At that point in my life, my awkward, shy nineteen-year-old self had never been to a Xmas office party and never cooked my own dish to bring to an event.

I called my mom, and she suggested the following recipe because: "Gringos love this. It makes them happy. Everyone will love it." Translated from Momspeak: "Gringos love it, so they will love you."

My mother worked as an administrative assistant in a corporate office that did not treat her nicely. Many of the bosses' xenophobic ways were recounted in our daily dinner-table conversations. I knew what this meant. This was how my mom defused their xenophobia—through food. She was giving me a recipe for survival. A food force field.

She typed it up for me, so I would have it permanently. And anytime I needed to defuse or placate or just please a diverse crowd of people who are not from my land of IranianGuatemalalandia, I use this dish. It works, every time.

Fast-forward: I made this for the Xmas episode in Houston of my cooking show, *The Cooking Show con Karimi y Comrades*. My alter ego, Mero Cocinero, needed to thwart a right-wing Oprah character who wanted to co-opt his show, so he made my mom's casserole; he called it Spinach Frito Pie. The idea was to get the audience to have a vegetarian dish for the holidays and to laugh at the twist I put on the Texan dish Frito pie (there are no Fritos in it.)

Needless to say, it is the recipe I am asked for most to this day. For two years straight, older Mexicanas and Chicanas emailed me for the recipe, or they asked the producer, Jorge Piña, for it. Was it because it was delicious or because they had to keep gringos happy to stop xenophobia or racism? They never told me. *¿Quién sabe?* Perhaps if we feed it to anti-immigrant legislators, they will change their policies. Or defund Immigration and Customs Enforcement. We can only hope food has that power.

A Recipe for Survival Spinach Casserole Recipe

20 ounces chopped frozen spinach

16 ounces sour cream

1 can Campbell's Cream of Potato Soup

½ cup Parmesan cheese, shredded

Salt

Pepper

Shredded Monterey Jack cheese for topping (my mom was adamant: "The cheese must be Monterey Jack. No cheddar! Monterey Jack!")

1. Thaw spinach in a bowl, and remove as much liquid as you can.

2. Add soup, sour cream, salt, pepper, and Parmesan cheese. Mix well.

3. Place in a Pyrex dish, and top it with shredded Monterey Jack cheese.

4. Cover with aluminum foil, and place in a 350°F oven for 25 minutes.

5. Uncover, and continue baking another 5 minutes or until cheese is melted.

ABOUT THE ARTIST

Robert Farid Karimi (they/he) is a critically acclaimed performer, author, and social engagement artist who designs interactive, immersive game-performance experiences to spark players to imagine worlds of mutual community nourishment. A Creative Capital artist and Pushcart Prize–nominated writer, Karimi has had their work featured on NPR and HBO's Def Poetry Jam; at South by Southwest; and in the Smithsonian Institution, the *Los Angeles Times*, *Callaloo*, *Total Chaos: The Art and Aesthetics of Hip-Hop*, the *Asian American Literary Review*, *A Good Time for the Truth: Race in Minnesota*, and various platforms worldwide. He designed the satirical video game *Grandma Invaders* and card-game installation *Cards against Iranians* to challenge the US Muslim ban. They most recently designed *game recognize game / bazi recognize bazi [a series of broken games]*, a series of game performance installations meant to shine light on playfulness and the power of fun, generosity, and kinship to break and remix Orientalism at the Shangri La Museum of Islamic Art, Culture & Design in Honolulu. Karimi serves as assistant professor in the School of Music, Dance and Theatre at Arizona State University. https://robertfaridkarimi.com/

Robert Farid Karimi, playing cards from the game-performance *oncewehonorandliftheweightweflythenwegottadealwiththecagesandtheracism*, 2019. *Image courtesy of Robert Farid Karimi.*

This is a modern take on José Guadalupe Posada's *Juego de la oca* (Game of the goose), a Mexican take on Chutes and Ladders. In my version, gallery participants became geese trying to migrate across borders and avoid receiving a yellow or red card from a haphazard referee—hoping to get a green card, which institutionally allows them to fly free. The design uses international road-sign fonts to bring home the global crisis that is US immigration policy and the horrific and indiscriminate treatment of Central Americans in detention centers.

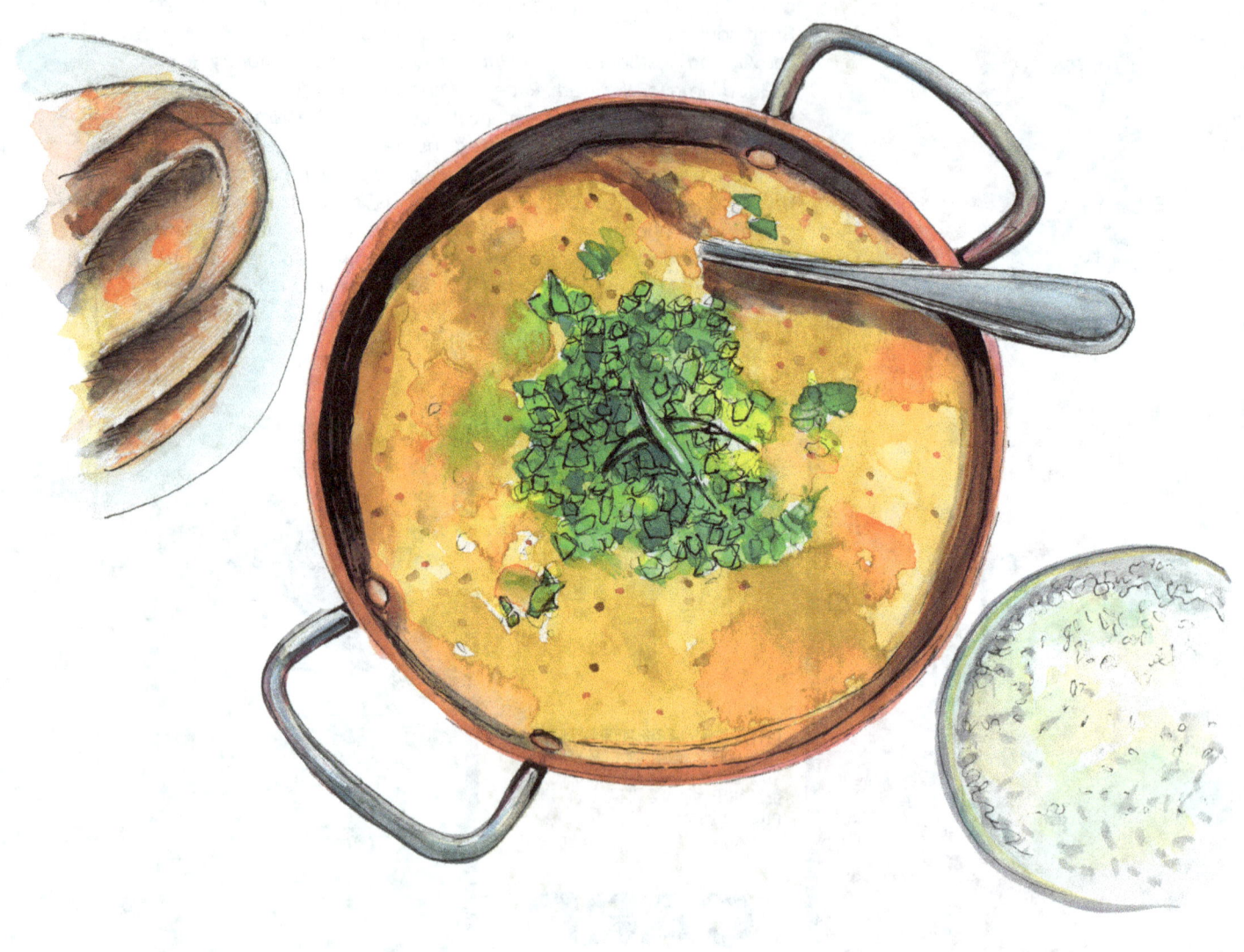

Laura Kina, *Baseera Khan's Red October Dal*, 2021. Watercolor, pen, and colored pencil on paper, 9 × 12 in. *Image courtesy of Laura Kina.*

RED OCTOBER DAL

Baseera Khan

This was the meat and potatoes of my family when I was growing up. We pooled money and resources together and performed mutual aid before mutual aid was a thing nonprofit arts organizations started talking about in their mission statements—ha ha ha. Red and yellow dal gave me a sense of comfort and continues to do so, and I am very proud of myself for making it and making it well. My dad used to say this is the food for a true Marxist.

Red October Dal Recipe

1 cup split red lentils or masoor dal

2 tomatoes, roughly chopped

1 or 2 jalapeño peppers, sliced

½ a carrot, thinly sliced

1 teaspoon sea salt

1 tablespoon ghee or vegetable oil

Green Thai chilies, 1 whole, more chopped, to taste

1 large bay leaf (or 4-5 curry leaves)

1 teaspoon whole cumin seeds

1 teaspoon black mustard seeds

1 teaspoon fennel seeds

1 small onion, chopped

2 garlic cloves, chopped

1 teaspoon grated ginger

1 teaspoon grated turmeric (or use dried turmeric)

1 teaspoon fenugreek leaves (or seeds), finely chopped

1 teaspoon garam masala, plus extra for garnish

A handful of freshly chopped coriander for garnish

1. The first step is to clean the dal. It has extra starch on it and may have bugs in it from its packaging. Wash with room temperature water. It cooks fast! Basically the minute you start washing it, it starts to get soft. After washing the dal, set it aside.

2. Get out a tall pot and add enough water to it that it will properly submerge the dal with around half an inch of water above it—like 4 parts water to 1 part lentil.

3. Start to heat the water, and dump the clean lentils into the pot of water. Before the water boils with the lentils in it, also add a roughly chopped large tomato, 1 sliced green jalapeño, and the thinly sliced carrot. Put in a ½ teaspoon of sea salt. Have the water come to a boil. Don't worry about the froth that appears yet. Make sure that the pot is still watery. Add more water to make sure it does not all cook off. The froth should be skimmed off the top before lentils cook fully and the pot is taken off the stove to prepare for the next step. Leave to simmer for 10 minutes. Check that the lentils are cooked by squeezing them between your fingers. They should be soft and easy to squish. Make sure the tomato and pepper are soft, and squish them into the pot, and mix everything around. Remove the pot from the heat altogether, and start on the spice and curry pan.

4. In a separate frying pan, heat up ghee. If you don't have ghee, you can use mustard oil or high heat olive oil. Add a whole green Thai chili—make sure you puncture it first with a knife so it doesn't explode in the pan when it is heated up. Add the chili and a large bay leaf to the pan. If you have curry leaves, you can use those too, but they are sometimes hard to find. Now add the different types of seeds one at a time. Make sure you smell the aroma between adding each spice or herb. Add the cumin seeds, mustard seeds, and fennel seeds. When the seeds sizzle, remove the chili, and set it aside for your garnish at the end.

5. Now as the seeds start to give off aroma, add the onion, wait until it is golden, then add garlic and ginger. Add turmeric if it is fresh (if it is powder, it can be added after the heat is reduced). Reduce the heat, and then add the remaining tomato, fenugreek, chopped Thai chili to taste, and turmeric (if powder). If you add too much turmeric, it will taste chalky. Continue to simmer, adding water as needed, for approximately 10 minutes, until it is a thick masala paste and the tomatoes are cooked down.

6. Add two ladles of lentils to the masala paste in the frying pan and stir together until it is mixed well. Pour the masala paste from the frying pan into the pot of lentils, and stir. The consistency should be like a thick soup. If it is too thick, add a little boiling water. Simmer the lentils for a few more minutes. For a thicker dal, let the lentils simmer until the dal reaches the consistency you desire. Check the dal seasoning, adding a little more sea salt if required. Stir in the garam masala and fresh-cut coriander.

7. You can dish this up now. Top it off with the fried chili you set aside.

ABOUT THE ARTIST

Baseera Khan (they/she), born in Texas, lives and works in Queens, New York. Khan's practice uses the lens of their own body to investigate and disrupt social and capitalist systems. Much of this inquiry revolves around the experience of power and surveillance and how this intersects with their construction of gender and Muslim identity.

Recent solo exhibitions include: *Statements* with Simone Subal Gallery, Art Basel, Switzerland (2023); Hirshhorn Museum and Sculpture Garden, Washington, DC (2023); High Line, New York, NY (2023); Georgetown University, Washington, DC (2023); Contemporary Arts Center, Cincinnati, OH (2022); Moody Center for the Arts, Houston, TX (2022); Brooklyn Museum, Brooklyn, NY (2021); and Simone Subal Gallery, New York, NY (2019).

Selected group exhibitions include: Kiran Nadar Museum of Art, New Delhi, India (2023); Sharjah Art Foundation, Sharjah, UAE (2022); Wexner Center for the Arts, Columbus, OH (2021); New Orleans Museum of Art, New Orleans, LA (2020); the Kitchen, New York, NY (2018); SculptureCenter, Queens, NY (2018); and Aspen Art Museum, Aspen, CO (2018).

Baseera Khan's work is in the public collections of the Brooklyn Museum, Brooklyn, NY; Solomon R. Guggenheim Museum, New York, NY; Whitney Museum of American Art, New York, NY; and Walker Art Center, Minneapolis, MN, among others. https://baseerakhan.com/

Baseera Khan, *Blue White and Red (portals)*, 2020. Leather, pleather, C-print, grommets, 35 × 21.75 in. *Photo by Dario Lasagni. Image courtesy of Baseera Khan and Simone Subal Gallery, New York.*

This work is a banner, a seal, a portal, a flag, a garment—I don't know yet. After a feverish dream in May 2020, I knew how to achieve this new series: through a flowing system of layers grommeted together to conceal and reveal different elements at different times. The cutout pleather patterns obscure intimate moments of photographic love. Akin to an older series of mine called the *Acoustic Sound Blankets*, this new body of work stems from radical-ornamentation histories.

Laura Kina, *Auntie Nora's Mac Salad*, 2023.
Watercolor, acrylic, and pen on paper, 9 × 12 in.
Image courtesy of Laura Kina.

SPAM MUSUBI AND AUNTIE NORA'S MAC SALAD

Laura Kina

SPAM became popular in Hawai'i during World War II, and the state still has the largest per capita consumption of SPAM in the US. When I was growing up in the Pacific Northwest in a Norwegian community, my grandma Kina, who was from a sugarcane plantation on the Big Island of Hawai'i, taught us to enjoy making and eating SPAM maki sushi, and it became symbolic of our identities as Uchinanchu (Okinawan diaspora) from Hawai'i. SPAM musubi is my kid Midori's favorite food, and they have fond memories of making this for big family reunions during our annual summer visits to my parents' house in Poulsbo, Washington.

During the COVID-19 pandemic in the summer of 2020, I was diagnosed with stage 1 breast cancer, and Midori often took over for me in the kitchen when I was too sick to cook. This was one of the first dishes they mastered on their own. Between travel restrictions and my compromised immune system, we couldn't leave Chicago to see our family on the West Coast during the pandemic, so Midori and I looked for any excuse to make SPAM musubi. It's our guilty pleasure comfort food that helps us feel connected to family.

My grandma's version of SPAM maki sushi was Okinawan plantation–style, which was very similar to Korean kimbap. She made oversized maki sushi rolls, which were seasoned strongly with white vinegar (and salt and sugar) and rolled with either SPAM or canned tuna and whatever was around. Think recycling. Later we evolved these to be a variation on the California roll, adding in strips of egg, cucumber, avocado, sugar- or soy-sauce-marinated dried gourd shavings (kampyo), and shiitake mushrooms. Today, I make the musubi style since it's more convenient.

Another family reunion summertime favorite is Mac Salad. We sadly lost my auntie Nora Matsumoto (1950–2023) during the pandemic. She used to bring this dish to family gatherings in Southern California. What makes this version of a Hawaiian plate lunch staple unique is the Japanese American twist of tsukemono (pickled) cucumbers and surimi (imitation crab). The peas, red potato, and red onion are California-cuisine adaptations.

These two recipes were originally published in Kiam Marcelo Junio, *Filipino Fusions: A Culinary Critique* (Chicago: Inside the Artist's Kitchen and Kiam Marcelo Junio, 2016), 36–40.

SPAM Musubi Recipe

3 cups Japanese sushi rice

4 cups water (or one knuckle level over the rice)

Seasoned rice vinegar (Marukan brand), to taste

1 can SPAM

2 tablespoons vegetable oil

4 eggs

½ teaspoon soy sauce

½ teaspoon sugar

1 tablespoons dashi (made from scratch or instant Hondashi or dashinomoto powder—dissolve ¼ teaspoon powder into ¼ cup warm water, and use 1 tablespoon broth)

½ teaspoon mirin

Package—of sushi nori

Furikake (Japanese rice seasoning; Wasabi Fumi Furikake is *ono*!)

1. Rinse the raw rice in cold water until the water is no longer cloudy (approximately 4 times). Put rice in a pot or rice cooker with enough water to cover. Use package or rice cooker instructions, or measure the water so that it is one finger knuckle over the rice. If using a stovetop, soak rice in water for 30 minutes, then bring to a boil; reduce heat to low, and simmer, covered, 20 minutes or until liquid is absorbed. Remove from heat; let stand, covered, 10 minutes. Fluff the rice with a rice paddle. Scoop out 2 cups at a time into a glass bowl (don't take it all out, or it will get too hard), and season the rice to taste with seasoned rice vinegar. Make sure it's not too wet but has a slight punch of vinegar.

2. Cut up 1 can of SPAM into 8 slices, approximately ¼ inch thick. Heat 1 tablespoon vegetable oil in a pan. When the pan is hot, fry the SPAM in it until light brown on both sides. Set cooked SPAM slices on a paper towel to absorb excess oil.

3. Mix eggs, and lightly season as you would when making dashimaki tamago with soy sauce, sugar, dashi, and mirin. Heat a small round frying pan or square tamagoyaki pan to medium high, and add in ½ tablespoon vegetable oil to lightly coat pan. Pour half the egg mixture into the pan to form a thin omelet. Let the eggs set up, and then carefully flip the omelet. Cook briefly, and then slide it onto a plate to cool. Repeat, cooking the remainder of the egg mixture in the last ½ tablespoon of oil. Cut the two omelets into 8 rectangles the same size as your SPAM slices.

4. Cut the sheets of nori in half. Place a sheet of nori on a cutting board. Put a SPAM musubi press (or use the empty SPAM can with both top and bottom removed) in the middle, and begin to assemble the layers of the musubi.

5. Put enough rice at the bottom of the press to make a ¼-to-½-inch layer of rice. Use the press to gently flatten the rice. Sprinkle a layer of furikake seasoning, add a layer of SPAM, add a layer of egg, and add a final layer of rice. Press to flatten rice, and then push the layers through the mold. Fold the nori over the layers. Place musubi seam side down on a plate. The moisture from the hot rice will seal the nori. Makes 8 musubis.

6. After all musubis are assembled, you can either eat them whole (a great option for lunches or snacks on the go) or cut them in half or in fourths to serve as appetizers sushi-style. Make sure that your knife blade is wet so that the rice won't stick to the blade. Make sure to wipe your knife blade each time. A simple way to do this is to just put water on a paper towel.

Variation: *Marinate the SPAM in teriyaki sauce, omit egg and furikake, and substitute a grilled pineapple slice.*

Laura Kina, *Laura Kina's SPAM Musubi*, 2020. Watercolor and pen on paper, 7 × 10 in. *Image courtesy of Laura Kina.*

Auntie Nora's Mac Salad Recipe

1 English cucumber

Kosher salt

4-6 new potatoes

6 eggs

¼ cup red onion, diced

8-12 ounces surimi, flake-style (imitation crab meat)

15 ounces Hellmann's Real Mayonnaise (½ a big jar or 1 small jar)

2 tablespoons sugar

2 tablespoons white vinegar

16-ounce box of elbow macaroni

½ package frozen petite peas

Salt and pepper

1. The night before you want to make the salad, slice the entire cucumber very thin, and rub generously with kosher salt. Let sit for 30 minutes to 1 hour to quick pickle. Rinse numerous times with cold water, taste testing to make sure it's not too salty. Squeeze out the excess water. Put the cucumber slices in a ziplock bag, and let it sit in the fridge overnight. The next morning, squeeze the excess water from the cucumber slices. Taste test again. If they are still too salty, rinse with cold water, and squeeze out excess water.

2. Boil the new potatoes for 20 minutes in salted water. Drain, and let cool. Keeping the skin on, cut the potatoes into large cubes.

3. Put the eggs in small pot, and add cold water until they are covered by 1–2 inches of water. Bring to a boil. Remove from heat, cover, and let sit them the hot water for 12 minutes (no more than 15 minutes). Drain, peel, and chop.

4. Dice the red onion.

5. Chop the surimi flakes.

6. Mix mayonnaise, sugar, and vinegar. Adjust to taste.

7. Boil lightly salted water in a large pot. Add the macaroni. Boil uncovered for 7 minutes or until tender. Drain well.

8. Cover the noodles with the mayonnaise sauce; stir to coat.

9. Mix in the pickled cucumber slices, peas, onions, and surimi.

10. Add salt and pepper to taste. Keep in mind that the salty cucumber slices will release salt into the mac salad.

11. Carefully fold in the eggs and new potatoes.

ABOUT THE ARTIST

Laura Kina pictured in 2024 after receiving hajichi (Okinawan hand tattoos) from Okinawan Brazilian hajichiā Hiromi Toma. *Photo by Midori Aronson. Image courtesy of Laura Kina.*

Laura Kina (she/they) is a queer, mixed-race Okinawan American artist based in Chicago (land of the Three Fires Confederacy) whose practice focuses on Asian / Asian diasporic art. Kina has exhibited her art nationally and internationally in galleries and museums including the Chicago Cultural Center, the India Habitat Centre, the India International Centre, the Japanese American National Museum, the Okinawa Prefectural Art Museum, the Rose Art Museum, the Smithsonian Archives of American Art, Spertus Museum, and the Wing Luke Museum. Kina is an Art Matters Foundation grantee and, through 3Arts, a 3AMP mentorship artist, a Make a Wave artist, a Joan Mitchell Center Artist-in-Residence, a 3AP awardee, and a Ragdale Fellow.

Laura Kina is a Vincent de Paul Professor at the Art School at DePaul University, curator for the Virtual Asian American Art Museum, and series editor for the University of Washington Press Critical Ethnic Studies and Visual Culture series. She coedited *War Baby / Love Child: Mixed Race Asian American Art* (University of Washington Press, 2013) and *Queering Contemporary Asian American Art* (University of Washington Press, 2017). Kina illustrated Lee A. Tonouchi's award-winning children's book *Okinawan Princess: Da Legend of Hajichi Tattoos* (Bess Press, 2019). https://www.laurakina.com/; Instagram: @laura.kina

Laura Kina, *Ufushu Gajumaru (Giant Banyan Tree), Valley of Gangala, Okinawa, Japan*, 2019. Acrylic on canvas, 48 × 72 in. *Image courtesy of Laura Kina.*

Laura Kina, *Phoebe Kuo's Chinese Milk Bread*, 2021. Watercolor and pen on paper, 9 × 12 in. *Image courtesy of Laura Kina.*

CHINESE MILK BREAD

Phoebe Kuo

My first encounter with baked goods was prenatal. It was California in the 1980s, and every day my pregnant mother went to the office, where people smoked indoors, and a cloud of smoke always hung over her cubicle. My mother escaped periodically to rest on a vinyl chaise in the ladies' room, and once a day at 10:00 a.m., my father fetched a cinnamon roll for her from the food truck outside. My mother had never had a sweet tooth or much of an appetite at all, but now she ate for two, and eating this large soft, sticky pastry became an essential ritual.

As a child, I was introduced to other American pastries and sweets. On Saturday mornings my parents walked me and my sisters to the local donut shop, where we pointed at our favorites in the glass case: a buttermilk bar, a glazed twist we called a unicorn horn. At Sunday School I received, with the reverence accorded to the Holy Communion, a handful of Mother's Circus Animal Cookies and a Dixie cup of bright pink punch mixed from powder. In the public school cafeteria, I watched classmates unwrap the Twinkies and Ding Dongs my parents refused to buy. My parents had come from Taiwan to the US as grad students in the 1970s and learned to cook without the help of family, reproducing remembered dishes with the offerings of our small-town supermarket—broccoli and spinach passing for gai lan and kong xin cai—and trying their hand at enchiladas, steak, and spaghetti. A family of five on a single salary, we rarely ate out; home cooking was nutritious and economical. My parents' one gesture toward baking, consistent with their sense of thrift, was the purchase of a bread maker, which produced a dreaded loaf—dense with a heavy crust—that I swallowed with a helping of filial piety.

What does it mean to reclaim a culinary heritage when one is cut off from extended-family traditions? In my early adulthood, I reached reflexively for cookbooks in the American canon, beginning my self-education with cupcakes and muffins from Irma S. Rombauer's accessible classic *The Joy of Cooking*, later advancing to scones and seasonal fruit galettes from activist chef Alice Waters. It was not until recently that I found my way into Taiwanese and Chinese culinary traditions. A flourishing of websites and Instagram accounts by diasporic Asian Americans offers personal stories alongside detailed illustrated recipes, making Chinese recipes accessible to English-speaking, second-generation Taiwanese Americans like me. These resources have been an education and a connection to a culture I never knew firsthand, filling in a cultural gulf opened by my parents' emigration from Taiwan in the 1970s.

When the COVID-19 pandemic arrived in the United States in 2020—and white-collar workers retreated into their homes, while essential workers continued to show up for their shifts at supermarkets, meat-packing plants, and growing fields to keep food on our tables—I baked my way through our state-mandated lockdown, at first making focaccia and flatbreads, sourdough boules and sourdough discard crumpets, ordering sacks of flour from a local mill amid a months-long flour shortage in all major supermarkets. In my quarantine kitchen, pained

by the president's anti-Asian rhetoric and the violence against Asian Americans he encouraged, I began to consider the racial valence of my baking frenzy. Thanks to food blogs, I attempted Chinese buns for the first time. Soon, shiny knots of milk bread replaced the sourdough boules; Swedish kardemummabullar moved aside for sesame-freckled pork buns.

It is hard to explain this late-arriving nostalgia for Asian breads I did not grow up with; at age thirty-seven, I am adding to my American repertoire new Asian recipes that nonetheless taste intimately familiar. It is now these sweets, and not the cinnamon roll I experienced through the umbilical cord, that I crave.

The following recipe for Chinese milk bread is a family recipe—but not mine. It is adapted from The Woks of Life, a website created by parents Judy and Bill, with their daughters Sarah and Kaitlin, to document their family's history through food. I have relied gratefully, and heavily, on their knowledge during the pandemic.

Chinese Milk Bread Recipe

160 milliliters heavy cream, at room temperature

250 milliliters milk, at room temperature (I used oat milk)

1 large egg, at room temperature

75 grams sugar

70 grams cake flour

500 grams bread flour

11 grams active dry yeast

7 grams salt

Butter

FOR THE EGG WASH

1 egg

1 teaspoon water

FOR THE SIMPLE SYRUP

2 teaspoon sugar

2 teaspoon hot water

1. Into the bowl of a mixer, add the first eight ingredients in the order listed. Using a dough hook attachment, set the machine to "stir" for 15 minutes, stopping as needed to push the dough together.

2. Cover the bowl with a damp towel, and proof in a warm spot for an hour or until the dough grows to 1½ times the original size.

3. Grease two 9-inch round cake pans with butter. Or for loaves, use two standard loaf pans.

4. Once it's proofed, put the dough back in the mixer, and stir for five minutes to release any air bubbles. Dump the dough on a lightly floured surface, and divide into two equal pieces. Cut each of the halves into eight equal pieces, and shape into buns. Alternatively, if you're using loaf pans, divide each of the halves into three pieces, and place them in the pans. Once it's shaped, let the dough proof for another hour.

5. Preheat the oven to 350°F/175°C. Make egg wash by whisking together 1 egg and 1 teaspoon water. Brush the buns with egg wash, and bake for 20–25 minutes on the middle rack. While buns are baking, make simple syrup by dissolving 2 teaspoons sugar in 2 teaspoons hot water. Remove buns from the oven, and brush immediately with simple syrup for shine, sweetness, and color.

ABOUT THE ARTIST

Phoebe Kuo (she/her) is a design researcher and studio woodworker who makes site-specific sculpture using traditional furniture-making techniques. Her work engages the built environment to propose alternative relationships and systems of value. Born in California to Taiwanese American mathematicians, she earned her BS in product design from Stanford University and an MFA in design from Cranbrook Academy of Art. She lives in Oakland, California. https://www.phoebekuo.com/

Phoebe Kuo, *Jewelry for Furniture*, 2018. Coopered pine, 9 × 9 × 4 in. *Image courtesy of Phoebe Kuo.*

Jave Yoshimoto, *Larry Lee's "I'm a Pepper, You're a Pepper, Wouldn't You Like To Be a Pepper, Too?" Chicago/LA Kalbi Marinade/Serenade*, 2021. Ink, watercolor, and gouache on paper, 9 × 12 in. *Image courtesy of Jave Yoshimoto.*

"I'M A PEPPER, YOU'RE A PEPPER, WOULDN'T YOU LIKE TO BE A PEPPER, TOO?" CHICAGO/LA KALBI MARINADE/SERENADE AND TRADER VIC'S MAI TAI

Larry Lee

My dad worked during the sixties and seventies as a chef at Trader Vic's, an upscale nightclub/restaurant in the basement of the Palmer House Hilton in downtown Chicago serving trademark tiki cocktails while offering Americanized Cantonese cuisine disguised as posh Polynesian fare. For special-occasion banquets, his specialty was roasting the "big pig"—whole with an apple in its mouth. And it came as no surprise really that I as the number one son would inherit his barbecuing gene given how the proverbial apple from the big pig's mouth doesn't fall far from the family tree. . . .

So the origin of my recipe is circuitously linked to his employment there, as two decades later, when I was doing my MFA at the School of the Art Institute of Chicago, whose scattered-site campus was right across the street from Trader Vic's, I met the other player in this narrative, my buddy Mark Werle, finishing up his BFA at the same time, both of us indulging every Thursday in the half-price Mai Tai Happy Hour, replete with free pupu platters of crab rangoons, egg rolls, BBQ spareribs, and if we were lucky, rumakis. Trading Trader Vic's stories, we learned that our parents, my Chinese father and his Korean mother, had worked together, one in the kitchen, the other in the dining room, for years as our shared tastes formed shared experiences ultimately resulting in Mark's sharing his mom's secret of adding a can of Dr Pepper to marinate kalbi. This caramel-colored nectar of the gods tenderizes the short ribs and releases the sugars of the thinly sliced pear to sweeten the marinade for grilling.

With coming together to grill and eat delicious kalbi also comes the need for the perfect drink as accompaniment. What recaptures the beauty of those magical moments before Trader Vic's closed down than their iconic mai tai, its smooth but sharp lime twang an ideal complement?

"I'm a Pepper, You're a Pepper, Wouldn't You Like to Be a Pepper, Too?" Chicago/LA Kalbi Marinade/Serenade Recipe

1 cup or so soy sauce

1 yellow onion, diced or grated

¾ cup brown sugar, packed

3–5 garlic cloves, minced

2 tablespoons sesame oil

¼ cup or so white wine (dry, such as sauvignon blanc)

Couple of healthy shakes of black pepper

5 pounds or so short ribs

1 pear (ideally Asian pear), quartered and thinly sliced

1 can Dr Pepper

1. Mix the first seven ingredients above together, and pour into a bag or pot with short ribs, then add the sliced pear and the can of Dr Pepper.

2. Refrigerate for at least 3–6 hours if not longer.

3. As you know, I usually eyeball rather than precisely measure, so the above should be a decent enough amount of marinade for maybe 5 pounds of short ribs, but okay to alter the ratio, or sometimes when Lar be lazy, I use any store-bought jar of kalbi marinade and add the pear and Dr Pepper. Just as good if not gooder.

Trader Vic's Mai Tai Recipe, Circa 1944

1 ounce amber Martinique rum

1 ounce dark Jamaican rum

1 ounce fresh lime juice

½ ounce orgeat syrup

½ ounce of Cointreau

Mint for garnish (and a lime if you like)

1. Add all ingredients to a cocktail shaker, except the garnish. Shake, and strain into a rocks glass filled with crushed ice. Garnish with fresh mint and a lime if you fancy that. You can also float some dark rum on top of the cocktail.

Laura Kina, *Trader Vic's Mai Tai*, 2020. Watercolor, pen, and colored pencil on paper, 7 × 10 in. *Image courtesy of Laura Kina.*

ABOUT THE ARTIST

PAUL HOPKINS

Larry Lee (he/him) is a multimedia artist, independent curator, and writer who earned his bachelor of fine arts from the University of Illinois Chicago and his master of fine arts in sculpture at the School of the Art Institute of Chicago where he also teaches art history, theory, and criticism.

His practice includes sculpture, video, installation, and painting that "remakes" his personal history in specific and the Asian American experience in general into stylized multimedia objects and images he facetiously terms "orientalia." His work has been exhibited in the Chicago metro area at the Chicago Cultural Center, Gallery 400, and the Evanston Arts Center as well as in New York City, San Francisco, Philadelphia, Dallas, Houston, Cleveland, New Haven, and Glasgow, Scotland. In addition to his curatorial project, Molar Productions, Lee collaborates with the painter Jason Dunda to perform as "the International Chefs of Mystery!" in a long-running video series available on Vimeo. https://www.larryleechicago.com

Still from Larry Lee, *Cooking the Books (with Jason Dunda)*, 2011. Videography, sound, and postproduction by Joshua Slater. Vimeo video, 25:00. *Image courtesy of Larry Lee.*

This is from part two, following up the inaugural but little-seen *Boos and Bakin'*, of the series featuring your favorite so-called International Chefs of Mystery! Jason Dunda and I return a year later and stir up trouble, literally cooking the books this time for "the toy formerly known as . . ." yet another summer group show at slow gallery in Chicago.

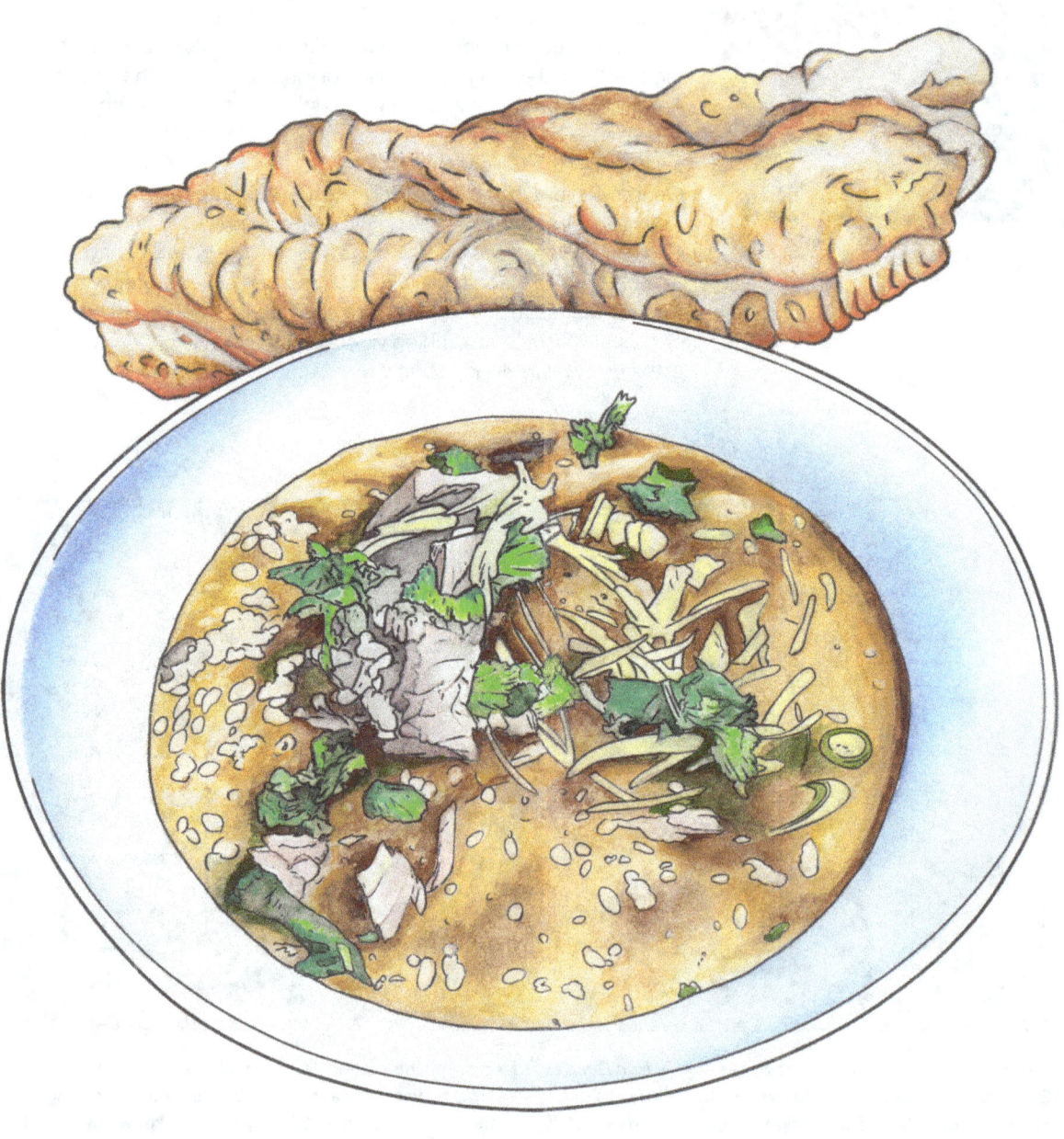

Jave Yoshimoto, *Kathy Liao's Milkfish Congee*, 2021.
Ink, watercolor, and gouache on paper, 9 × 12 in.
Image courtesy of Jave Yoshimoto.

MILKFISH CONGEE 虱目魚粥

Kathy Liao

My mom grew up on the island of Penghu in Taiwan, and she inhales seafood like a Midwesterner devours steaks. Among all the fishes in the sea, milkfish has a special place in her stomach. I have fond memories from growing up of my mom taking me to different street food stands, telling me how this stand has the best seafood congee, this stand has the best milkfish soup, etc. Some days, my mom would take me to the open market in our neighborhood in Taipei and buy fresh milkfish. Maybe because congee is so easy to cook, that is always her go-to home-cooked dish. When my dad was sick in the hospital, I remember my mom would search the local markets for milkfish congee, claiming that it was the most nutritious and nourishing food for someone who was convalescing. If I ever get to request a last meal, this will have to be it.

Milkfish Congee 虱目魚粥

1 cup day-old rice

6-10 cups water or fish stock (depends on how soupy you want the congee to be)

1 teaspoon dashi (if using water)

Salt

Few slices of ginger

Milkfish belly and head, cut into 2-inch pieces (you can substitute other whitefish, but milkfish is the best)

Dash of white pepper

Dash of sesame oil

1 green onion (finely chopped)

Cilantro

Pickled ginger strips

1. Save a cup of leftover rice.

2. In a pot, add rice, fish stock (or water and dashi), salt, and ginger slices. Bring everything to a boil at high heat, and then turn it down to a simmer.

3. Cover, and simmer for 20 minutes or until the congee starts to thicken. Sometimes, I add more water or stock halfway through to make it soupier.

4. Once congee reaches the desired consistency, throw in the milkfish chunks, add a dash of white pepper and a dash of sesame oil, and let it cook for a few minutes.

5. Dish it out in a bowl, and garnish it with chopped green onion, cilantro, and ginger strips.

 Tip: Best served with a side of Chinese fried dough.

JEREMY UNDERWOOD

ABOUT THE ARTIST

Kathy Liao (she/her) is a Taiwanese American artist who looks for patterns and repetitions that weave through immigrant families' experiences in her mixed-media work. Her recent paintings and wall-drawing installations document the fluid state between experience, memory, and place. Liao received her MFA in painting from Boston University. She is a recipient of various awards including the 2023 Joan Mitchell Fellowship, 2022 21C KC Artadia Award, and a public art commission for the new Kansas City International Airport. As a mentor and educator, Liao has taught and lectured at multiple institutions and conferences nationwide. Formerly, Liao was director of the Painting and Printmaking Studio Art Program at Missouri Western State University. She was nominated "Most Influential Professor" by the Missouri Western State University Honors System in 2019. https://www.kathyliao.com/

Kathy Liao, *In Between the Lines*, 2019. Collage, charcoal, marker, ink, silk screen, and oil on paper and canvas, approximately 252 × 132 in. Site-specific installation at H&R Block Artspace at the Kansas City Art Institute, Kansas City, MO. Photo by E. G. Schempf. Image courtesy of Kathy Liao.

heather c. lou, *dumplings reprise*, 2021. Digital art, 12 × 12 in. *Image courtesy of heather c. lou.*

DUMPLINGS

heather c. lou

we sat across the table
the back of my legs stuck to the plastic
that covered the seats of her dining room
chairs
all of the ingredients laid perfectly arranged
on the lazy susan, waiting to be
assembled
at six, my time had come to be written in
on the lou family secret—how to wrap the
perfect wonton
in silence, *amma* showed me how to
nourish myself and the ones i love for the
generations to come
just like her *amma* probably did for her
her pale and wrinkled hands caressed the
dough and perfectly portioned the meat
dotted egg to bind
pinched edges and folded with care
bent quickly but not to tear the delicate
package
she made it look effortless
as i followed her steps
i fumbled
i furrowed my brows
bit my lips
grumbled with frustration
my tiny little wonton was a pile of mush
she looked at me and simply said, "again."
"again. again. again."
that day i made all of five wontons for our
meal while *amma* made a bounty

but what i didn't know then
was that *amma* had persevered
she had fought and been silenced her
whole life
she had made wontons in a restaurant that
she owned
she had struggled and had immigrated
men had catcalled her
called her their china doll
she had been scared and alone
did she ever fight back
did she ever say something to their sexist
and sinophobic remarks
and although her work seemed effortless
it was a culmination of her many years of
wisdom
her guidance from ancestors
love and nourishment
resistance
practice
i have white hairs now
i'm getting wrinkles and i'm getting rounder
i'm walking like my *amma* more and more
each day
each time i make wontons, it's becoming
more like muscle memory
i can feel *amma* with me each time i make
them
"again," she says
"again. again. again."

ABOUT THE ARTIST

heather c. lou (she/her) is an angry gemini earth dragon, multiracial, asian, queer, cisgender and gender-expansive, disabled, survivor/surviving, anxious, and depressed womxn of color tattoo and visual artist based in saint paul, minnesota, which is the hxstorical occupied land of the Dakota peoples. https://www.hclouart.com/

heather c. lou, *Mooncake*, 2023. Digital art.
Image courtesy of heather c. lou.

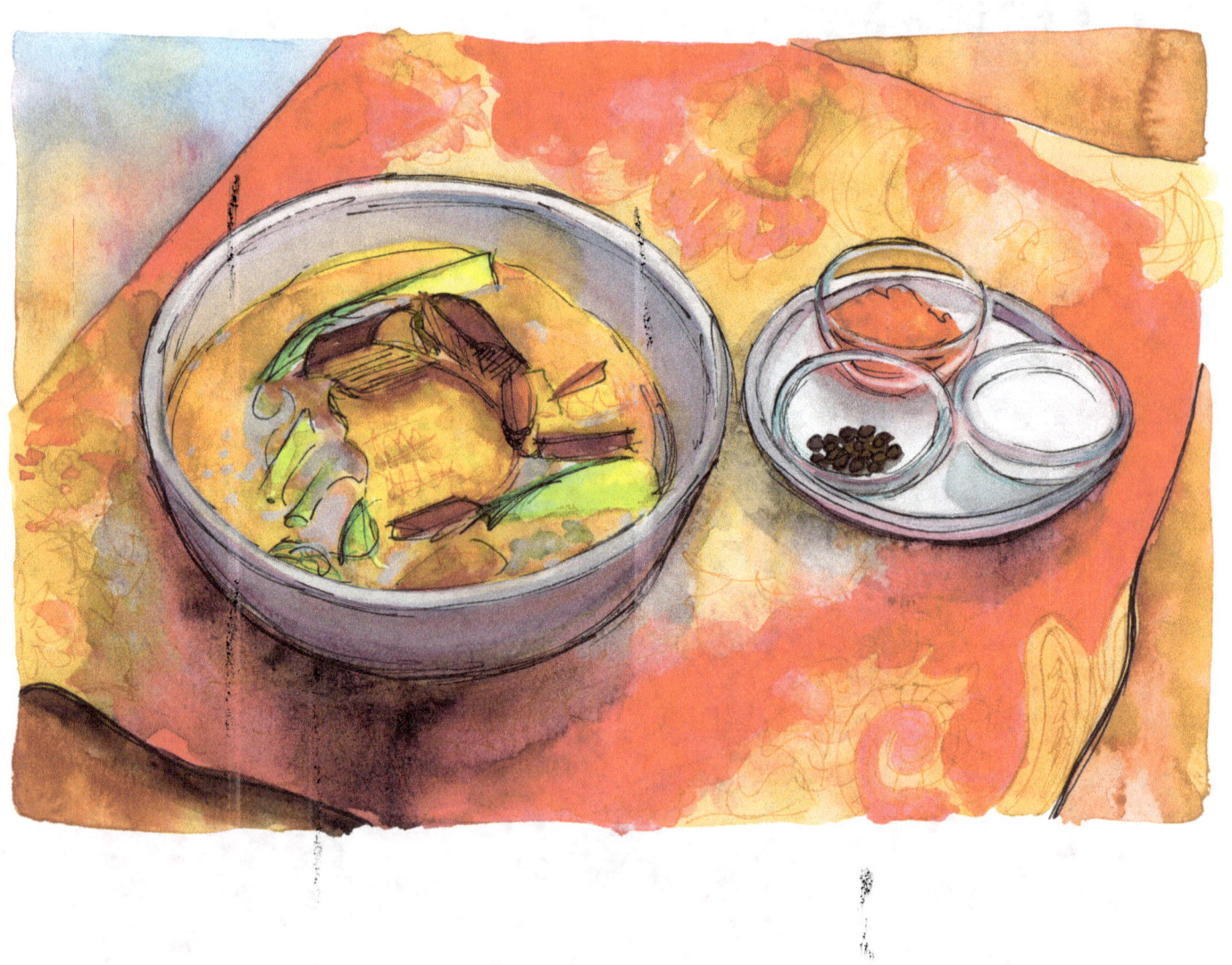

Laura Kina, *Kiam Marcelo Junio's Vegan Kare Kare*, 2021. Watercolor and pen on paper, 9 × 12 in. In the collection of Mary Doi. *Image courtesy of Laura Kina.*

VEGAN KARE KARE

Kiam Marcelo Junio

Kare kare gets its name from the Tamil word *kari* (better known by its English form, "curry"), which refers to a type of spiced sauce or gravy. Curry has numerous variations based on country, region, and even family recipe. In the Philippines, kare kare is a beloved national dish with elusive origins, likely developed as a melting pot of flavors from the country's illustrious history (mixing Spanish, Muslim, Indian, Malay, and Polynesian influences with Indigenous cultures).

Traditionally, this dish is made with oxtail, toasted glutinous rice, and crushed peanuts to give it its characteristically creamy texture. My adaptation puts a unique twist (vegan, with additional Pan-Asian spices) on the classic recipe that I learned from my mom.

With meal prep and delivery services now so widely available, it's easy to take our food for granted. We become so distanced from the origins and colorful histories of these ingredients. We forget that some of them traveled across great distances, picked and processed by countless hands before they reach our taste buds.

Here is a small window into the colorful lives of several beloved ingredients:

Black Peppercorns

While now ubiquitous in kitchens and dining tables around the world, the humble black pepper still only grows near the equator and was once worth more than gold. During the Middle Ages, Arabs had a monopoly on the spice trade, and only the wealthiest Europeans could afford to use it. In fact, the search for pepper was one of the key driving factors of Columbus's failed expedition—he was searching for the Malabar region of India and ended up in the Bahamas instead. While peppercorns were nowhere to be found there, the Indigenous people of the area widely used chili peppers to spice up their food. Chilies were much easier to grow in different types of weather, and this led to the cultivation of peppers in all their multicolored forms, including sweet peppers and paprika.

Bok Choy

Got milk? No. How about bok choy? A cup of this low-calorie, high-fiber vegetable provides as much calcium as a ¼ cup of cow's milk. It's also high in vitamins A, B6, C, and K; folate; and potassium. Bok choy (or pak choi) is in the mustard family along with cabbage, turnips, broccoli, and kale.[1]

Coconut

Even before the recent coco craze, the coconut always enjoyed widespread use all over the tropical world. The fruit provides nourishing water, healing oil, and full-bodied meat, which can be turned into all types of ingredients from flour to sugar to butter and many more. When I was growing up, we even used the coconut husks to polish our floors! Coconut has many health properties as it's high in medium-chain triglycerides (MCTs), which, unlike the long-chain triglycerides of animal fats, bypass the lower digestive tract to be absorbed directly into the liver, helping to burn more calories than they store. Coconut oil is also used widely

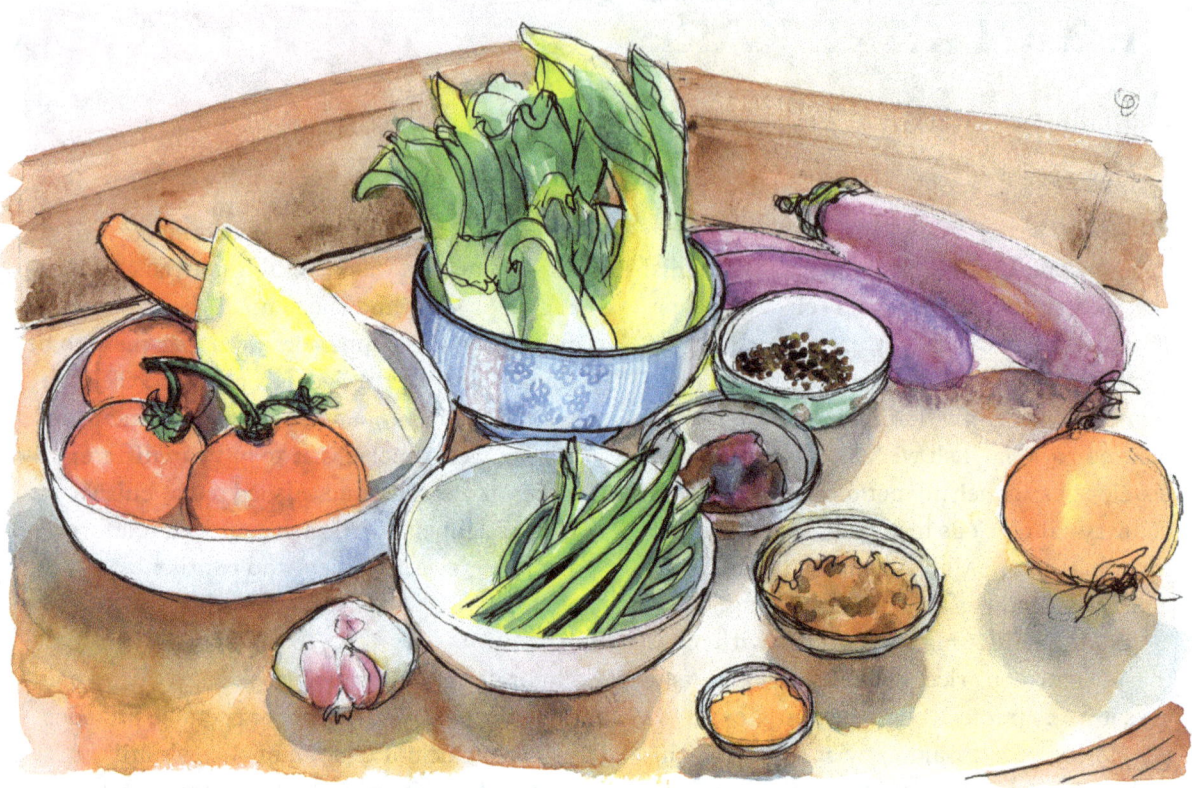

in skin and body care because of its antibacterial, antifungal, anti-inflammatory, and emollient (skin-soothing) properties.

Eggplant

These look nothing like eggs. . . . What gives? Known in Europe as "aubergine," this plant gave its name to its distinctive shade of purple, but older cultivars of this plant pre–Industrial Revolution were smaller and white or yellow, actually resembling eggs. Google it![2]

Garlic

Since ancient times, garlic has been one of humanity's most loved ingredients, enjoyed by many cultures in food and medicine. Modern research backs up our ancestors' intuition on garlic, noting its antioxidant, anti-inflammatory, anticarcinogenic, and glucose- and cholesterol-lowering properties, which help to promote health and prevent disease.[3]

Miso Paste

Miso paste is made from fermented soybeans and is available in different strengths including red, which is salty and flavorful, and white, which is milder and sweeter. Fermentation is a natural process used to make wine, cheese, and beer in which a carbohydrate (such as a starch or sugar) converts into an alcohol or acid, often with the use of yeast or bacteria. Fermented foods are

Above: Laura Kina, *Ingredients for Kiam Marcelo Junio's Vegan Kare Kare*, 2021. Watercolor and pen on paper, 9 × 12 in. In the collection of Mary Doi. *Image courtesy of Laura Kina.*

high in prebiotics and probiotics—meaning that the bacteria has a chance to digest the food before you eat it, making it easier for your body to process, and that they provide some much-needed beneficial bacteria for digestive health.[4]

Onion

First it makes you cry, then it heals your body. One of the most used vegetables in the world, the ordinary onion (and its hundreds of varieties such as scallions and shallots) packs a punch for your health. It's rich in quercetin, a known cancer-fighting chemical shown to reduce risks of developing colon, breast, prostate, ovarian, esophageal, oral, kidney, endometrial, pancreatic, and stomach cancer. It's now easy to see why garlic and onion always go together.

Saffron

If the bodacious black pepper can claim the title of "King of Spices," then meet the queen. Saffron is the world's most expensive spice—and for good reason. What we call saffron threads are the stigma (the pollen-gathering part) of the saffron flower. It takes 80,000 flowers and 250,000 dried stigmas to produce one pound of saffron. Here's more: the flowers are so delicate that traditionally only women and children were tasked to pick them. Chemically, the compounds crocin and safranal show great promise in relieving depression because of their ability to protect several brain chemicals such as serotonin, dopamine, and norepinephrine. Saffron bestows a rich golden color and an unmistakable aroma befitting royalty. It's a worthy investment, as a pinch is all you need.

Turmeric

Saving the best for last? Yes, indeed. Turmeric is perhaps the poster child for food as medicine. The compound curcumin is a powerful antioxidant and anti-inflammatory—which is a big deal as most modern diseases have inflammation as an underlying mechanism. Turmeric is the key ingredient (and color) of most curry blends. Traditional kare kare does not have turmeric, relying instead on annatto for color. I decided to add this revered spice into my version of kare kare to bridge the gap between this traditional Filipino dish and its neighboring curry counterparts.

NOTES

1. Megan Ware, "The Health Benefits of Bok Choy," Medical News Today, November 9, 2023, https://www.medicalnewstoday.com/articles/280948.
2. L. Trujillo, "The Elegant Eggplant," *Master Gardener Journal* 1 (2003): 12–14, https://cals.arizona.edu/maricopa/garden/html/pubs/0203/eggplant.html (page deleted).
3. Johura Ansary et al., "Potential Health Benefit of Garlic Based on Human Intervention Studies: A Brief Overview," *Antioxidants* (Basel) 9, no. 7 (2020): 619, https://doi.org/10.3390/antiox9070619.
4. "Miso Paste," Japanese Cooking 101, Oishii America, accessed April 1, 2021, https://www.japanesecooking101.com/miso-paste/.

Vegan Kare Kare Recipe

3 tablespoons vegetable oil (grapeseed, avocado, or coconut oil for additional flavor)

1 medium onion, chopped

6 cloves garlic, crushed

1 pinch saffron threads

3 ripe tomatoes, diced

1 teaspoon powdered turmeric

1½ cup crunchy peanut butter

2 tablespoons red (or mixed) miso paste

4 cups vegetable stock

2 small Asian eggplants, cut into 2-inch cubes

2 cups string beans, cut into 2-inch pieces

4 bunches baby bok choy, cut in half with ends removed

Steamed rice, quinoa, or riced cauliflower

Coconut milk for garnish

Chili-garlic paste for garnish

Crushed black peppercorns for garnish

1. Heat oil in a large pan over medium heat.
2. Sauté onion, garlic, and saffron until onion is translucent and the garlic browned, about 4–5 minutes.
3. Add tomatoes, and simmer until tomatoes are cooked down, about 2 minutes. Add turmeric, and stir.
4. Add peanut butter and miso paste. Stir until incorporated, about 2 minutes. Add vegetable stock. Bring to a boil, then reduce heat to low.
5. Add eggplant and string beans. Cover, and cook until tender, about 10 minutes.
6. In the last 2 minutes of cooking, add baby bok choy as the final ingredient to maintain its crunch.
7. Serve with rice (white, brown, or wild), quinoa, or riced cauliflower.
8. Garnish with coconut milk, chili-garlic paste, and crushed black peppercorns to taste.

ABOUT THE ARTIST

Kiam Marcelo Junio (they/them), born in the Philippines, is a non-binary artist, certified holistic wellness coach, and US Navy veteran. They hold a bachelor of fine arts from the School of the Art Institute of Chicago and a master of science in health and human performance from Pacific College of Health and Science.

As an artist, Kiam explores themes of spirituality, identity, and time. Their work eludes rigid definitions of discipline, taking shape as writing, sound, visual art, and performance, as well as perfumery, cuisine, fashion, and graphic design—exploring and communicating through all five senses.

Kiam's mission is rooted in helping people cultivate deep self-knowledge, sustainable self-love, and authentic self-expression. As a coach and consultant, Kiam works with creative professionals seeking to develop a stronger relationship with their body, mind, and spirit so they can show up with more confidence and purpose in the worlds they inhabit.

Connect with Kiam at https://www.kiam.online/ and on Instagram at @iamkiam.

Kiam Marcelo Junio, *Dona Nobis Pacem: Samskaras*, 2017. Archival print on metallic paper, 24 × 36 in. *Image courtesy of the Kiam Marcelo Junio.*

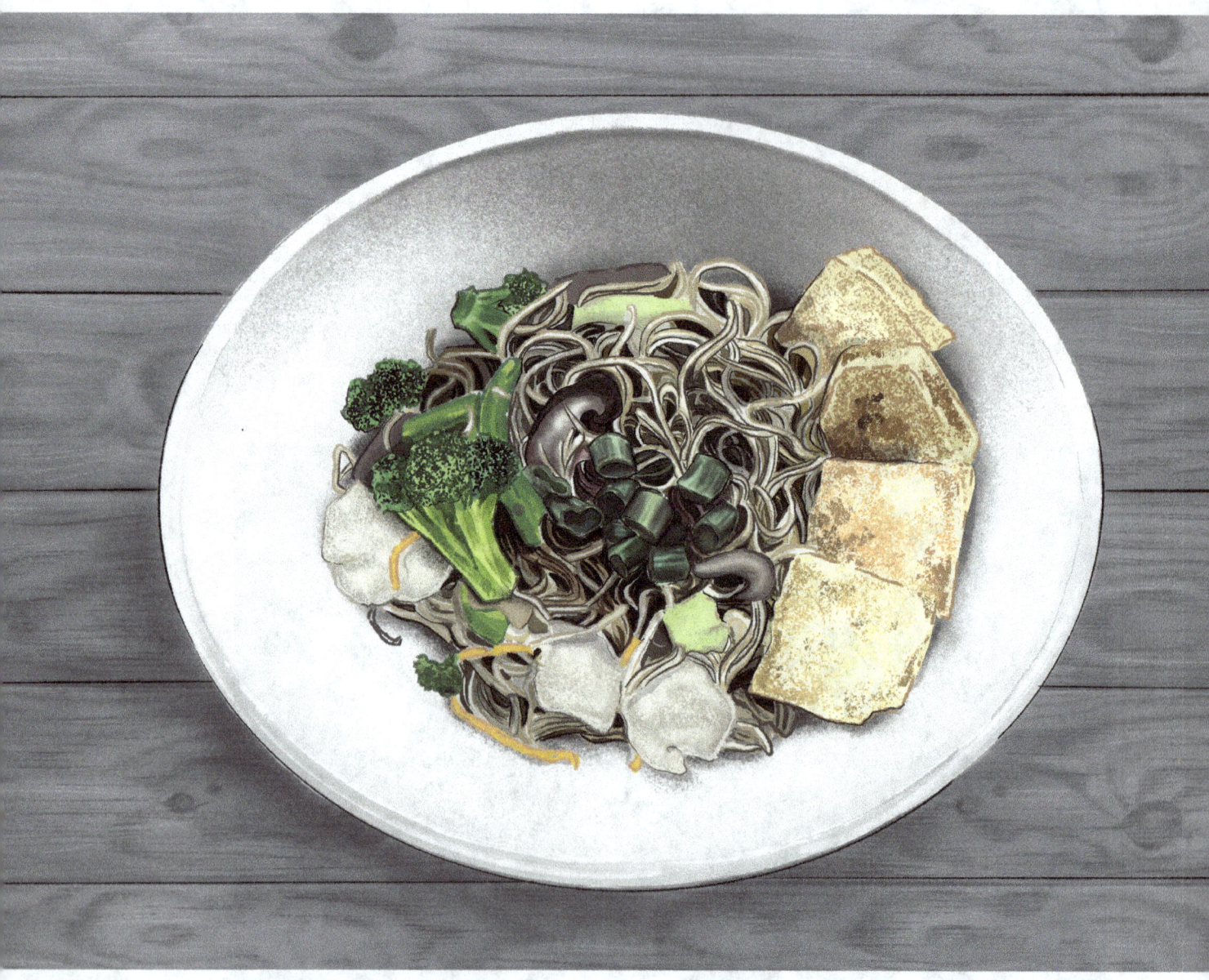

Mia Matlock, *Mia Matlock's Pancit Guisado 2.0*, 2020. Digital illustration, 8 × 10 in. *Image courtesy of Mia Matlock.*

PANCIT GUISADO 2.0

Mia Matlock

When I went vegan in 2016, I found myself at a difficult intersection between Western and Filipino values. On one hand, you are expected to refuse food that doesn't conform to your values. On the other, refusing food is considered a grave insult in Filipino culture. It has been a goal of mine to create plant-based versions of my family favorites that I can bring to holiday gatherings.

Filipinos will laugh at you for being a vegan. They won't be laughing for long when they return for seconds. Shiitake broth and red miso help make up a more complex umami flavor profile than its traditional counterpart. Before you ask where the shrimp is, take one bite, and you will find your answer. Lion's mane mushrooms and kelp pack a seafood flavor punch unlike any other. Every bite is full of meaty, savory mushrooms and crisp vegetables. You'll probably want to double this recipe; it's simply irresistible to constantly "quality control" test while cooking!

Pancit Guisado 2.0 Recipe

8 ounces rice noodles

1 block (14 ounces) extra-firm tofu

2 ounces dried shiitake mushrooms (about 8-10 pieces)

3 cups boiling water

Oil (any neutral-tasting oil, such as vegetable oil)

1 medium onion, sliced

4-6 cloves garlic, minced

4 ounces brown button mushrooms, quartered

4 ounces lion's mane mushrooms, cut into ½-inch cubes

4 ounces green beans, ends cut, sliced into 1-inch pieces

4 ounces broccoli florets

4 ounces cabbage, sliced into ½-inch-wide strips

4 ounces shredded carrots

green onions, for garnish

lemon slices, for garnish

FOR THE BROTH

1 bouillon cube of vegetarian chick'n stock

1 teaspoon red miso paste

4 tablespoons soy sauce, plus more to taste

Juice of 1 lemon

1 tablespoon kelp seasoning

1 teaspoon finely ground black pepper

½ cup water

1. Soften noodles: Soak noodles in lukewarm water until soft and workable. If they are too long, feel free to cut them. Set aside.

2. Press tofu: Wrap the tofu block in a paper towel or a rag, and place between two plates. Place a heavy weight (such as books) on top for 10–20 minutes. When the block is dry, cut into 1-inch cubes.

3. Prep shiitake mushrooms: Soak the dried shiitake mushrooms in boiling water for 10–15 minutes. Once the shiitakes are soft, squeeze out any excess water, and slice into strips, and reserve the water they soaked in; this is very important.

4. Prepare broth: Over medium heat, add bouillon to the leftover shiitake broth. Stir until dissolved. Add in miso paste, soy sauce, lemon juice, kelp seasoning, and pepper along with ½ cup of water. This will have a strong, salty taste.

5. Fry tofu: Heat ½ inch of oil in a wok over medium-high heat. Fry tofu until golden on all sides. Set on a paper towel to absorb any excess oil.

6. Sauté aromatics: In the same wok, sauté the sliced onions about 2 minutes, until soft. Add in garlic, and cook until fragrant.

7. Sauté remaining vegetables: Add in mushrooms and salt. Sauté until brown on all sides. They will crowd the pan at first, but they will cook down. Once the mushrooms are browned, add in green beans and broccoli. Cook until soft. Finally, add the cabbage and carrots. Stir frequently until the cabbage has softened slightly.

8. Finish pancit vegetable base: Add the broth to the vegetable mixture, and bring to a simmer.

9. Incorporate noodles: Slowly incorporate rice noodles by adding a little at a time. Toss the noodles in the pan until coated in the broth. Repeat this process until all the noodles are incorporated.

10. Finish and garnish: Stir noodles until liquid has cooked off. Add tofu, and incorporate thoroughly. Top with green onions, and season with pepper to taste. Serve with a lemon slice and soy sauce on the side.

Mia Matlock, *Shiitake, Lion's Mane, Tree Oyster*, 2020. Digital illustration, 8 × 10 in. *Image courtesy of Mia Matlock.*

ABOUT THE ARTIST

Mia Matlock (they/them) is a second-generation Filipino American born and raised in Omaha, Nebraska. In 2017, they graduated with a bachelor of fine arts from the University of Nebraska Omaha and began working as a freelance illustrator.

In 2020, Mia opened Oso Good Kitchen and Panaderya (@osogoodpan on Instagram), a tiny Filipino American home bakery focused on the creation of *kawaii*-inspired pastries. Aside from providing tasty, plant-based treats, Oso Good's mission is to celebrate Filipino culture through the use of language and food. In the three years since its creation, Oso Good has become a favorite among vegans and non-vegans alike throughout the greater Omaha metro area. Mia hopes to grow Oso Good into a food truck and expand the menu to include more traditional offerings.

When Mia isn't experimenting in the kitchen or reading cookbooks, they enjoy watching birds and drawing cute pastries. They currently reside in Omaha, Nebraska.

Mia Matlock, *Beautiful Apathy*, 2017. Relief print, 24 × 32 in. *Image courtesy of the Mia Matlock.*

Jave Yoshimoto, *Jarrett Min Davis's Ground Pork Japchae*, 2021. Ink, watercolor, and gouache on paper, 9 × 12 in. *Image courtesy of Jave Yoshimoto.*

GROUND PORK JAPCHAE

Jarrett Min Davis

I am a Korean adoptee and was raised in the American South and Midwest by white parents. Assimilation was thought to be better for adopted children at the time, and I grew up with a general ignorance about my Korean heritage and culture. It wasn't until I got older that I became aware of all the delicious things that I'd missed out on growing up. This recipe for japchae was the first Korean recipe that I learned to make at home and is a regular staple of my cooking. Eating Korean food was my first step into the exploration of my identity as a Korean American and served as the launching point for my future artistic and personal growth. Loving Korean food helped me love a part of myself that I didn't always want to embrace growing up.

Ground Pork Japchae Recipe

1 tablespoon canola oil

½ pound ground pork

2 tablespoons dry white wine, sake, or cheongju (Korean sake)

2 eggs, lightly beaten

1 carrot, thinly sliced

½ onion, finely diced

¼ ounce shiitake mushrooms

1 package Korean sweet potato glass noodles

1 bunch of spinach

Sesame seeds

FOR THE SAUCE

1 tablespoon soy sauce

1 tablespoon sesame oil

1 tablespoon sugar

1. Mix together soy sauce, sesame oil, and sugar to create a sauce.

2. Boil a large pot of water for noodles.

3. In a large skillet, add canola oil, and cook ground pork (add wine or cheongju to tenderize) over medium-high heat until it starts to brown. Add ⅓ of the prepared sauce. Remove ground pork when thoroughly cooked.

4. Add lightly beaten eggs. Cook, remove from skillet, and dice.

5. Add and cook onion, shiitake, and carrot until onions are translucent. Add pork and eggs, and cook for 3 minutes, and then turn to low heat.

6. Cook noodles according to directions (*do not overcook*).

7. Add cooked noodles and spinach and the remaining ⅔ of the sauce, and mix thoroughly until spinach is wilted.

8. Serve and top with sesame seeds.

ABOUT THE ARTIST

Jarrett Min Davis (he/him) was born in Seoul, South Korea, and adopted by American parents at the age of two. He was raised in Saint Louis and earned a bachelor of fine arts from the University of Dayton in Ohio. He then went on to earn a master of fine arts from the Maryland Institute College of Art's Hoffberger School of Painting in Baltimore. He currently resides in Amesbury, Massachusetts, and teaches in the Studio Foundation program at the Massachusetts College of Art and Design in Boston. He has exhibited work nationally and internationally with recent exhibitions in Boston, Baltimore, and Bangkok, Thailand. He was recently the artist in residence at Studio Arts College International in Florence, Italy. https://www.jarrettmindavis.com/; Instagram: @jmindavis

Jarrett Min Davis, *Exploration of the Terrain between the Time We Were and We Were Not*, 2016. Oil on panel, 30 × 40 × 2 in. *Image courtesy of Jarrett Min Davis.*

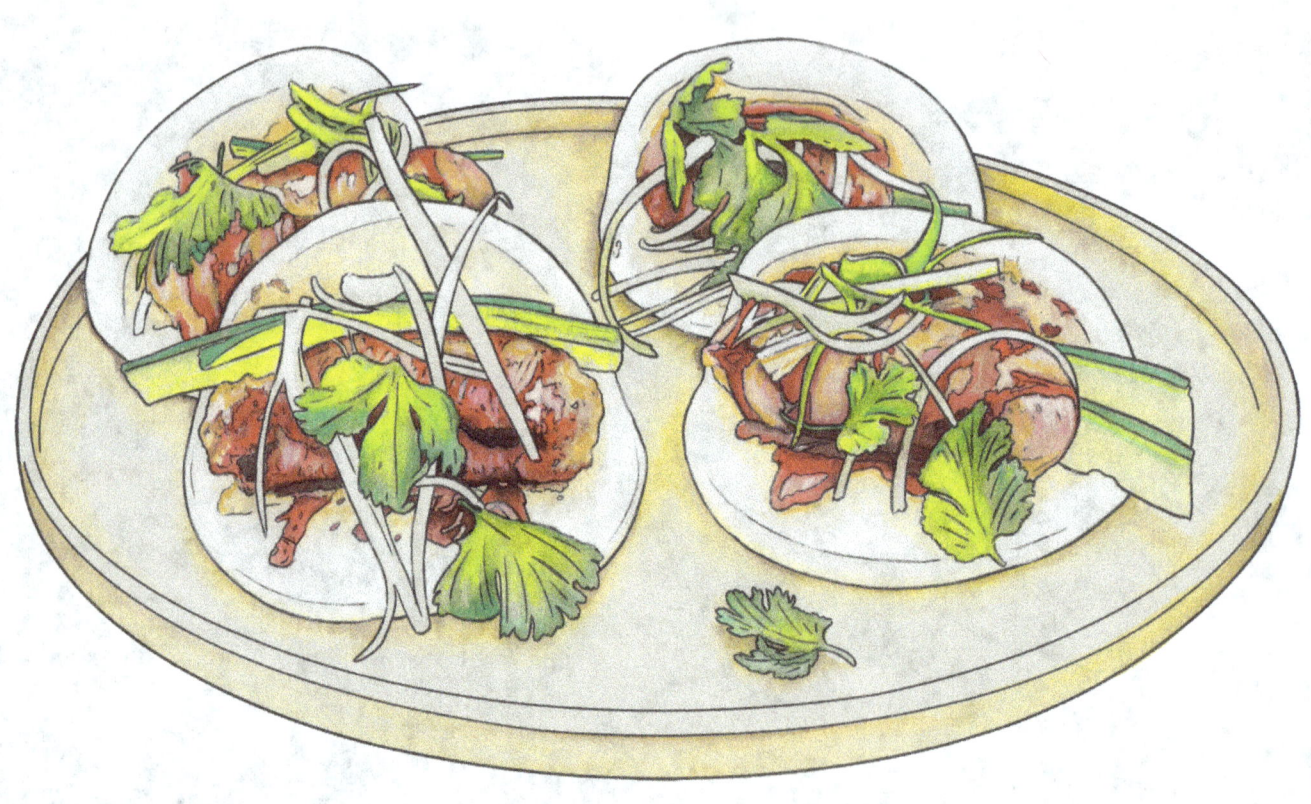

Jave Yoshimoto, *Genevieve Erin O'Brien's Pork My Buns XXXX*, 2021. Ink, watercolor, and gouache on paper, 9 × 12 in. *Image courtesy of Jave Yoshimoto.*

PORK MY BUNS XXXX

Genevieve Erin O'Brien

This recipe comes from my performance series *Meat My Friends*, which originated in the gallery but by popular demand became a regular pop-up event. *Meat My Friends* is a gathering of artisanal sausages that take storytelling to another stage—the plate. The sausages were developed for performance. Each sausage is inspired by the stories of the lives of my family and friends. The first series of homages is to my father. A variety of sausages are on offer wholesale and at a series of pop-ups, and I also collect stories and narratives to inspire new sausage homages.

Meat My Friends uses quality meat and local ingredients—organic where possible—and strives to make an ethical sausage at all levels of production, which includes paying workers a living wage.

Pork My Buns XXXX was created in honor of Christopher Lee, an Asian American transgender filmmaker and founder of the San Francisco Transgender Film Festival (originally called Tranny Fest), which continues to this day. Lee was a pioneer filmmaker known for making trans porn. His death catalyzed a movement for change. To the outrage of his friends and community after his death, the coroner's office deadnamed and misgendered him on his death certificate. Friends were spurred to action and quickly organized to get California's Respect after Death Act passed. The Respect after Death Act mandates that a person's gender pronouns be respected after death.

Pork My Buns XXXX sounds dirty, but it's just a little char siu BBQ pork. In Lee's honor, this sausage is made into little chubby, stubby links that are cooked and served in buns steamed and splayed open and slathered with hoisin sauce and flogged with scallions and cilantro. Orientalize this!

Pork My Buns XXXX Recipe

10 pounds deboned or boneless pork shoulder

2-2½ pounds pork fatback

1-inch pork casing

Steamed bao buns (the folded kind)

Green onions

Firm cucumber

Cilantro

Hoisin sauce

FOR THE MARINADE

½ cup honey granules

½ cup soy sauce or soy sauce powder if available (powder is ideal because when it comes to sausages, you want less liquids)

½ cup hoisin sauce

¼ cup rice wine (huangjiu if you can get it, but any mijiu or Shaoxing works)

¼ cup fermented soybeans (tương hột or salted fermented soybean, not the Japanese natto)

4 tablespoons fermented red bean curd (2 tablespoons liquid and 2 tablespoons bean curd)

3 tablespoons five-spice powder

2 tablespoons red yeast sea salt (you can also use regular Diamond coarse salt if you can't find red yeast salt)

1 tablespoon sesame oil

½ tablespoon ginger powder

1. Mix marinade ingredients together, and blend with stick blender.

2. Cut pork and pork fatback into 2-inch square pieces.

3. Pour marinade over pork, and leave in the refrigerator for at least 12–24 hours.

4. Use meat grinder to coarse grind marinated pork. If you are using a lower-powered grinder, use a few ice cubes to keep the pork cool as you grind.

5. Use a sausage stuffer to stuff your sausages. Before you stuff the sausages, cook a little uncased sausage to make sure the flavor is right. Should be little sweet and taste similar to xá xíu or char siu (red roast pork). Adjust salt to taste, and add more honey granules if it needs to be sweeter. The flavor will intensify when it's cooked in the casing, so don't oversalt it.

6. Once you are done casing the sausages, let them dry a bit in the fridge before linking. Link the sausage in 3-inch-long sausages by twisting every other sausage in the same direction.

7. Let the sausages dry in the fridge for a few more hours. You want to give the links time to dry so they don't come undone when you cut them.

8. Take the chilled, now-drier linked sausages, and use a sausage poker to poke each sausage a few times, and then cut the links.

9. To cook the sausages, vacuum seal them in a BPA-free bag, and cook them sous vide for 45 minutes at 145°F.

10. Remove the sausages from the bag, and transfer to a heavy pan, preferably cast iron, on the stovetop to finish them off.

11. Alternatively, you can cook the sausages directly from raw, but be sure to let the links come close to room temperature and cook them in the pan without oil slow and low. Don't put cold sausages in a hot pan. They will immediately explode and leak out the ends.

12. Serve the sausages in steamed folded bao buns with green onions sliced lengthwise in 2-to-3-inch pieces and thin slices of cucumber, also cut lengthwise in 2-to-3-inch pieces, and top with a few sprigs of cilantro and a squeeze of hoisin sauce.

AARON HENDERSON

ABOUT THE ARTIST

Genevieve Erin O'Brien (they/them) is a Los Angeles-based queer, nonbinary, Vietnamese/Irish/German artist. O'Brien holds an MFA in performance from the School of the Art Institute of Chicago and was a Fulbright Fellow to Vietnam. O'Brien was a Department of Cultural Affairs, City of Los Angeles's Creative Economic Development Fund recipient in 2015 and 2016. As a US Department of State / ZERO1 American Arts Incubator artist, O'Brien traveled to Hanoi to develop a digital media project highlighting LGBTQ visibility and equality. *More Than Love on the Horizon* and *Sugar Rebels* were commissioned by the Smithsonian Asian Pacific American Center. O'Brien's performance series *Refugee Resistance Menu* was funded by the Critical Refugees Studies Collective of the University of California. O'Brien was a Civic Media Fellow at the University of Southern California Annenberg Innovation Lab for 2023-24. They are a California Community Foundation Fellowship for Visual Arts awardee for 2024-25.

In their art practice, O'Brien uses conceptual performance, food-based performance, video, installation, fiber and material arts, art and tech, and social practice to share stories and shift narratives. Their work explores diaspora, community, queer domesticity, memory and belonging, the body and bodily autonomy, and impending climate change. O'Brien, once a butcher's apprentice and frequent lecturer in Asian American studies, is also a chef and owner of sausage enterprise *Meat My Friends*. O'Brien is a fermentation fanatic, sourdough enthusiast, pasta maker, and dumpling lover.

Performance still of Genevieve Erin O'Brien, *Meat My Friends*, 2015. Photo by Grace Umali. Image courtesy of Genevieve Erin O'Brien.

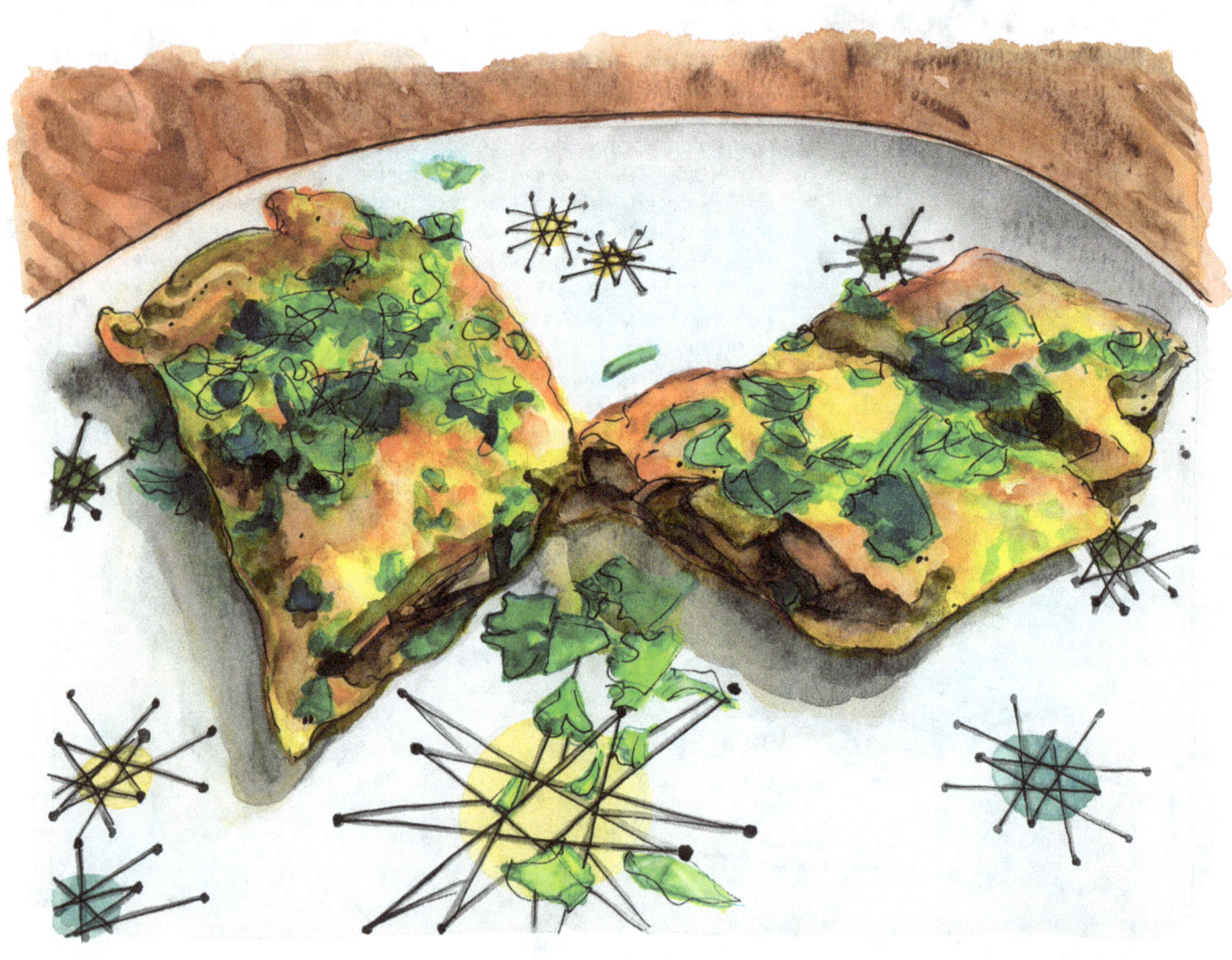

Laura Kina, *Valerie Soe's Sourdough Starter Jian Bing*, 2021. Watercolor and pen on paper, 9 × 12 in. *Image courtesy of Laura Kina.*

SOURDOUGH STARTER JIAN BING

Valerie Soe

When the COVID-19 crisis started, someone in my San Francisco neighborhood began giving away sourdough starter to anyone who wanted it. Since my last batch of starter had accidentally been thrown out a while ago, I quickly claimed a new starter and resumed baking bread. But as anyone who makes sourdough knows, the starter needs constant feeding to replenish and grow, and if you're not baking bread every day, the unused starter accumulates pretty quickly. So when my friend Karen Chow posted on Facebook that she had successfully made green onion pancakes with unfed starter and a little bit of salt and seasoning, I followed suit, also making variations including kimchi pancakes (kimchijeon 김치전). I then remembered a delicious breakfast food that I loved that I'd had in Taiwan called jian bing 煎餅, or egg crepe, and decided to make a sourdough starter version.

Since 2013, I've traveled to Asia several times every year except during the height of the pandemic, and I lived in both Hong Kong and Taiwan for a few months when I was making my film, *Love Boat: Taiwan* (2019). During COVID-19 lockdowns and travel restrictions, making and eating jian bing helped alleviate some of the pain and longing I had from not being able to go overseas during that time. When I was still wondering if we would all get through this to the other side, it reminded me of the time before the pandemic and offered the possibility of visiting Asia again.

Sourdough Starter Jian Bing Recipe

¼-⅓ cup unfed sourdough starter

2-3 tablespoons water

1 egg

1 teaspoon sesame oil

3-4 sheets wonton pei (wrappers)

Vegetable oil

Everything but the Bagel Sesame Seasoning Blend (Trader Joe's) or sesame seeds

Salt

1 green onion, sliced into thin rings

1-2 tablespoons hoisin sauce

A few squirts of sriracha, to taste

1. Mix sourdough starter with water in a small bowl or measuring cup. It should be the consistency of a medium-thin pancake batter.

2. Beat egg with sesame oil.

3. Slice wonton pei into ½-inch strips. Fry in a small amount of oil until crisp and brown, and set aside.

4. Heat 1 tablespoon cooking oil in a 10-inch cast-iron skillet. Add thinned-out sourdough starter, and swirl to cover the pan. It should be about as thin as a crepe, not a pancake.

5. Sprinkle with Everything but the Bagel seasoning or sesame seeds and a bit of salt. Cook over medium-high heat until the starter crepe rises a bit and looks cooked, being careful not to burn it.

6. When the crepe has risen, pour the beaten egg over it, and swirl or spread the egg to cover the entire surface of the crepe. Scatter the green onion on the egg. Let it cook a bit until semifirm but not fully cooked. With a large spatula, flip the crepe-egg combo over so that the egg side is down. Turn off the heat.

7. Spread the crepe side, which is now facing up, with the hoisin sauce and sriracha to taste.

8. Arrange the fried wonton skins on one third of the crepe. Roll up into thirds, egg side out. Slide onto a plate, and cut in half. Eat.

ABOUT THE ARTIST

Valerie Soe (she/her) creates experimental videos, installations, and documentary films, which have won dozens of awards, grants, and commissions and have been exhibited worldwide since 1986. Her feature documentary, *Love Boat: Taiwan*, was released in 2019 and won the Audience Choice Award at the Urban Nomad Film Festival in Taipei, Taiwan, and has played to sold-out festival audiences across North America and in Taiwan. Her experimental short documentary, *Radical Care: The Auntie Sewing Squad* (2020), won a Director's Choice Award at the 2021 Thomas Edison Film Festival and the 2021 Best of Bernal award at Bernal Heights Outdoor Cinema. Her writing has been published in books and journals including *Countervisions: Asian American Film Criticism*, *The Palgrave Handbook of Asian Cinema*, *Amerasia Journal*, and *Asian Cinema*, among others. Soe is the author of the blog *Beyondasiaphilia* (recipient of a 2011 Art Writers Grant from Creative Capital / the Andy Warhol Foundation), which looks at Asian and Asian American art, film, culture, and activism. She is professor of Asian American studies at San Francisco State University. https://beyondasiaphilia.com/

Promotional image for Valerie Soe, *Love Boat: Taiwan*, 2019. Image courtesy of Valerie Soe.

Love Boat: Taiwan looks at the allure of the Taiwan Love Boat, one of the longest-running summer programs in the world, where college-aged Taiwanese Americans get closer to their history, their culture, and each other.

Throughout its history the Love Boat has served as a political tool for Taiwan's government, as a means for Taiwanese American parents to ensure the preservation of Taiwanese bloodlines, and as a site for romance for young Taiwanese Americans, reflecting Taiwan's history as well as the history of the Taiwanese American community.

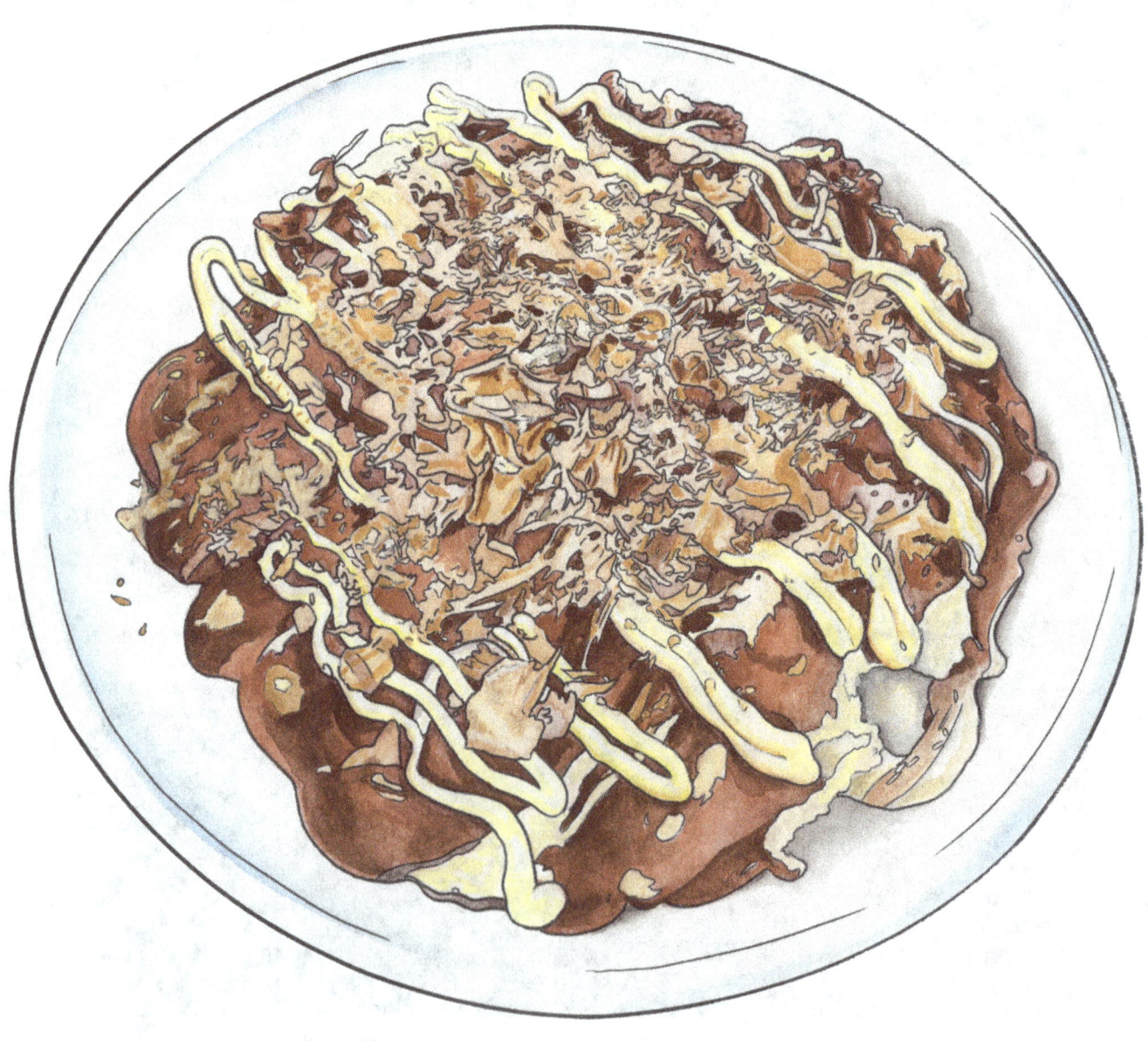

Jave Yoshimoto, *Taro Takizawa's Okonomiyaki*, 2021, ink, watercolor and gouache on paper, 9 × 12 in. *Image courtesy of Jave Yoshimoto.*

OKONOMIYAKI

Taro Takizawa

Okonomiyaki is a savory pancake with a variety of ingredients and often available as street food in Japan. There are a few different styles from different regions. Two popular styles are Osaka style and Hiroshima style. I personally grew up eating Osaka style, but my Okonomiyaki has turned into a kind of hybrid. This is one of my favorite comfort foods from home. It's easy to make at home and also a great street food I can get at summer festivals while I'm in Japan.

After experiencing Hiroshima-style okonomiyaki, I made a small change in my recipe. While Osaka-style okonomiyaki mostly has all the ingredients mixed in the batter, Hiroshima style is in separate layers, with the pancake resembling a tortilla with shredded cabbage, fried egg, fried noodles, and meat. It's a great comfort food. Invite some friends over, and enjoy it with beer.

This dish grew on me after I left my home country. Okonomiyaki became an item on my "repeating menu" of Japanese dishes I cook at home. There have been a lot of tough times in my life, but cooking is one of the few things that's been consistent. The preparation, which has an aspect of performing, is part of my daily routine that brings order to my life. It is comforting, and I began to find more joy in cooking during quarantine life. When it was time to cook, I could stop either working or trying to find tasks to do and go to the kitchen and cook something good.

Okonomiyaki Recipe

Sliced pork belly (I used squid for mine; shrimp goes well with this as well)

Salt

A pinch of black pepper

5 ounces water

1 teaspoon Hondashi

2 eggs

Nagaimo or yamaimo, about a 3-inch piece, grated

5.3 grams chijimi powder (or all-purpose flour)

¼ head cabbage, shredded (diced if you like more crunch)

1 scallion, chopped

Vegetable oil

Katsuobushi (bonito flakes)

Dried seaweed flakes

Okonomiyaki sauce

Japanese mayonnaise

1. Cut the pork belly slices in half (into a small enough size to make it easier to eat). Salt and pepper lightly.

2. Mix water and Hondashi in a bowl, and add 1 egg, then nagaimo or yamaimo, and mix well. Slowly add the chijimi powder to make the batter, then add cabbage and scallion.

3. Add vegetable oil to a frying pan or skillet with a lid, drop in 1 egg, and pour 1 serving of the mixed batter into a pancake shape. Lay a few pork belly slices on top, and cook on medium heat.

4. Flip the pancake after one side is cooked. Put the cover on the pan, turn the heat to low, and cook it for another few minutes to make sure it is cooked. Do the same for the rest of the pancakes.

5. Serve each pancake on a plate with okonomiyaki sauce, Japanese mayonnaise, katsuobushi, and some dried seaweed flakes.

Serves 3-4.

ERIC BURKE

ABOUT THE ARTIST

Taro Takizawa (he/him) is an artist who focuses on printmaking, wall vinyl installations, drawings, and 2-D designs. Born in Japan and currently residing in the US, he makes images connecting what he has experienced in Japan, where he grew up, and what he has experienced in the US since he moved here in 2002. His works contain both Western and Eastern aesthetics with appreciation of traditional printmaking processes and mark making. He is fascinated with blending the boundaries of contemporary studio practice and traditional processes, printmaking, and installations and is influenced by traditional Japanese patterns from textile designs, architecture, and crafts.

He received his BFA with an emphasis in printmaking from Central Michigan University in 2011 and his MFA in printmaking from Syracuse University's College of Visual and Performing Arts in 2017. Takizawa has exhibited nationally and internationally at venues such as the Fowler-Kellogg Art Center in Chautauqua, NY; Paradox European Fine Art forum and its exhibition at CK Zamek in Poznan, Poland; *ArtPrize 10* at Grand Rapids Art Museum in Grand Rapids, MI; LUX Center for the Arts in Lincoln, NE; Ty Pawb in Wrexham, Wales; and the China Printmaking Museum in Shenzhen, China. And he recently attended artist residencies at the Saltonstall Foundation for the Arts in Ithaca, NY; Morgan Conservatory in Cleveland, OH; GoggleWorks Center for the Arts in Reading, PA; and Lawrence Arts Center in Lawrence, KS. Takizawa is an assistant professor of art at University of North Carolina Wilmington. https://cargocollective.com/tarotakizawa

Taro Takizawa, *Ikasumi Pasta*, 2019. Stone lithograph, 16 × 11 in. *Image courtesy of Taro Takizawa.*

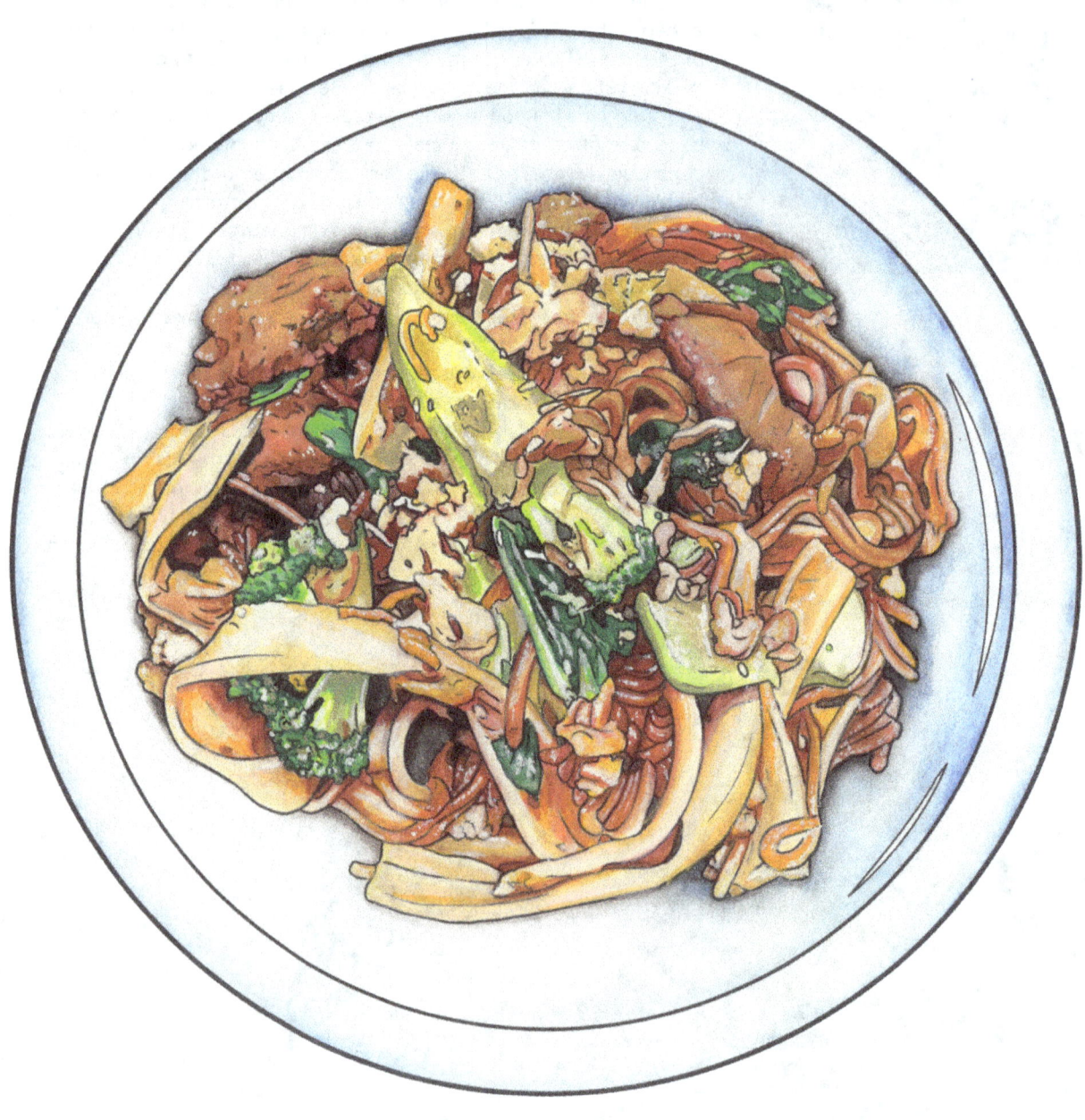

Jave Yoshimoto, *Heinrich Toh's Beef Chow Fun*, 2021. Ink, watercolor, and gouache on paper, 9 × 12 in. *Image courtesy of Jave Yoshimoto.*

BEEF CHOW FUN (FRIED RICE NOODLES)

Heinrich Toh

With the vast variety of Asian dishes that I actually do cook, this Beef Chow Fun has to be one of my favorite comfort foods. It is probably one of the most popular Asian noodle dishes—with different variations based on your cultural background—in Southeast Asia.

This is a fairly easy dish to put together. Vegetables or meat can easily be substituted depending on what is available. This is my modified version of a classic dish that never fails to remind me of home. It's definitely a dish that I would serve while hosting dinner parties, with its different levels of sweet and salty flavors. This was one of the dishes I made during a dinner party I hosted where I first met Jave Yoshimoto.

Beef Chow Fun (Fried Rice Noodles) Recipe

⅔ pound sliced beef, sirloin

32-ounce bag of fresh rice noodles (found in the refrigerated section of most Asian grocery stores)

2 tablespoons vegetable oil

1 tablespoon garlic, chopped

1 pound broccoli, chopped bite size

1 pound choy sum, sliced to about 3-inch strips

1 onion, sliced

4 green onions, sliced, plus extra for garnish

1 tablespoon peanut oil

FOR THE MARINADE

2 tablespoons Chinese cooking wine

1 tablespoon low-sodium light soy sauce

2 tablespoons oyster or mushroom sauce

½ teaspoon salt

½ teaspoon pepper

2 teaspoons cornstarch

FOR THE SAUCE FOR NOODLES

1 tablespoon low-sodium light soy sauce

2 tablespoons dark soy sauce

2 tablespoons oyster sauce

2 tablespoons sweet soy sauce

1 teaspoon fish sauce

1 teaspoon sriracha

1. Marinate slices of beef with the marinade in a mixing bowl, and set aside for at least 15 minutes.

2. Place rice noodles in pot of boiling water, separating the noodles so they cook evenly. Boil for about 7 minutes, or until al dente, being careful not to overcook them. Rinse in cold water, drain, and set aside.

3. In a wok or large nonstick skillet, fry garlic in 1 tablespoon of vegetable oil over medium heat until fragrant. Add the marinated beef and the vegetables, and stir-fry for about a minute. Remove, and set aside.

4. Heat 1 tablespoon of vegetable and 1 tablespoon of peanut oil over medium to high heat. Add noodles, frying them for a minute before adding the sauce. Toss until noodles are evenly covered and seared.

5. Return the beef and vegetables to noodles, and fry for another 2 minutes, adding green onions before serving.

Serves 4.

Cook time: 40 minutes.

ABOUT THE ARTIST

Heinrich Toh (he/him) is a studio artist and educator based in Kansas City, Missouri. Born and raised in Singapore, he is a graduate of the Cleveland Institute of Art and the LASALLE College of the Arts in Singapore. Toh has exhibited extensively for the past twenty years, at venues such as the Nelson-Atkins Museum of Art, the Albrecht-Kemper Museum of Art, the Wing Luke Museum, and the Bellevue Art Museum. His work is featured in public and private collections, including the collections of the Nelson-Atkins Museum of Art, the Albrecht-Kemper Museum of Art, American Century Investments, University Health Truman Medical Center, the Loews Kansas City Convention Center Hotel, University Hospitals of Cleveland, and Dell Children's Medical Center.

Toh's work investigates ideas of longing, past and present memories, personal history, layered cultural identities, and the definition of home. When not making art, he loves spending time in the kitchen creating culinary bedlam. http://www.heinrichtoh.com/

Heinrich Toh, *Dawning Wonder #7*, 2020. Monoprint, paper lithography on Rives BFK paper, 30 × 30 in. *Image courtesy of Heinrich Toh.*

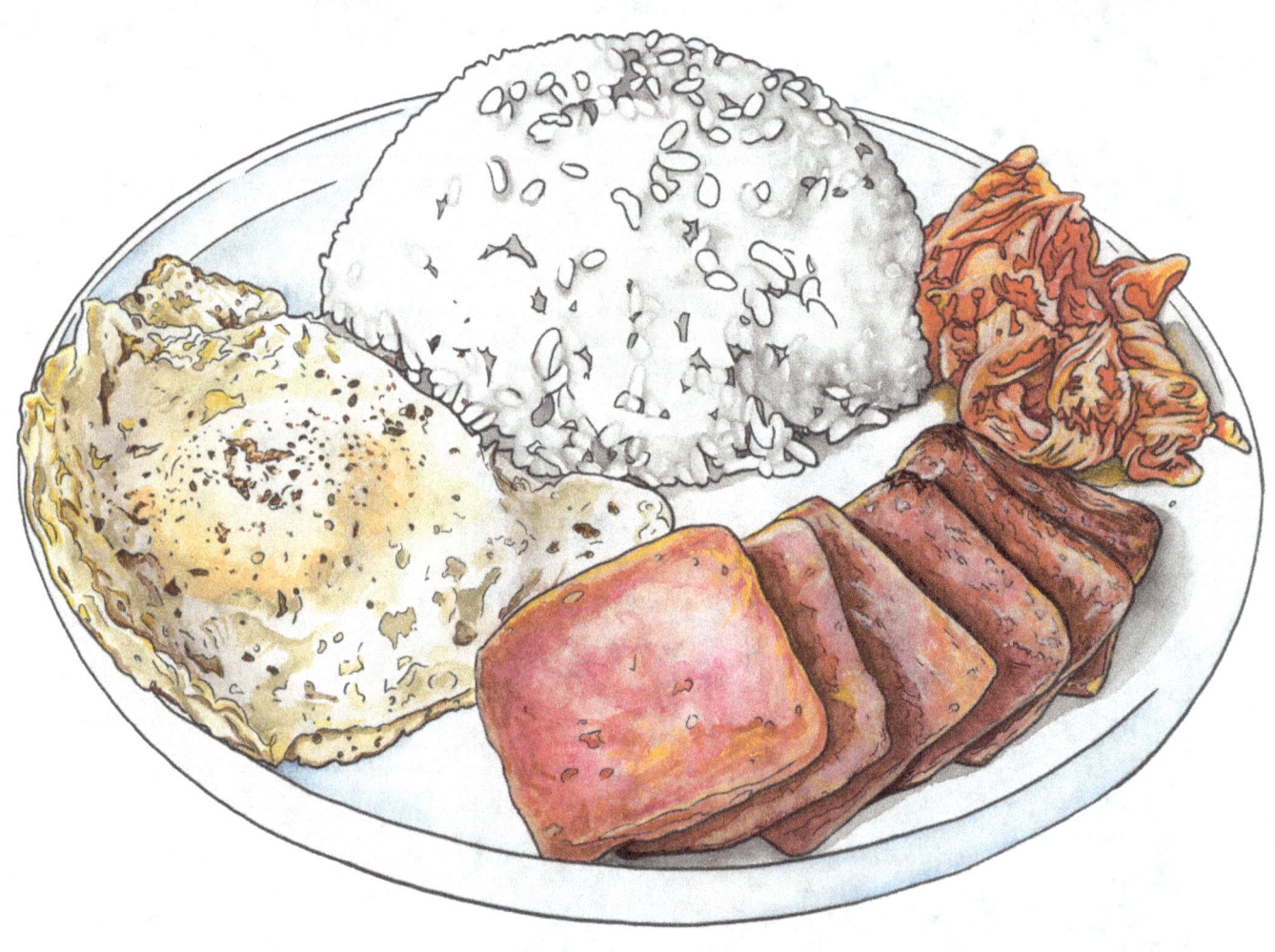

Jave Yoshimoto, *Mathew Tom's SPAM and Eggs*, 2021. Ink, watercolor, and gouache on paper, 9 × 12 in. *Image courtesy of Jave Yoshimoto.*

SPAM AND EGGS

Mathew Tom

My ex-girlfriend is from South Korea, and she cooked this dish for breakfast every day. Even though we are no longer together, this dish has stuck with me over the years and is a staple of my mornings. I like how it is both very American and very Asian. It is a simple but satisfying breakfast.

SPAM and Eggs Recipe

¼ can of SPAM

1 egg

1 cup of cooked white rice

¼ cup of kimchi

1. Cut the SPAM into smaller squares, then fry in a pan until crispy on both sides.

2. Using the excess oil from the SPAM, fry the egg.

3. Serve with white rice and kimchi.

ABOUT THE ARTIST

Mathew Tom (he/him) is a Chinese American painter based in Brooklyn, New York. He holds an MFA from Goldsmiths, University of London, and has also studied at the School of the Art Institute of Chicago. Tom has been the recipient of several prestigious fellowships and residencies, including the Starr Fellowship from the Royal Academy in London.

His work has garnered international recognition, with exhibitions in the United States, England, Wales, Spain, the Netherlands, Denmark, South Korea, Taiwan, and India. https://www.mathewtom.com/

Mathew Tom, *Looking for Love*, 2019. Oil on linen, 48 × 60 in. *Image courtesy of Mathew Tom.*

Jave Yoshimoto, *Lien's Fried Banana Cake*, 2021. Ink, watercolor, and gouache on paper, 9 × 12 in. Note: This is an illustration of a single cake layer. The recipe is for a three-layer cake. *Image courtesy of Jave Yoshimoto.*

LIEN'S FRIED BANANA CAKE

Lien Truong

In 1995 my family and I took a trip to Vietnam to visit family and friends, the first time since we had left in 1975. The visit was memorable and endearing, full of celebration, reunion, and the most *amazing food*. One relative I met during that trip was taking baking classes and brought home a banana cake. The bánh chuối nướng had an intense banana flavor, with chewy texture more like a bread pudding. At the time I was in college and working at an organic bakery named the Flour Garden in Eureka, California. The bakery owners, Kevin and Ellen, had a love for making exquisite, high-quality baked goods from locally harvested ingredients. They gave me a copy of Rose Levy Beranbaum's *The Cake Bible*. I set myself the task of bringing the fried banana flavor of Southeast Asia into a frosted layer cake. This cake is somewhat high maintenance but combines the intense fried banana flavor with a delicate cake crumb, using an adaptation of Beranbaum's reverse cream method and frying the bananas on both sides to give the cake a rich banana caramel flavor.

Lien's Fried Banana Cake Recipe

I use a scale and measure out almost everything in grams. It provides much better consistency!

1 cup / 8 ounces softened butter, at room temperature, plus extra for greasing the pans

1 cup / 240 grams buttermilk, at room temperature

3 large eggs, at room temperature

½ cup / 112 grams safflower or canola oil

2 teaspoons vanilla

3 cups / 342 grams cake flour

1⅓ cup / 255 grams sugar

2 teaspoons baking powder

1½ teaspoons baking soda

1 teaspoon salt

FOR THE FRIED BANANA PUREE

¼ cup high-heat oil (such as safflower)

10 overripe bananas

Tip: *Mixture after frying should be about 450–550 grams total.*

FOR THE FROSTING

1 pound / 454 grams full-fat cream cheese, at room temperature

2 sticks (8 ounces / 227 grams) unsalted butter, at room temperature

½ teaspoon fine sea, kosher, or Himalayan salt

3½ / 454 grams sifted powdered sugar

2 teaspoons vanilla extract

1. Preheat oven to 335°F.

2. Butter the bottom and sides of three 8-inch round cake pans. Line the bottoms with parchment.

3. Set out butter, eggs, and buttermilk to let them reach room temperature.

4. Place ¼ cup high-heat oil in a large stainless-steel or cast-iron skillet over medium heat. Unpeel bananas, and place them whole in sizzling oil. Fry bananas on one side until it becomes a deep, dark caramel brown but not burnt, then turn with a spatula, scraping up any caramelized bits. Do the same on the other sides. It takes about 15 minutes on each side for me to do this, about 30 minutes total, adding a bit more oil if necessary. Remove from heat, scraping up all the browned bits and piling them on top of bananas, and let cool.

5. When fried bananas are cool, place everything that's in the skillet in food processor (bananas, residual oil, and all the gooey caramelized brown parts), and puree. Measure out 1½ cups (345 grams), and set the extra aside to add to frosting. I always fry 10 bananas as I love the added flavor in the frosting. Place the 1½ cups of fried banana puree back in food processor, add sour cream and oil, and puree together. Set this aside.

6. In a separate bowl, whisk together buttermilk, eggs, and vanilla. Set aside.

7. In mixer bowl, add flour, sugar, baking soda, baking powder, and salt. Whisk several times to incorporate dry ingredients together. Add softened butter in pats, then using paddle attachment, mix until first batter resembles coarse sand, then ingredients come together. Add the fried banana, oil, and sour cream mixture, and mix on low for a few seconds to incorporate. Then beat for 2 minutes on medium (setting 4 on a KitchenAid mixer), scraping the bottom of the bowl once in midway through. Stop mixer, scrape bottom and sides of the bowl, then with the mixer running on low, slowly pour in the buttermilk, eggs, and vanilla mixture, stopping to scrape bowl one more time halfway through. Mix till just combined.

8. Pour batter evenly between the three pans. Tap pans lightly on counter to even out batter and get rid of air bubbles. Bake about 35 minutes, can be a little more or a little less depending on oven. A toothpick inserted in the middle should come out clean, and the center should be springy to the touch. Cool on rack. After 10 minutes, invert on wire rack, and cool completely. This cake has a very delicate crumb, so if needed, you can wrap the layers in plastic and freeze for 30 minutes before frosting. I skip that step.

9. To make frosting, beat cream cheese, butter, and salt at medium-high speed until uniformly smooth, scraping as needed. Add powdered sugar. Cover the edges of the mixer bowl with a kitchen towel or with a bowl shield, and beat on very low, pulsing if needed, to incorporate powdered sugar while avoiding sugar plumes, then beat on medium high until thick and creamy, scraping the bowl 1–2 times as needed. Beat in vanilla. Beat in all the extra fried banana puree.

10. Frost cake! Everyone likes a different amount of frosting, and I love a good amount of this one. Spread frosting in between layers, then create a crumb coat on the sides and top, chilling cake for about 20–30 minutes after this to harden frosting. Then frost completely. If you have extra frosting, you can store in airtight freezer container for 2–3 months.

ABOUT THE ARTIST

Lien Truong (she/her) examines cultural and material ideologies and notions of heritage in her art practice. Her work blends painting techniques, materials, philosophies, and military, textile, food, and art histories, forming a hybrid, diasporic language interrogating the relationship between aesthetics and doctrine. Her paintings have been presented at the National Portrait Gallery, Nasher Museum of Art, North Carolina Museum of Art, Station Museum of Contemporary Art, Weatherspoon Art Museum, Oakland Museum of California, Art Hong Kong, S.E.A. Focus in Singapore, and Southern Exposure. Truong is the recipient of a Joan Mitchell Foundation Painters and Sculptors Grant, a Jack K. and Gertrude Murphy Fine Arts Fellowship, fellowships from the Institute of the Arts and Humanities and the North Carolina Arts Council, and residencies at the Oakland Museum of California, Jentel Foundation, and Marble House Project. https://www.lientruong.com/

VERO KHERIAN

Lien Truong, *The Passage through Sea, Cloth and Bone*, 2020. Diptych; oil, acrylic, silk, and gold pigment on canvas, 84 × 72 in. *Photo by Peter Paul Geoffrion. Image courtesy of Lien Truong.*

Laura Kina, *Francis Wong's Szechuan Spicy Alligator*, 2023. Watercolor and pen on paper, 9 × 12 in. *Image courtesy of Laura Kina.*

SZECHUAN SPICY ALLIGATOR

Francis Wong

I grew up in Mandeville, Louisiana—a white-flight suburb across a lake and a twenty-four-mile bridge from New Orleans. My mom's family fled the Cultural Revolution in the 1960s and immigrated from Canton (now Guangzhou) to Hong Kong and then Oakland, California, where she eventually met my dad.

When my dad, Frank Wong, was ten years old, he immigrated to the United States from Hong Kong with his mother and four brothers after his father had passed away. His grandfather co-owned a Chinese restaurant in Amarillo, Texas, on Route 66, and they settled there first. Growing up in Texas, my dad learned about early Chinese American cooking and then traveled to different relatives' restaurants in Kansas, Oakland, and other areas to learn more. My grandmother told the brothers to always stick together. She used the metaphor that if you have one chopstick, you can break it; if you have five together, they are much stronger—like a fist.

When my dad's older brother got a job in New Orleans as a bellboy, the other brothers followed. They also had cousins from the same village who had restaurants in Baton Rouge, Louisiana. My dad moved to Baton Rouge and worked in different Chinese restaurants in Baton Rouge and New Orleans.

In 1971, when my dad was only twenty-one, he opened China Inn in Hammond, Louisiana. In 1980, his family opened the award-winning Trey Yuen in Mandeville. My dad came up with most of the recipes and the decor for Trey Yuen, which was built to look like a palace, with imported rosewood ceilings, real antiques, and mother-of-pearl-inlaid dining chairs. The restaurant is surrounded by a Chinese garden with pagodas, waterfalls, and koi ponds.

Both China Inn and Trey Yuen featured a mix of Cantonese, Szechuan, Hong Kong, Hunan, Chinese American, and regional cuisine. Whenever possible, they used fresh local seafood and other ingredients such as crawfish, drum (fish), catfish, soft-shell crab, and alligator. Trey Yuen became the first restaurant in the state to serve alligator after it became legal to do so. They have a steady supply year round from the Kliebert & Sons alligator farm in Ponchatoula, Louisiana. I am one of fourteen children in the Wong restaurant dynasty. I grew up busing tables, packing to-go orders, being a runner, dishwashing, doing some cooking, and eventually working as a waiter, bartender, and mock manager. I'm making art and music when I can along with any creative jobs that come my way. I've seen my dad host many dinners in the VIP room at Trey Yuen, and he always let the guests try an alligator dish. He describes alligator as a mix between pork and chicken. Of late, I see my nieces and nephews running around the restaurant as I once did with my siblings and cousins.

Szechuan Spicy Alligator Recipe

½ pound alligator meat

½ cup celery, chopped

½ cup carrot, sliced into thin julienne

½ cup onion, sliced into thin julienne

2 green onions, cut into 2-inch slices

8 tablespoons vegetable oil

3 dried cherry peppers

½ teaspoon garlic, chopped

2 tablespoons soy sauce

2 tablespoons sugar

1 tablespoon white vinegar

1 tablespoon sherry

1 teaspoon sesame oil

½ teaspoon salt

½ teaspoon crushed Szechuan peppercorn

FOR THE MARINADE

½ egg white

1 tablespoon soy sauce

1 tablespoon vegetable oil

1 teaspoon cornstarch

1. Slice alligator ⅛ inch thick, removing fat and gristle. Combine marinade ingredients, and marinate alligator for 20 minutes. Cut all vegetables as specified above.

2. Heat wok or heavy skillet until very hot, adding 5 tablespoons of oil and heating for 30 seconds.

3. Add alligator. Stir-fry to separate, cooking until 70 percent done.

4. Remove meat from pan, and drain oil.

5. Reheat pan with 3 tablespoons of oil in it. Break cherry peppers in half, and drop them into the oil. Cook until it turns brown. Add garlic; then add vegetables.

6. Stir-fry for 2 more minutes.

7. Add alligator back into wok.

8. Add sherry, vinegar, soy sauce, salt, peppercorn, sugar, and sesame oil, and stir for 30 seconds.

9. Remove to serving platter.

ABOUT THE ARTIST

Francis Wong (he/him) grew up in the New Orleans area and escaped into art from a young age. He attended the New Orleans Center for Creative Arts and the University of New Orleans, where he studied fine art and film. Hurricane Katrina interrupted his college education but educated him on so much more in life. His work is influenced by the carnival spirit in New Orleans and the toxic yet beautiful landscape of southeastern Louisiana. Water is reoccurring theme in Wong's work as both subject and material and through his process of rain painting. Across his mixed media paintings, music, and videos, he uses art to help heal ancestral trauma and PTSD and to live out his ancestors' wildest dreams. His work is a unique hybrid of his Chinese heritage and his southern American upbringing. Francis has exhibited his art across Louisiana, including at the New Orleans Museum of Art and Contemporary Art Center, New Orleans, as well as in New York and Oakland. Instagram: @downtimefrancis

Francis Wong, *The Chariot (inner landscape)*, 2020. Acrylic, gouache, and water from Lake Pontchartrain on canvas, 24 × 48 in. *Image courtesy of Francis Wong.*

UNCLE VAN HUYNH MASK

- ——— CUT LINE
- – – – SEW LINE
- ——— FOLD LINE
- – – – TOPSTITCH
- ✕ ELASTIC or TIES ATTACH HERE

PRINT ACTUAL SIZE
0 ½ 1 INCH

M SIZE

UNCLE VAN HUYNH MASK

CUT WITH RIGHT SIDES TOGETHER
FRONT – CUT 2
LINING – CUT 2 ON GREEN LINE

CUT LINING PIECES ON THIS LINE

1. With right sides together, sew FRONT pieces together along center curved edge (1/4" seam). Repeat for LINING pieces.

2. Finish ends of FRONT and LINING with 1/4" rolled hem. (Fold where indicated and stitch in place.) Topstitch center seams to keep flat.

3. With right sides together, match centers and edges. Sew FRONT to LINING (1/4" seam) along top and bottom. Leave sides open.

4. Turn right side out. Attach elastic or ties at ends. Optional: Topstitch 3/8" from top edge (as shown) to form sleeve for nose bridge insert.

The Auntie Sewing Squad, *Uncle Van Huynh Mask*, 2020. Pattern layout by Chey Townsend, 11 × 8.5 in. *Image courtesy of Kristina Wong.*

RECIPE FOR POLITICAL ACTION
The Auntie Sewing Squad

Kristina Wong

While everyone else was working on their sourdough starters during the pandemic, I was screaming at people to feed me. This is why I don't have some innovative comfort recipe to contribute to this recipe book.

I am the "factory overlord" of the Auntie Sewing Squad, a national volunteer group of hundreds of mostly women-of-color mask makers who literally ran a shadow federal aid agency to put PPE on essential workers and very vulnerable communities. Our aunties are college professors, award-winning filmmakers, executive directors of nonprofit organizations, healthcare workers, scientists, and award-winning artists like me.

Forget images of the quaint, meditative seamstress at her machine. Running an amateur medical supply company in the absence of any government leadership turned me into Jack from *Lord of the Flies*. Being avalanched by unending mask requests, onboarding new sewing aunties every hour, making death-defying post office visits, and trying to find quarter-inch braided elastic during a lockdown created such a mental tsunami that I didn't notice my period leaking through my pants for two days.

I screamed for help online: "If you can sew or cut, step up. If not, feed the ones who are." It wasn't that the aunties were food insecure. We just needed to know that while the rest of the world was baking sourdough bread and watching Netflix, we exhausted soldiers stopping genocide from our home sewing machines weren't being taken for granted.

If there was ever a complicated scheme to extort pizza and baked goods from non-sewing friends, this was it. Caring aunties and uncles sent us care and food offerings to fuel us for the sewing of three hundred and fifty thousand masks. The labor of sewing became our currency, hard-to-find fabric and elastic more valuable than the cash that bought it.

Three months into the pandemic, factory-made masks had surfaced across the market, but there was still a need to sew masks for First Nations, day laborers, farmworkers, peaceful Black Lives Matter protestors, the incarcerated, and very poor communities of color. Our masks were smuggled across the border into Mexico to migrants seeking asylum. Some went as far north as Six Nations, which is an Iroquois Confederacy reserve in Ontario, Canada. The Auntie Sewing Squad grew to include a college class, a kids' summer camp, multiple relief vans, seamstresses of the Navajo and Hopi peoples, a book, and most importantly, hundreds of new friendships grounded in a heart-to-heart connection we made with one another in the most fraught time in history.

We are contributing a pattern designed by Van Huynh, named after him by all the aunties. We had learned that a free pattern we had been using from FreeSewing.org named the "Fu Facemask" had actually been given its name as a racist honorific by the Belgian patternmaker who designed it, who had literally Googled "Asian names that start with F" to name this pattern to honor "Asians for being the first to wear masks."

Van Huynh is an incredible human with a remarkable life story who also is a tailor who modified the racist-named pattern. He had been sewing with his mother, a garment worker, while also working with his lawyers on getting a pardon—all during quarantine. Because Van is an actual incredible human, not a Googled Asian sound, we named this mask after him. We now refer to all two-piece-per-layer masks as "UVH" or "Uncle Van Huynh masks."

Van Huynh (he/him) was born on a small island in South Vietnam. At four years old, Van Huynh escaped with his mom and sisters to Japan, Florida, San Francisco, and all over Southern California. He continued to search for acceptance, for self, for home, and for purpose. Huynh was given a multiple-life sentence at age sixteen. He was practically condemned to take his last breath in prison, but twenty-five years later, he is out. It's not quite freedom, because he is waiting to be deported to Vietnam while on federal supervision and state parole. Social justice workers broke that cycle of hate, vengeance, aggression, and violence for him with love and kindness—turning that death sentence into an opportunity to heal our communities. He found his purpose by knowing and accepting himself, his *truth*. The Auntie Sewing Squad found and accepted him, and together they are searching for and finding ways to spread love through *action*.

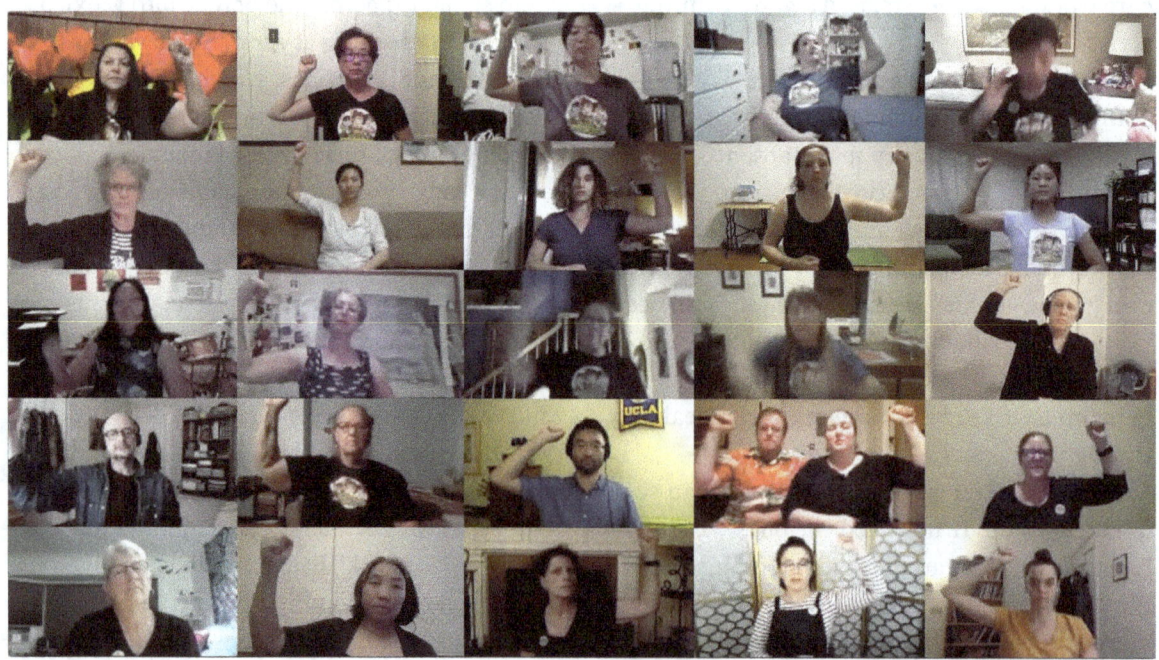

Still from Valerie Soe, dir., *Radical Care: The Auntie Sewing Squad*, 2020. Image courtesy of Valerie Soe.

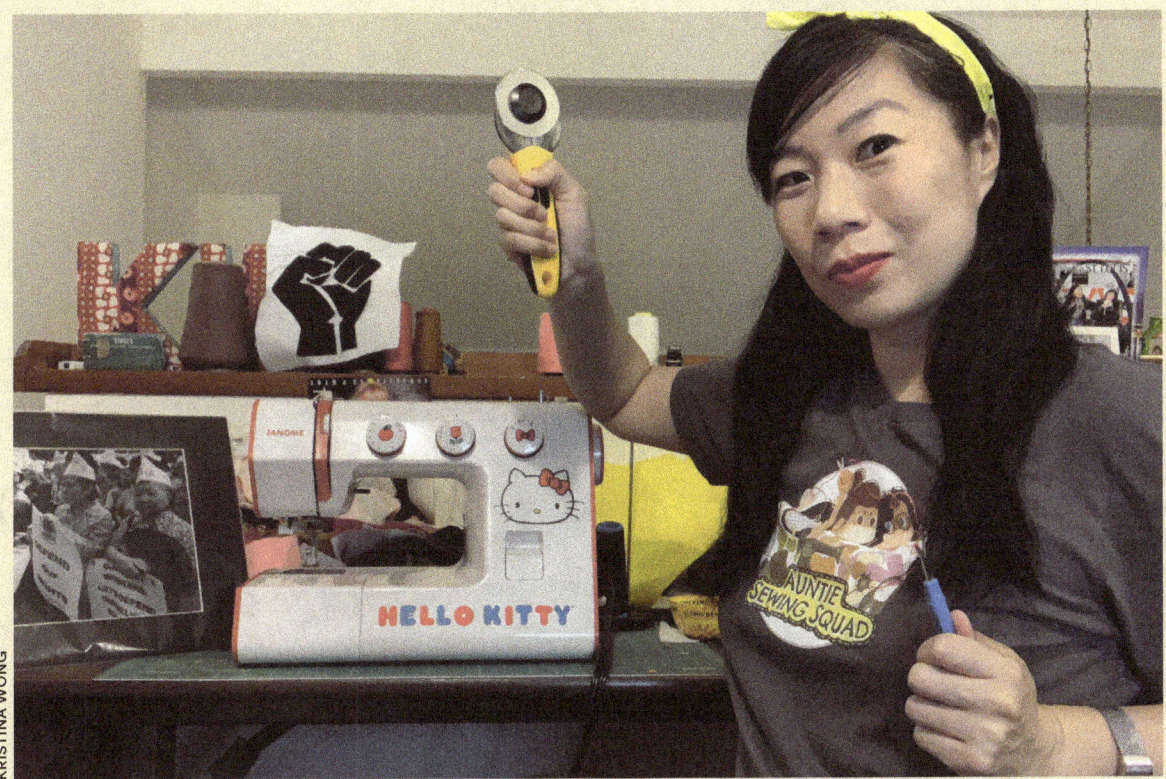

KRISTINA WONG

ABOUT THE ARTISTS

Auntie Sewing Squad was a national network of eight hundred-plus aunties of all genders who turned our living rooms into "sweatshops" because of the failure of the federal government to provide proper PPE to essential workers and vulnerable communities. Started by performance artist Kristina Wong on March 24, 2020, as a temporary stopgap to sew cloth face masks during the COVID-19 pandemic, the Auntie Sewing Squad ballooned into a shadow FEMA, active for 504 days until its retirement in August 2021. The Squad's work has expanded to include relief vans to the Navajo Nation and asylum seekers. While it no longer sews masks, it still sends other forms of care to the communities it partnered with at the height of the pandemic—First Nations, undocumented immigrants, day laborers, poor communities of color, and migrants seeking asylum at the border. In 2021, the University of California Press published *The Auntie Sewing Squad Guide to Mask Making, Radical Care, and Racial Justice*.

Kristina Wong (she/her) is a Doris Duke Artist Award winner, a Guggenheim Fellow, and a Pulitzer Prize Finalist in Drama. She's a performance artist, comedian, actor, and writer who has been presented internationally across North America, the UK, Hong Kong, and Africa. She's been a guest on late-night shows on NBC, Comedy Central, and FX. Her role in starting the Auntie Sewing Squad is the subject of *Kristina Wong, Sweatshop Overlord*—a *New York Times* Critic's Pick that premiered off Broadway at New York Theatre Workshop. The show won the Drama Desk and Outer Critics Circle awards for outstanding solo performance and the Lucille Lortel Award for Outstanding Solo Show. Among her many community theater collaborations, she is most proud of having directed *From Number to Name*, quite possibly the only digital theater piece ever to address the impact of incarceration in Asian American communities, created with the formerly incarcerated members of API RISE. https://www.kristinawong.com/

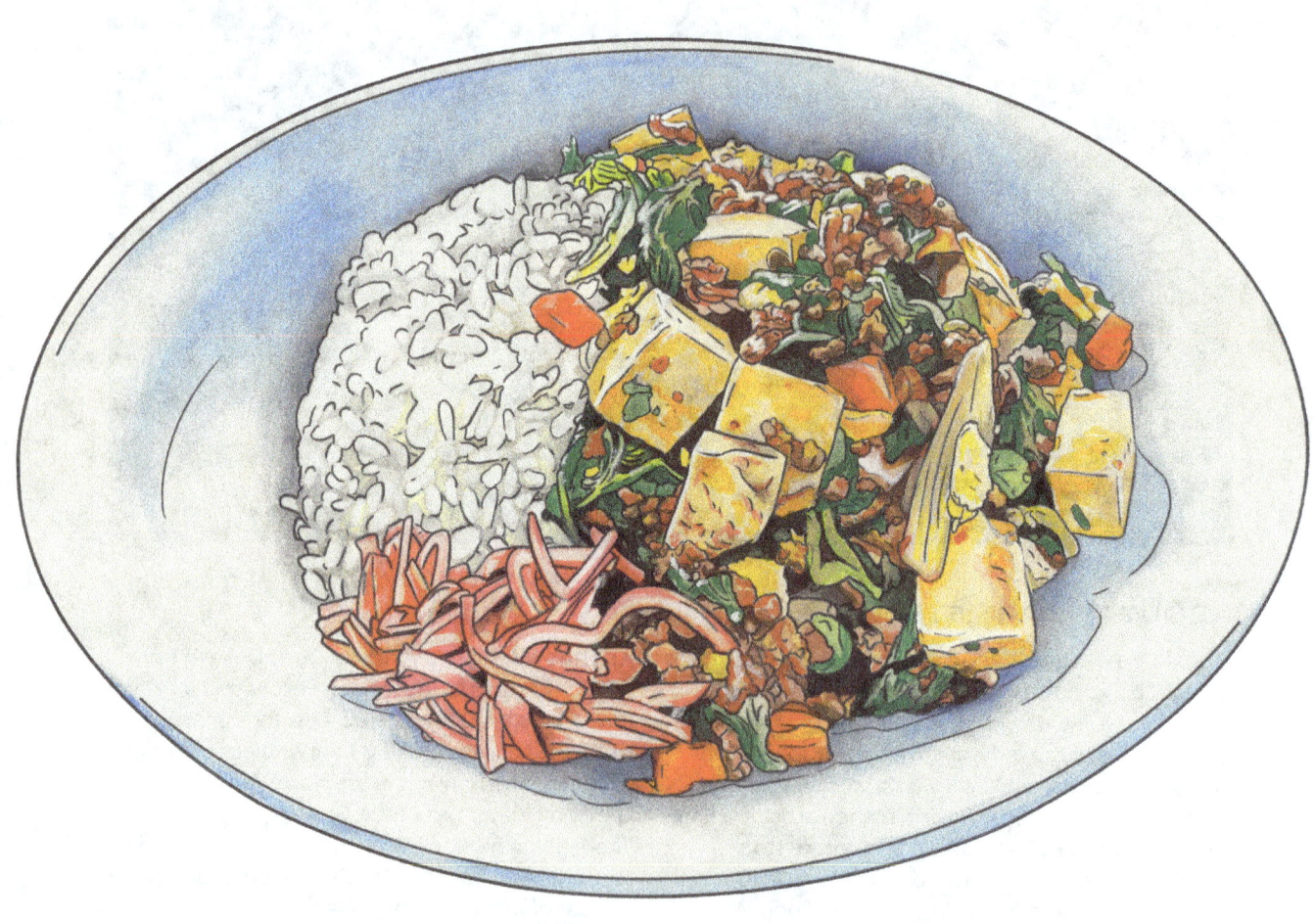

Jave Yoshimoto, *Jave Yoshimoto's Mapo Tofu*, 2021. Ink, watercolor, and gouache on paper, 9 × 12 in. *Image courtesy of Jave Yoshimoto.*

JAVE'S OMEGA MAPO TOFU AND KIMCHI FRIED RICE FLAVOR EXPLOSION

Jave Yoshimoto

My love for mapo tofu originated in Japan, where the flavor is considerably milder than the Szechuan version of the same dish to cater to the taste buds of the Japanese food lovers. Having grown up there for the first nine years of my life, I came to be fond of this particular dish, and when I immigrated to the US, I kept searching for the same flavor and recipe by trying out the dish in various Chinese restaurants across the country.

What I found was that I liked little things that were done differently in each restaurant. Some restaurants only had the meat and the tofu. Others added onions or scallions, while another place added peas and carrots. I came across one restaurant in Chicago that added mushrooms, which I truly enjoyed. As I learned to make this dish for myself, I decided to add every ingredient that I'd come to enjoy and threw in my own mix of vegetables, such as spinach and bean sprouts. In the end, my mix of ingredients and sauces is something I still make to this day and share with my friends and dear ones. I'm fairly proud to say that this is my studio assistant's favorite dish, which she requests I make quite often.

Jave's Mapo Tofu Recipe

1 tablespoon vegetable oil

1 yellow onion, sliced

1 tablespoon garlic, minced

1 pound ground meat of choice (traditionally pork, but any ground meat will work)

1 cup frozen peas and carrots mixed vegetables

6 ounces (or ¾ cup) frozen spinach

⅔ cup shiitake mushrooms, sliced

2 large handfuls (or 1½ cup) bean sprouts

1 cup French-style green beans

3 ounces (or ⅓ cup) spicy bean sauce

1 tablespoon mirin

1 cup water

3 ounces (or ⅓ cup) oyster sauce

1 egg

14-ounce container soft tofu

1 green onion stalk, chopped, for garnish

Ginger, for garnish

1. Heat 1 tablespoon vegetable oil in deep frying pan.
2. Sauté onion with 1 tablespoon garlic until golden brown.
3. Add the ground meat. Stir until cooked.
4. Add the sliced mushrooms, peas and carrots mixture, and spinach. Stir.
5. Simmer for 2 minutes over medium heat.
6. Add green beans and bean sprouts. Stir.
7. Add mirin and spicy bean sauce. Stir, adding ⅓ cup water.
8. Add the oyster sauce. Stir with another ⅔ cup water.
9. Add the egg, cracking it directly into the pan. Stir into the mixture.
10. Simmer on low heat for 2 minutes.
11. Turn off heat. Stir in tofu gently.
12. Garnish with green onions and ginger.

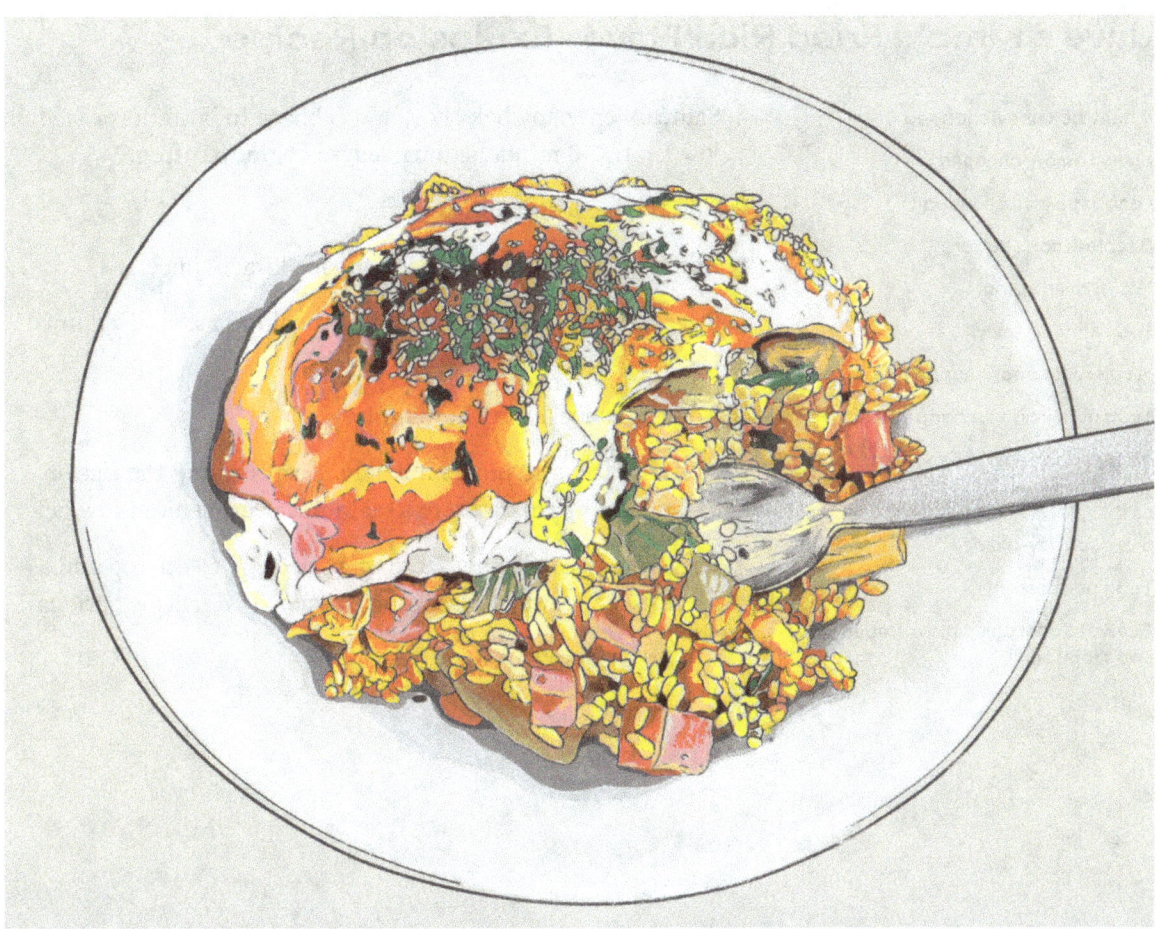

Jave's Kimchi Fried Rice Flavor Explosion

When I was in graduate school, I lived in the Rogers Park neighborhood of Chicago, where there were a couple of small family-owned Korean restaurants nearby that had kimchi fried rice on their menus. I would always walk out of them feeling satisfied and amazed at the meal I'd just had in my mouth. This was a type of comfort food that I would have in the middle of the week on a hot Midwestern summer afternoon. The feeling of joy I experienced then was what I wanted to remember when I started making this recipe.

This is the kind of meal I like having with friends, and it was particularly enjoyed by my studio assistant and friend, Elisa, during the time of the pandemic lockdown. While I would make a large batch, it wouldn't be long before it was all gone. In a time when the world seemed to be falling apart, sharing laughter and stories over a delicious meal was a precious moment to cherish.

Above: Jave Yoshimoto, *Jave's Kimchi Fried Rice Flavor Explosion*, 2023. Gouache and ink on paper, 9 × 12 in. *Image courtesy of Jave Yoshimoto.*

Jave's Kimchi Fried Rice Flavor Explosion Recipe

4 baby bok choy, chopped

1 small onion, chopped

1 cabbage leaf, chopped

3 tablespoons butter

⅔ cup bean sprouts

1 cup kimchi (spicy)

½ cup roast beef, chopped

1 cup mushrooms, chopped

1 tablespoon spicy bean sauce

1 tablespoon soy sauce

4-5 cups day-old rice

1 egg per person

Seaweed seasoning from Trader Joe's (optional)

1. Sauté onion, baby bok choy, and cabbage in butter over medium-low heat, 2–3 minutes, until leaves begin to soften.

2. Add the bean sprouts, and stir.

3. Add kimchi plus about 2 tablespoons kimchi juice.

4. Over medium heat, add meat and mushrooms, stirring until the mushrooms begin to soften.

5. Add the sauces. Stir thoroughly.

6. Add the rice, stirring completely. Keep stirring the rice on and off for approximately 10 minutes over medium-low heat.

7. Serve the fried rice hot, adding a fried egg to the top and a sprinkle of seaweed seasoning to each bowl (this is optional).

JAVE YOSHIMOTO

ABOUT THE ARTIST

Jave Yoshimoto (he/him) is an artist and educator with a multicultural background. He was born in Japan to Chinese parents and immigrated to California at a young age. Yoshimoto has since traveled and lived in various states, which influenced his artistic practice. He believes in creating works that are socially conscious and true to his authentic self.

Yoshimoto received his bachelor of arts from University of California, Santa Barbara, his master of arts in art therapy from the School of the Art Institute of Chicago, and his master of fine arts in painting from Syracuse University.

He is a recipient of the 2015 Joan Mitchell Foundation Painters and Sculptors Grant, which he used to travel to Nepal and Lesvos island in Greece to research the topics of humanitarian crises, survival, and resilience. He has been featured in numerous publications such as the *Huffington Post*, the *Chicago Tribune*, *New American Paintings*, and *Guernica* magazine, among others. He received a letter of recognition from the United Nations and exhibits his works nationally and internationally.

He has been artist in residence at various residencies across the US, including Vermont Studio Center, the Kimmel Harding Nelson Center for the Arts, Jentel, the Tulsa Artist Fellowship, and the Joan Mitchell Foundation, among others. https://www.javeyoshimoto.com/

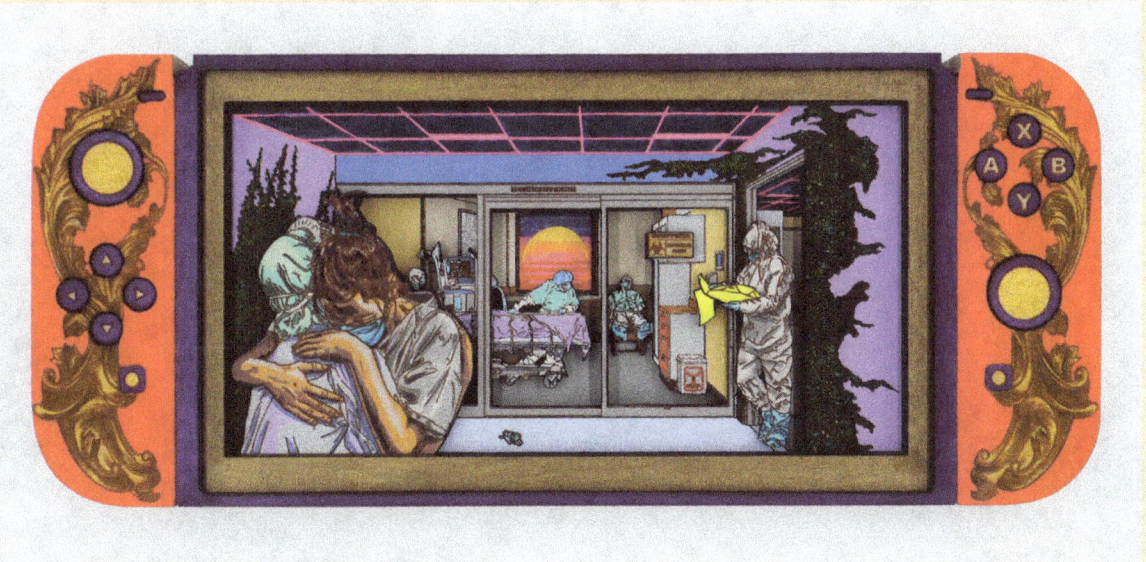

Jave Yoshimoto, *Memento Mori*, 2021. Laser-carved digital illustration and gouache on wood. *Image courtesy of Jave Yoshimoto.*

INDEX

Page numbers in *italics* indicate photographs or illustrations. Page numbers in **bold** indicate recipes.

A

Abhichandani, Jaishri, 39
acting, of Kristina Wong, 129
active art
 of Karimi, 57
 of Sifuentes, 53
adoptee, 95–96
aesthetics
 doctrine and, 121
 post-relational, 24
 relational, 15, 25
 in Takizawa's work, 109
affinity(-ies)
 racial, 27
 shared, 28
 through cooking someone else's recipe, 27
Ali, Anida Yoeu, 37
 background and art of, 37
 Double-Fried Garlic Chicken, 28–29, *34*, **35–36**
 Push / 99 Eggs, 37
Alligator, Szechuan Spicy, **123–24**
alternative relationships, in Kuo's art, 71
Amazon Olympia (Choi), *45*
Anida Yoeu Ali's Double-Fried Garlic Chicken (Kina), *34*
anti-Asian sentiment, during pandemic, 13, 21, 28, 70
appetizers
 Okonomiyaki, *106*, **107–8**
 Pork My Buns XXXX, *98*, **99–100**
 SPAM Musubi, *14*, *15*, **63–65**, *65*
Aram Han Sifuentes's Rabokki (Yoshimoto), *50*

art
 intersection of food and, 23–25
 relational, 25
 See also specific types of art
art-based cookbooks, 23
art history, in Truong's work, 121
Asian American experience, in Larry Lee's art, 75
Asian American Feminist Collective, 13
Asian American(s)
 diverse experiences of, 28
 as homogenized identity, 27–28
 identity of, 27
 during pandemic, 13, 21, 27, 28, 29–30n5
 reclaiming of culinary heritage by, 69–70
Asian American visual culture, Yee's study of, 31
Asian / Asian diasporic art, of Kina, 67
Asian diasporic culture
 online stories and recipes in, 69
 Yee's study of, 31
Asians
 pandemic violence against, 27, 29–30n5
 and yellow peril, 30n12
assimilation
 Davis on, 95
 Elahi on, 47
audiovisual installations, of Chishti, 41
Auntie Nora's Mac Salad, *62*, *63*, *66*
Auntie Nora's Mac Salad (Kina), *62*
Auntie Sewing Squad
 Uncle Van Huynh Mask, *126*, 128
 work of, 127–29
authentic self, in Yoshimoto's work, 135

B

backstories
 of artists, 22–23 (*See also individual artists*)
 of recipes, 15, 28
bananas
 fried, 119
 Lien's Fried Banana Cake, *118*, **119–20**
bao buns
 Pork My Buns XXXX, **99–100**
barbecue
 "I'm a Pepper, You're a Pepper, Wouldn't You Like to Be a Pepper, Too?" Chicago/LA Kalbi Marinade/Serenade, **73–74**
 Pork My Buns XXXX, **99–100**
Baseera Khan's Red October Dal (Kina), *58*
beans, green. *See* green beans
bean sprouts
 Jave's Kimchi Fried Rice Flavor Explosion, **133–34**
 Jave's Mapo Tofu, **131–32**
Beautiful Apathy (Matlock), *93*
beauty ideals, in South Korea, 45
beef
 Beef Chow Fun (Fried Rice Noodles), **111–12**
 "I'm a Pepper, You're a Pepper, Wouldn't You Like to Be a Pepper, Too?" Chicago/LA Kalbi Marinade/Serenade, **73–74**
 Jave's Kimchi Fried Rice Flavor Explosion, **133–34**
 Kebab Karahi, *38*, **39–40**
Beef Chow Fun (Fried Rice Noodles), *110*, **111–12**

belonging
 food representing, 20
 in O'Brien's art, 101
 in Sifuentes's work, 53
 tastes and flavors of, 19
Bhabha, Homi, 27
biographies of artists, 22–23
 See also individual artists
Bishop, Claire, 25
black peppercorns, 85
Blue White and Red (portals) (Khan), *61*
bodily autonomy, in O'Brien's art, 101
body
 in Khan's art, 61
 in O'Brien's art, 101
body image, in Choi's work, 45
bok choy
 about, 85
 Jave's Kimchi Fried Rice Flavor Explosion, **133–34**
 Vegan Kare Kare, **88**
border issues
 in Elahi's work, 49
 in Karimi's work, *57*
Bourriaud, Nicolas, 25
Boym, Svetlana, 20, 29
bread
 Asian, 69
 Chinese Milk Bread, **69–70**
 See also buns
breakfast
 Sourdough Starter Jian Bing, **103–4**
 SPAM and Eggs, **115**
Breakfast Piece (Claesz), *22*
broccoli
 Beef Chow Fun (Fried Rice Noodles), **111–12**
 Pancit Guisado 2.0, **91–92**
brown button mushrooms
 Pancit Guisado 2.0, **91–92**
built environment, in Kuo's art, 71
buns
 Chinese Milk Bread, *68*, **69–70**
 Pork My Buns XXXX, *98*, **99–100**

C

cabbage
 Kimchi, **43–44**
 Okonomiyaki, **107–8**
 Pancit Guisado 2.0, **91–92**
Cake, Lien's Fried Banana, *118*, **119–20**
California cuisine, 63
California Respect after Death Act, 99
Cantonese cuisine, 73
capitalist disruption, Khan's practice for, 61
card games, of Karimi, 57, *57*
carrots
 Jave's Mapo Tofu, **131–32**
 Pancit Guisado 2.0, **91–92**
 Rabokki, **51–52**
 Red October Dal, **59–60**
 Szechuan Spicy Alligator, **123–24**
Casserole, A Recipe for Survival Spinach, *54*, **55–56**
cauliflower, riced
 Vegan Kare Kare, **88**
Caws, Mary Ann, *The Modern Art Cookbook*, 23, *23*
celery
 Szechuan Spicy Alligator, **123–24**
The Chariot (inner landscape) (Francis Wong), 125
char sui, 99–100
cheese
 Rabokki, **51–52**
 A Recipe for Survival Spinach Casserole, **55–56**
Chicago, Judy, *Dinner Party*, 23
chicken
 Double-Fried Garlic Chicken, *34*, **35–36**
 Kebab Karahi, *38*, **39–40**
chilies, 85
 Kebab Karahi, *38*, **39–40**
 Red October Dal, **59–60**
 Tripe Stew, **48**
Chinese Americans, pandemic violence against, 21, 27
Chinese cuisine
 Chinese Milk Bread, **69–70**
 culinary traditions, 69, 70
 Szechuan Spicy Alligator, **123–24**
Chinese Milk Bread, *68*, **69–70**
Chinese restaurant syndrome, 29n4
Chishti, Ruby, *41*
 background and art of, 41
 Kebab Karahi, *38*, **39–40**
 The Present Is a Ruin Without the People, 41
Choi, Hyegyeong, 45, *45*
 Amazon Olympia, 45
 background and art of, 45
 Kimchi, **43–44**
 Kimchi Baby, 42
choy sum
 Beef Chow Fun (Fried Rice Noodles), **111–12**
citizenship issues
 in Elahi's work, 49
 in Sifuentes's work, 53
Claesz, Pieter, *Breakfast Piece*, 22
climate change, in O'Brien's art, 101
coconut, 85, 86
College Art Association 2023 conference, 14, 15
Colouch, Laura, 55
comedy, of Kristina Wong, 129
comfort food/cooking
 Ali on, 35
 as coping mechanism, 17
 during COVID-19 pandemic, 13, 16–18, 63, 103
 Elahi on, 47
 Takizawa on, 107
 Yoshimoto on, 133
community
 food as symbol of, 13
 forged in isolation, 19–30
 juxtaposed with privacy, 27
 in O'Brien's art, 101
 racializing notion of, 28
conceptual performance, of O'Brien, 101
condiments
 Kimchi, *42*, **43–44**
Congee, Milkfish, *76*, **77**

138 INDEX

connection, 17–18
 to culinary heritage, 69–70
 dichotomy of difference and, 20–21
 food as form of, 20–21
 represented by this book, 28
 through comfort food, 63
 through diasporic experiences, 20, 21, 29 (*See also* diasporic intimacy[-ies])
cooking
 as intimacy, 23, 24
 as self-care, 13
 of someone else's recipe, 27
 See also comfort food/cooking
The Cooking Show con Karimi y Comrades, 55
Cooking the Books (with Jason Dunda) (Larry Lee), *75*
COVID-19 pandemic
 anti-Asian sentiment during, 13, 21, 28
 Auntie Sewing Squad work during, *126,* 127–28
 comfort cooking during, 13, 16–18, 63, 103
 community forged in isolation during, 19–30
 Kuo's baking during, 69–70
 lockdown, 9, 17, 21, 29, 69, 103, 127, 133
 racial violence during, 21, 27, 28
cream
 Chinese Milk Bread, **69**
cream cheese
 Lien's Fried Banana Cake, **119–20**
cream of potato soup
 A Recipe for Survival Spinach Casserole, **55–56**
crepes
 Sourdough Starter Jian Bing, **103–4**
critical race visual culture, Yee's study of, 31
cucumber
 Auntie Nora's Mac Salad, **63**, **66**
culinary heritage, reclaiming, 69–70
cultural heritage, food representing, 20

cultural identities, in Toh's work, 113
cultural ideology, in Truong's work, 121
cultural issues, in Choi's work, 45
Cunningham, David Scott, 15
curry
 Junio on, 85
 Khmer paste for, 35
 Red October Dal, *58,* **59–60**
 Vegan Kare Kare, *84,* **85–88**, 86

D

dal
 Red October Dal, *58,* **59–60**
Davis, Jarrett Min, *96*
 background and art of, 86
 Exploration of the Terrain between the Time We Were and We Were Not, 97
 Ground Pork Japchae, *94,* **95**
Dawning Wonder # 7 (Toh), *113*
dduk
 Rabokki, **51–52**
diaspora, 28
 in Kina's art, 67
 in O'Brien's art, 101
 Okinawan, 63
diaspora studies, third space in, 27
Diasporic Asian Arts Network, 15
diasporic existence, tastes and flavors of, 19
diasporic experiences
 defamiliarization and uprootedness in, 20
 food as connectivity in, 20–21, 29
 in Larry Lee's art, 75
diasporic identity
 art exploring questions of, 25
 predicated on a shared present, 28
 shared in food, 29
diasporic intimacy(-ies), 15, 20
 disconnect, 20
 familiarity, 20
 food as form of, 20–21
 narratives of nostalgia in, 20
 promise of, 29
 shared identity in, 27

diasporic language, in Truong's work, 121
diasporic spaces, public and private, 25
difference
 dichotomy of connection and, 20–21
 food as manifestation of, 20
 held with togetherness, 15, 28
 related to foods, 21
digital media art
 of O'Brien, 101
 of Yoshimoto, *135*
The Dining Project (Lee Mingwei), 25, *26*
Dinner Party (Chicago), 23
disabled time, 14
disenfranchised communities, in Sifuentes's work, 53
dissent, in Sifuentes's work, 53
documentary films, of Soe, 105
Dona Nobis Pacem: Samskaras (Junio), *89*
Double-Fried Garlic Chicken, 28–29, *34,* **35–36**
drawings
 of Liao, 78, *79*
 of lou, *80, 83*
 of Matlock, *90, 92, 93*
drink
 Trader Vic's Mai Tai Recipe, Circa 1944, *14,* **73**, *74, 74*
Dr Pepper
 "I'm a Pepper, You're a Pepper, Wouldn't You Like to Be a Pepper, Too?" Chicago/LA Kalbi Marinade/Serenade, **73–74**
"dumplings" (lou), 81–82
dumplings reprise (lou), *80*
Dunda, Jason, *75*

E

eating in public, 25, 27
eggplant
 about, 86
 Vegan Kare Kare, **88**

eggs
 Auntie Nora's Mac Salad, **66**
 Jave's Kimchi Fried Rice Flavor Explosion, **133–34**
 Okonomiyaki, **107–8**
 Rabokki, **51–52**
 Sourdough Starter Jian Bing, **103–4**
 SPAM and Eggs, **115**
 SPAM Musubi, **64–65**
Eid-ul-Azha, 39
886 (Taiwanese eatery), 21
Elahi, Hasan, *49*
 background and art of, 49
 on comfort food, 47
 Home v1, 49
 Tripe Stew, *46*, **47–48**
Elahi's Tripe Stew (Kina), *46*
Enemy Kitchen (Rakowitz), 24
experience(s)
 of Asian Americans, diversity of, 28
 diasporic (*See* diasporic experiences)
 in Karimi's game performances, 57
 in Liao's work, 78
 during pandemic (*See* COVID-19 pandemic)
Exploration of the Terrain between the Time We Were and We Were Not (Davis), *97*

F

fabric
 Auntie Sewing Squad masks, *126*, 127–28
familial traditions, 20
fashion, of Junio, 89
Feast exhibition (Smart Museum), 24–25
fiber art
 of Chishti, 41
 of Khan, 62
 of O'Brien, 101
 of Sifuentes, 53
Filipino culture
 in Matlock's work, 93
 values in, 91

Filipino Fusions (Junio), 63
film
 of Soe, 105
fish and seafood
 Auntie Nora's Mac Salad, **63**
 Kimchi, **43–44**
 Milkfish Congee, *76*, **77**
 Okonomiyaki, **107–8**
food
 as basic need, 23
 as connection to homeland, 20
 during COVID-19 pandemic, 21
 and desire for intimacy, 23, 24
 and diasporic identity, 29
 as form of connectivity and diasporic intimacy, 20–21
 intersection of art and, 23–25
 intimacies and meanings associated with, 20
 reflecting person's culinary home, 47
 relationship between artists and, 23
 as symbol of community, resilience, and survival, 13
 See also comfort food; *individual types of cuisine*
food history, in Truong's work, 121
food studies, third space in, 27
Francis Wong's Szechuan Spicy Alligator (Kina), *122*
frontier issues, in Elahi's work, 49
Fu Facemask, 127
fun, in Karimi's work, 57

G

game-performance experiences, of Karimi, 57, *57*
garlic
 about, 86
 Double-Fried Garlic Chicken, *34*, **35–36**
 in Khmer food, 35
 Kimchi, **43–44**
 Vegan Kare Kare, **88**
gender construction
 in Choi's work, 45
 in Khan's art, 61

generosity, in Karimi's work, 57
Genevieve Erin O'Brien's Pork My Buns XXXX (Yoshimoto), *98*
George Eastman Museum, *The Photographer's Cookbook*, 23
goat-slaughtering ritual *(qurbani)*, 39
graphic design, of Junio, 89
green beans
 Jave's Mapo Tofu, **131–32**
 Pancit Guisado 2.0, **91–92**
 Vegan Kare Kare, **88**
Ground Pork Japchae, *94*, *95*

H

Hawai'i, 63
Heinrich Toh's Beef Chow Fun (Yoshimoto), *110*
heritage
 culinary, reclaiming, 69–70
 cultural, food representing, 20
 in Truong's work, 121
 Yee on, 19
Herscher, Ermine, 13
Hmong Americans, COVID-fueled violence against, 27
home
 food as connection to, 20
 imaginary homeland, 29n1
 tastes and flavors of, 19
 in Toh's work, 113
 See also belonging
Home v1 (Elahi), *49*
Hsieh, Tehching, 25
Huynh, Van, *126*, 127–28
hybrid transnational identity, in Ali's works, 37

I

Identical Lunch (Knowles), 24
identity(-ies)
 in Ali's works, 37
 of artists, 22–23
 of "Asian American," 27–28
 in Choi's work, 45
 diasporic, 25, 28, 29
 hybrid transnational, 37
 in Junio's art, 89
 in Khan's art, 61

racialized, 28
shared, 27, 28
in Sifuentes's work, 53
tastes and flavors of, 19
in Toh's work, 113
Uchinanchu, 63
Ikasumi Pasta (Takizawa), *109*
illustration(s)
by Kina, 22 (*See also* Kina, Laura)
by Matlock, 93
by Yoshimoto, 22 (*See also* Yoshimoto, Jave)
imaginary homeland, 29n1
"I'm a Pepper, You're a Pepper, Wouldn't You Like to Be a Pepper, Too?" Chicago/LA Kalbi Marinade/Serenade, *72*, **73–74**
immigrant issues, 20
Elahi on, 47
in Liao's work, 78
in Sifuentes's work, 53
In Between the Lines (Liao), *79*
Ingredients for Kiam Marcelo Junio's Vegan Kare Kare (Kina), *86*
installation art
of Ali, 37
of Chishti, 41
of Larry Lee, 75
of Liao, 78
of O'Brien, 101
of Soe, 105
of Takizawa, 109
interactive works, of Karimi, 57
intimacy
food and eating as, 23–25
through artists' voices and backstories, 28
See also diasporic intimacy
Intimate Eating (Mannur), 25, 27
isolation, community forged in, 19–30

J

jalapeño peppers
Red October Dal, **59–60**
Japanese cuisine
Okonomiyaki, **107–8**
Japanese culture, art influenced by, 14
Japanese traditional patterns, in Takizawa's work, 109
Japchae, Ground Pork, *94*, **95**
Jarrett Min Davis's Ground Pork Japchae (Yoshimoto), *94*
Jave's Kimchi Fried Rice Flavor Explosion, *133*, **133–34**
Jave's Kimchi Fried Rice Flavor Explosion (Yoshimoto), *133*
Jave's Mapo Tofu, *130*, **131–32**
Jave Yoshimoto's Mapo Tofu (Yoshimoto), *130*
Jewelry for Furniture I (Kuo), *71*
Jian Bing, Sourdough Starter, **103–4**
Junio, Kiam Marcelo, 63, *89*
background and art of, 89
Dona Nobis Pacem: Samskaras, *89*
Vegan Kare Kare, *84*, **85–88**, *86*

K

kalbi
"I'm a Pepper, You're a Pepper, Wouldn't You Like to Be a Pepper, Too?" Chicago/LA Kalbi Marinade/Serenade, **73–74**
kare kare
about, 85
Vegan Kare Kare, *84*, **85–88**, *86*
Karimi, Robert Farid, *57*
background and art of, 57
oncewehonorandlifttheweightweflythenwegottadealwiththecagesandtheracism, *57*
A Recipe for Survival Spinach Casserole, *54*, **55–56**
Kathy Liao's Milkfish Congee (Yoshimoto), *76*
Kebab Karahi, *38*, **39–40**
Khan, Baseera, *61*
background and art of, 61
Blue White and Red (portals), *61*
Red October Dal, *58*, **59–60**
Khmer cuisine, 35
Kiam Marcelo Junio's Vegan Kare Kare (Kina), *84*
Kimchi, *42*, **43–44**
Jave's Kimchi Fried Rice Flavor Explosion, **133–34**
SPAM and Eggs, **115**
Kimchi Baby (Choi), *42*
Kina, Laura, 17, 67
Anida Yoeu Ali's Double-Fried Garlic Chicken, 34
Auntie Nora's Mac Salad, *62*, **63**, *66*
Auntie Nora's Mac Salad, *62*
background and art of, 67
Baseera Khan's Red October Dal, *58*
and creation of this book, 15, 17, 21–23, 28
Elahi's Tripe Stew, *46*
Francis Wong's Szechuan Spicy Alligator, *122*
friendship of Yoshimoto and, 29
illustrations created by, 22
Ingredients for Kiam Marcelo Junio's Vegan Kare Kare, *86*
Kiam Marcelo Junio's Vegan Kare Kare, *84*
on pandemic experience, 13–16
Phoebe Kuo's Chinese Milk Bread, *68*
Robert Farid Karimi's Spinach Casserole, *54*
SPAM Musubi, **63–65**
SPAM Musubi, *14*, 15, *65*
Trader Vic's Mai Tai, *14*, 74
Ufushu Gajumaru (Giant Banyan Tree), Valley of Gangala, Okinawa, Japan, 67
Valerie Soe's Sourdough Starter Jian Bing, *102*
kinship, in Karimi's work, 57
Knowles, Alison, *Identical Lunch*, 24
Korean cuisine
Davis on, 95
Ground Pork Japchae, *94*, **95**
Jave's Kimchi Fried Rice Flavor Explosion, **133–34**
Kimchi, *42*, **43–44**
Larry Lee on, 73
Rabokki, *50*, **51–52**
Sifuentes on, 51
sweet potato glass noodles, **95**
Yoshimoto on, 133

INDEX 141

Kuo, Phoebe, *71*
 background and art of, 71
 on baked goods, 69–70
 Chinese Milk Bread, *68*, **69–70**
 Jewelry for Furniture, 71

L

language, diasporic, 121
Larry Lee's "I'm a Pepper, You're a Pepper, Wouldn't You Like to Be a Pepper, Too?" (Yoshimoto), *72*
The Last Supper (Leonardo), 23
layered cultural identities, in Toh's work, 113
Lee, Christopher, 99
Lee, Larry, *75*
 background and art of, 75
 Cooking the Books (with Jason Dunda), 75
 "I'm a Pepper, You're a Pepper, Wouldn't You Like to Be a Pepper, Too?" Chicago/LA Kalbi Marinade/Serenade, *72,* **73–74**
 Trader Vic's Mai Tai Recipe, Circa 1944, *14, 73, 74, 74*
Lee Mingwei, *26*
 The Dining Project, 25, *26*
 in *Feast* exhibition, 25
lentils
 Red October Dal, **59–60**
 Tripe Stew, **48**
Leonardo da Vinci, *The Last Supper,* 23
Liao, Kathy, *78*
 background and art of, 78
 In Between the Lines, 79
 Milkfish Congee, *76,* **77**
Lien's Fried Banana Cake, *118,* **119–20**
Lien's Fried Banana Cake (Yoshimoto), *118*
lion's mane mushrooms
 Pancit Guisado 2.0, **91–92**
longing, in Toh's work, 113
Looking for Love (Tom), *117*

lou, heather c., *83*
 background and art of, 83
 dumplings reprise, 80
 Mooncake, 83
Love Boat: Taiwan (Soe), *105*

M

macaroni
 Auntie Nora's Mac Salad, **66**
Mai Tai, Trader Vic's, *14,* **73, 74,** *74*
maki sushi, 63
Mannur, Anita
 on an intimate eating public, 25, 27
 Intimate Eating, 25, 27
 on tension in holding togetherness and difference, 28
mapo tofu
 Jave's Mapo Tofu, **131–32**
marinade
 "I'm a Pepper, You're a Pepper, Wouldn't You Like to Be a Pepper, Too?" Chicago/LA Kalbi Marinade/Serenade, **73–74**
the Market (restaurant), 25
masks, from Auntie Sewing Squad, *126,* 127–29
masoor dal
 Red October Dal, **59–60**
material ideology, in Truong's work, 121
Mathew Tom's SPAM and Eggs (Yoshimoto), *114*
Matlock, Mia, *93*
 background and art of, 93
 Beautiful Apathy, 93
 Pancit Guisado 2.0, *90,* **91–92**
 Shiitake, Lion's Mane, Tree Oyster, 92
Matsumoto, Nora, 63
mayonnaise
 Auntie Nora's Mac Salad, **66**
measurements
 inexact, 36, 47
 in recipes, 28

meat
 animals slaughtered for, 39
 Jave's Mapo Tofu, **131–32**
 Szechuan Spicy Alligator, **123–24**
 Tripe Stew, **47–48**
 See also beef; chicken; pork; SPAM
Meat My Friends (O'Brien), 99, *101*
Memento Mori (Yoshimoto), *135*
memory
 in Chishti's work, 41
 in Liao's work, 78
 in O'Brien's art, 101
 in Toh's work, 113
Messages to Our Neighbors (Sifuentes), *53*
Mia Matlock's Pancit Guisado 2.0 (Matlock), *90*
migration issues
 in Chishti's work, 41
 in Elahi's work, 49
military history, in Truong's work, 121
Milkfish Congee, *76,* **77**
miso paste
 about, 86–87
 Vegan Kare Kare, **88**
mixed-media work
 of Khan, 61
 of Liao, 78, *79*
 of Francis Wong, 125
The Modern Art Cookbook (Caws), 23, *23*
Mooncake (lou), *83*
multimedia art
 of Larry Lee, 75
 of O'Brien, 99
mushrooms
 Jave's Kimchi Fried Rice Flavor Explosion, **133–34**
 Jave's Mapo Tofu, **131–32**
 Kimchi, **43–44**
 Pancit Guisado 2.0, **91–92**
 Shiitake, Lion's Mane, Tree Oyster (Matlock), *92*
music, of Francis Wong, 125
Muslim identity, in Khan's art, 61

N

new media practices, of Ali, 37
New Orleans, 9, 17, 29, 123
noodles
 Auntie Nora's Mac Salad, *62, 63,* 66
 Beef Chow Fun (Fried Rice Noodles), **111–12**
 Ground Pork Japchae, **95**
 Pancit Guisado 2.0, **91–92**
 Rabokki, **51–52**
nostalgia, 20

O

O'Brien, Genevieve Erin, *101*
 background and art of, 101
 Meat My Friends, 99, *101*
 Pork My Buns XXXX, *98,* **99–100**
Okinawan diaspora, 63
Okonomiyaki, *106,* **107–8**
oncewehonorandlifttheweightwefly-thenwegottadealwiththecages-andtheracism (Karimi), *57*
onions
 about, 87
 Beef Chow Fun (Fried Rice Noodles), **111–12**
 "I'm a Pepper, You're a Pepper, Wouldn't You Like to Be a Pepper, Too?" Chicago/LA Kalbi Marinade/Serenade, **73–74**
 Jave's Kimchi Fried Rice Flavor Explosion, **133–34**
 Jave's Mapo Tofu, **131–32**
 Kebab Karahi, *38,* **39–40**
 Kimchi, **43–44**
 Rabokki, **51–52**
 Red October Dal, **59–60**
 Szechuan Spicy Alligator, **123–24**
 Tripe Stew, **48**
 Vegan Kare Kare, **88**
orientalia, 75
Orientalism, 57

P

painting
 of Choi, *42,* 45
 of Davis, 96, *97*
 of Kina, 67
 of Larry Lee, 75
 of Liao, 78
 of Tom, 116, *117*
 of Truong, 121
 of Francis Wong, 125
 of Yoshimoto, 135
Pakistan, 41
pancakes
 Okonomiyaki, *106,* **107–8**
 with sourdough starter, 103
Pancit Guisado 2.0, *90,* **91–92**
participatory art, of Sifuentes, 53
The Passage through Sea, Cloth, and Bone (Truong), *121*
paste
 for Khmer foods and medicine, 35
 miso, 86–87
pastries
 American, 69
 Chinese Milk Bread, **69–70**
peanut butter
 Vegan Kare Kare, **88**
pear
 "I'm a Pepper, You're a Pepper, Wouldn't You Like to Be a Pepper, Too?" Chicago/LA Kalbi Marinade/Serenade, **73–74**
peas
 Auntie Nora's Mac Salad, **66**
 Jave's Mapo Tofu, **131–32**
pepper(s)
 black peppercorns, 85
 in Khmer food, 35
 red, Kimchi, **43–44**
 See also chilies
performance art
 of Ali, 37
 of Junio, 89
 of Karimi, 57
 of Larry Lee, 75
 of O'Brien, 99, 101
 of Kristina Wong, 129
perfumery, of Junio, 89

personal history
 in Larry Lee's work, 75
 in Toh's work, 113
Philippines, kare kare in, 85
philosophies, in Truong's work, 121
Phoebe Kuo's Chinese Milk Bread (Kina), *68*
The Photographer's Cookbook (George Eastman Museum), 23
photography
 of Elahi, *49*
 of Khan, *61*
Picasso, Bon Vivant (Herscher), 13
Piihonua Kumiai Cookbook, 13
place, in Liao's work, 78
playing cards (Karimi), *57*
political agitation, in Ali's work, 37
political issues
 art related to, 24
 Recipe for Political Action, 127–28
 in Sifuentes's work, 53
pollock, dried
 Kimchi, **43–44**
pork
 Ground Pork Japchae, **95**
 Jave's Mapo Tofu, **131–32**
 Okonomiyaki, **107–8**
 Pork My Buns XXXX, **99–100**
 See also SPAM
Pork My Buns XXXX, *98,* **99–100**
porridge
 Milkfish Congee, *76,* **77**
possession and dispossession, in Sifuentes's work, 53
postcolonial/diaspora studies, third space in, 27
potatoes
 Auntie Nora's Mac Salad, **66**
 Tripe Stew, **48**
power issues, in Khan's art, 61
The Present Is a Ruin Without the People (Chishti), *41*
printmaking
 of Liao, 78, *79*
 of Matlock, *93*
 of Takizawa, 109

printmaking *(continued)*
 of Toh, *113*
private spaces, eating in, 26
protest, in Sifuentes's work, 53
public encounters, of Ali, 37
public spaces, eating in, 25, 27
Push / 99 Eggs (Ali), *37*

Q

queer, coming out, 13
queer domesticity, in O'Brien's art, 101
queer time, 14
quinoa
 Vegan Kare Kare, **88**
qurbani, 39

R

Rabokki, *50*, **51–52**
race, in Sifuentes's work, 53
racial injustices, Sifuentes's work confronting, 53
racialized identity, 28
racism, pandemic violence fueled by, 21, 27, 28
Radical Care: The Auntie Sewing Squad (Soe), *128*
rain painting, by Francis Wong, *125*
Rakowitz, Michael, *Enemy Kitchen*, 24
ramen
 Rabokki, **51–52**
A Recipe for Survival Spinach Casserole, *54*, **55–56**
Red October Dal, *58*, **59–60**
red pepper
 Kimchi, **43–44**
relational aesthetics, 15, 25
resilience, food as symbol of, 13
Respect after Death Act (California), 99
rice
 Jave's Kimchi Fried Rice Flavor Explosion, **133–34**
 Milkfish Congee, **77**
 Rabokki, **51–52**
 SPAM and Eggs, **115**
 SPAM Musubi, **64–65**
 Vegan Kare Kare, **88**
rice noodles
 Beef Chow Fun (Fried Rice Noodles), **111–12**
 Pancit Guisado 2.0, **91–92**
Robert Farid Karimi's Spinach Casserole (Kina), *54*
Ruby Chishti's Kebab Karahi (Yoshimoto), *38*
rum
 Trader Vic's Mai Tai, **73**, **74**
Rushdie, Salman, 29n1

S

saffron
 about, 87
 Vegan Kare Kare, **88**
Salad, Auntie Nora's Mac, **66**
salt, in Khmer food, 35
sauce, Kimchi, **43–44**
sausages
 artisanal, 99
 Pork My Buns XXXX, **99–100**
sculpture
 of Chishti, 41, *41*
 of Kuo, 71
 of Larry Lee, 75
seafood
 in Taiwanese culinary traditions, 77
 See also fish and seafood
self-care, cooking as, 13
sexuality
 in Choi's work, 45
 Korean taboos around, 45
Shiitake, Lion's Mane, Tree Oyster (Matlock), *92*
shiitake mushrooms
 Jave's Mapo Tofu, **131–32**
 Kimchi, **43–44**
 Pancit Guisado 2.0, **91–92**
Shin Ramyun, with Tripe Stew, 47
short ribs
 "I'm a Pepper, You're a Pepper, Wouldn't You Like to Be a Pepper, Too?" Chicago/LA Kalbi Marinade/Serenade, **73–74**
shrimp
 Okonomiyaki, **107–8**
Sifuentes, Aram Han, *53*
 background and art of, 53
 on Korean food, 51
 Messages to Our Neighbors, 53
 Rabokki, *50*, **51–52**
Smart Museum, *Feast* exhibition, 24–25
social consciousness, in Yoshimoto's work, 135
social disruption, Khan's practice for, 61
social engagement art, of Karimi, 57
social injustices
 experienced by Huynh, 128
 Sifuentes's work confronting, 53
social issues
 in Choi's work, 45
 for Korean women, 45
sociality
 food as conduit for, 13
 juxtaposed with privacy, 27
social memory, in Chishti's work, 41
social practice art
 of O'Brien, 101
 of Sifuentes, 53
societal perceptions, food associated with shifts in, 20
Soe, Valerie, *105*
 background and art of, 105
 Love Boat: Taiwan, 105
 Radical Care: The Auntie Sewing Squad, *128*
 Sourdough Starter Jian Bing, *102*, **103–4**
sound works, of Junio, 89
sour cream
 A Recipe for Survival Spinach Casserole, **55–56**
Sourdough Starter Jian Bing, *102*, **103–4**
Southeast Asian cuisine
 Beef Chow Fun (Fried Rice Noodles), **111–12**
 Lien's Fried Banana Cake, **119–20**

See also cuisine of specific countries
South Korean cuisine
 Ground Pork Japchae, *94,* **95**
 Kimchi, *42,* **43–44**
spaces
 diasporic, public and private, 25
 third, 27
SPAM, 51
 in Hawai'i, 63
 maki sushi, 63
 Rabokki, **51–52**
 SPAM and Eggs, *114,* **115**
 SPAM Musubi, *14, 15,* **63–65,** *65*
SPAM Musubi (Kina), *14, 15, 65*
spinach
 Ground Pork Japchae, **95**
 Jave's Mapo Tofu, **131–132**
 A Recipe for Survival Spinach Casserole, *54,* **55–56**
spirituality, in Junio's art, 89
squid
 Okonomiyaki, **107–8**
Stew, Tripe, *46,* **47–48**
stir-fry
 Szechuan Spicy Alligator, *29,* **123–24**
STOP AAPI, 21
street food
 Milkfish Congee, *76,* **77**
 Okonomiyaki, *106,* **107–8**
 Rabokki, *50,* **51–52**
string beans
 Vegan Kare Kare, **88**
 See also green beans
surimi (imitation crab)
 Auntie Nora's Mac Salad, **63,** 66
surveillance issues
 in Elahi's work, 49
 in Khan's art, 61
survival, food as symbol of, 13
sushi
 SPAM maki sushi, 63
 SPAM Musubi, **63–65**
sweet potato glass noodles
 Ground Pork Japchae, **95**
sweets
 American, 69

Chinese Milk Bread, **69–70**
Lien's Fried Banana Cake, *118,* **119–20**
Szechuan Spicy Alligator, *29,* **123–24**

T

taboos, in Choi's work, 45
Taiwanese Americans, *105*
Taiwanese cuisine
 finding one's way into culinary traditions, 69
 seafood in, 77
 Sourdough Starter Jian Bing, *102,* **103–4**
Takizawa, Taro, *109*
 background and art of, 109
 Ikasumi Pasta, 109
 Okonomiyaki, *106,* **107–8**
Taro Takizawa's Okonomiyaki (Yoshimoto), *106*
tattoo art, of lou, 83
technology, in O'Brien's art, 101
textile art, of Truong, 121
textile history, in Truong's work, 121
Thai food, 25, 30n9
third space, 27
time
 in Davis's art, *97*
 difference and togetherness held at same time, 15, 28
 disabled and queer, 14
 in Junio's art, 89
 shift in meaning of food across, 20
Tiravanija, Rirkrit
 in *Feast* exhibition, 25
 untitled 1990 (pad thai), 25
 untitled 1992 (free), 15, 24
tofu
 Jave's Mapo Tofu, **131–32**
 Pancit Guisado 2.0, **91–92**
togetherness
 held with difference, 15, 28
 See also belonging; connection
Toh, Heinrich, *113*
 background and art of, 113
 Beef Chow Fun (Fried Rice Noodles), *110,* **111–12**

Dawning Wonder # 7, 113
Tom, Mathew, *116*
 background and art of, 116
 Looking for Love, 117
 SPAM and Eggs, *114,* **115**
tomatoes
 Red October Dal, **59–60**
 Vegan Kare Kare, **88**
Trader Vic's (Chicago), 73
Trader Vic's Mai Tai (Kina), *14, 74*
Trader Vic's Mai Tai Recipe, Circa 1944, *14,* **73,** *74, 74*
transitional impediments, in Chishti's work, 41
transport issues, in Elahi's work, 49
trauma
 in Chishti's work, 41
 and Francis Wong's work, 125
tripe, 47
Tripe Stew, *46,* **47–48**
Truong, Lien, *121*
 background and art of, 121
 Lien's Fried Banana Cake, *118,* **119–20**
 The Passage through Sea, Cloth, and Bone, 121
tsukemono (pickled) cucumbers
 Auntie Nora's Mac Salad, **63**
turmeric
 about, 87
 Vegan Kare Kare, **88**
2-D designs, of Takizawa, 109

U

Uchinanchu identity, 63
Ufushu Gajumaru (Giant Banyan Tree), Valley of Gangala, Okinawa, Japan (Kina), *67*
Uncle Van Huynh Mask (Auntie Sewing Squad), *126*
untitled 1990 (pad thai) (Tiravanija), 25
untitled 1992 (free) (Tiravanija), 15, *24*

V

Valerie Soe's Sourdough Starter Jian Bing (Kina), *102*

value systems
 in Kuo's art, 71
 Western vs. Filipino, 91
vegan cuisine
 Matlock on, 91
 Pancit Guisado 2.0, *90*
 Trader Vic's Mai Tai Recipe, Circa 1944, *73*, **74**
 Vegan Kare Kare, *84*, **85–88**, *86*
video
 of Larry Lee, 75
 of O'Brien, 101
 of Soe, 105
 of Francis Wong, 125
Vietnamese Americans, COVID-fueled violence against, 27
Vietnamese cuisine
 Lien's Fried Banana Cake, *118*, **119–20**
Virtual Asian American Art Museum, 14
visual art
 of Junio, 89
 of lou, 83
voting, in Sifuentes's work, 53

W

wall-drawing installations, of Liao, 78, *79*
wall vinyl installations, of Takizawa, 109
water, in Francis Wong's work, 125
Way Stations exhibition (Whitney Museum of American Art), *26*
Werle, Mark, 73
Whitney Museum of American Art
 The Dining Project (Lee Mingwei), 25, *26*
 Way Stations exhibition, *26*
The Woks of Life, 70
Wolcott, Elisa, 18
women's issues
 in Choi's work, 45
 social and cultural issues, 45
Wong, Francis, *125*
 background and art of, 125
 The Chariot (inner landscape), 125

Szechuan Spicy Alligator, 29, *122*, **123–24**
Wong, Kristina, *129*
 Auntie Sewing Squad started by, 127–29
 background and art of, 129
 Recipe for Political Action, 127–28
wonton pei (wrappers)
 Sourdough Starter Jian Bing, **103–4**
woodworking, of Kuo, 71
writing
 of Junio, 89
 of Karimi, 57
 of Larry Lee, 75
 of lou, 81–82
 of Soe, 105
 of Kristina Wong, 129
 of Yee, 31

X

xenophobia, Karimi on, 55

Y

Yee, Michelle, 14, 15, *31*
 background and art of, 31
 and creation of this book, 15, 21–23, 27, 28
 on forging community in isolation, 19–30
 on her mother's cookbook, 19, *19*, 28
 on intersection of food and art, 23–25
yellow peril, 30n12
Yoshimoto, Jave, 13–15, *17*, *135*
 Aram Han Sifuentes's Rabokki, 50
 background and art of, 135
 and creation of this book, 17, 21–23, 28
 on departures and connections, 17–18
 friendship of Kina and, 29
 Genevieve Erin O'Brien's Pork My Buns XXXX, 98
 health deterioration for, 17
 Heinrich Toh's Beef Chow Fun, 110

illustrations created by, 22
Jarrett Min Davis's Ground Pork Japchae, 94
Jave's Kimchi Fried Rice Flavor Explosion, **133–34**
Jave's Kimchi Fried Rice Flavor Explosion, 133
Jave's Mapo Tofu, *130*, **131–32**
Jave Yoshimoto's Mapo Tofu, 130
Kathy Liao's Milkfish Congee, 76
Larry Lee's "I'm a Pepper, You're a Pepper, Wouldn't You Like to Be a Pepper, Too?," 72
Lien's Fried Banana Cake, 118
Mathew Tom's SPAM and Eggs, 114
Memento Mori, 135
Ruby Chishti's Kebab Karahi, 38
Taro Takizawa's Okonomiyaki, 106

www.ingramcontent.com/pod-product-compliance
Lightning Source LLC
Chambersburg PA
CBHW080546220526
45466CB00010B/3048